ID1042294

"The stars of the new era. Not just stars but phenomena, having exploded through the Web ether onto the world stage." —*Los Angeles Times*

"The masters of public mayhem." —College Humor

"Improv Everywhere is fighting the good fight to keep NYC unpredictable, off the grid and balls-out funny. I mean, how could you not laugh at someone setting themselves up as a bathroom attendant at the Times Square McDonald's or staging a synchronized swimming performance in the Washington Square Park fountain?"

—*Time Out New York*

"Improv Everywhere is reliably hilarious to millions of people. The masters of mischief. [The Frozen Grand Central stunt] is one of the funniest moments ever captured on tape." —MARTIN BASHIR, ABC News *Nightline*

"Improv Everywhere tramples the lines drawn between spectacle and spectator, theatre and real life, public and private, performance and protest, and reclaims the streets for ordinary people." —*The Guardian* (UK)

"Improv Everywhere has heightened public spectacle to an art form. Hilarious." —FAITH SALIE, Public Radio International

causing
a scene

extraordinary pranks in ordinary places with Improv Everywhere

charlie todd and alex scordelis

wm WILLIAM MORROW *An Imprint of* HarperCollins*Publishers*

All photos courtesy of Chad Nicholson and Improv Everywhere.

CAUSING A SCENE. Copyright © 2009 by Charlie Todd and Alex Scordelis. All rights reserved. Printed in the United States of America. No part of this book may be used or reproduced in any manner whatsoever without written permission except in the case of brief quotations embodied in critical articles and reviews. For information address HarperCollins Publishers, 10 East 53rd Street, New York, NY 10022.

HarperCollins books may be purchased for educational, business, or sales promotional use. For information please write: Special Markets Department, HarperCollins Publishers, 10 East 53rd Street, New York, NY 10022.

FIRST EDITION

Designed by James L. Iacobelli

Library of Congress Cataloging-in-Publication Data

Todd, Charlie.

Causing a scene : extraordinary pranks in ordinary places with Improv Everywhere / by Charlie Todd and Alex Scordelis.

p. cm.

ISBN 978-0-06-170363-8

1. Practical jokes. I. Scordelis, Alex. II. Title.

PN6231.P67T63 2009

818'.602—dc22 2008052734

09 10 11 12 13 OV/RRD 10 9 8 7 6 5 4 3 2 1

For every single person who has ever
participated in an Improv Everywhere mission.
None of this would be possible without you.

While Improv Everywhere does not break the law, we do occasionally have run-ins with the police. Should you choose to try any of the pranks in this book, remember that you do so at your own risk and that we are not responsible for your actions. We believe organized fun should be met with smiles and laughter, but that is not always how things turn out.

On a misty day in the autumn of 2008, I stood on a vast field shrouded in fog and surrounded by massive forts and castles. This ancient battlefield, which looked like something out of *Lord of the Rings* or a Led Zeppelin song, was located on Governors Island, a former military outpost in New York Harbor. I was joined by five hundred men, women, and children of all ages and races. Each of us were wearing either a blue or a green T-shirt and holding an inflated balloon. On the opposite side of the field, another group of five hundred warriors wearing red or yellow T-shirts, each with a balloon in hand, was lying in wait to attack us. This probably sounds insane (and it is), but it was all part of Improv Everywhere's annual MP3 experiment.

Every person on the field was listening to my voice through headphones on an MP3 player, synced up to the same track, waiting for my next command. Without warning, the MP3 track ordered everyone to "charge," and the two colorful armies clashed in the middle of the field, mercilessly beating one another with their balloons. As I dodged enemy attacks on the field of battle and clobbered a seventy-five-year-old woman over the head with a green balloon, I took a moment and wondered, *How the hell did I get here?*

I guess I've been a prankster my entire life, but I don't think my experience with pranks was all that unique as a child. At a very early age my mother and father taught me how to celebrate April Fools' Day, a day that had been my paternal grandfather's birthday. I can't remember the first prank ever played upon me, but I'm sure it was something along the lines of my father waking me on an early April 1 morning to say

that it had snowed overnight in our (very warm) hometown of Columbia, South Carolina.

As I grew older I started celebrating the holiday in my own right and would often claim it as my favorite day of the year. I put plastic roaches in my sister's food and tried in vain to fool my parents. In the eighth grade I successfully convinced my entire school that Bob Dylan had died on April 1, something that in retrospect seems more of a lie than a prank, and a pretty tasteless lie to boot. I started to feel a little guilty as my math teacher dedicated the first ten minutes of class to eulogizing Robert Allen Zimmerman.

Like many college kids, I engaged in regular prank wars with friends. My buddy Ken Keech got me pretty good on April 1 in 1999 when he put up a thousand flyers around campus announcing a party at my apartment. The poster claimed it would be "THE PARTY OF THE YEAR!" and would feature "free drinks and live music!" It even included a hand-drawn map to my place. Once I figured out it was him, we decided to join forces and heighten the prank the next night by staging a huge fake fight at another house party. Friends had to hold us back from each other as some of the women in attendance burst into tears. Everyone hated us twenty minutes later when we explained it was all a joke. Some even speculated that I had been in on the flyer prank all along.

I moved to New York City in July of 2001 after graduating from the University of North Carolina at Chapel Hill with a degree in dramatic art; I was twenty-two years old. I followed in the footsteps of most everyone I knew who had graduated in the years prior to me; I moved to the city with no real plan other than to be an actor. The cliché in New York is that all waiters are wannabe actors, but when I arrived it seemed that temp work

was the route of choice for actor types, especially if you didn't have restaurant experience, which I certainly did not.

I signed up with the first temp agency that called me back, and after completing some ridiculous test of my Microsoft Office skills, I was sent out to my first job. I was assigned to be the receptionist for the ad agency Messner Vetere Berger McNamee Schmetterer. Yes, the actual name of the agency was Messner Vetere Berger McNamee Schmetterer, and guess what? As receptionist I was *required* to say the full name of the company every time I answered the phone. That got old after, I don't know, three calls?

The first couple of months in the city, I spent my days answering phones and my nights drinking at bars and exploring the town, still shocked that this huge city was now my home. It was staggering to realize how insignificant you are in a sea of eight million people. I slowly started to realize that since no one knew who I was, I could be anyone I wanted to be, even someone else.

Exactly four weeks after I had arrived in New York, my friend Brandon Arnold came up to visit. I had done improv with him at UNC, and he was a notorious prankster and all-around-hilarious guy. We hadn't seen each other in a pretty long time, and as he greeted me the first thing he said was, "What's up, Ben Folds?" Ben Folds, of course, is the musician who rose to fame with his band Ben Folds Five in the 1990s and who was on the cusp of releasing his first solo album in 2001. Apparently, Brandon thought my outfit, a red and white plaid shirt, made me look like the rock star.

Now, I didn't think I looked anything like Folds apart from the fact that we were both white, had dark hair, grew up in the South, and were under forty, but at the time I was so excited to be in New York that I was down for anything. "For the rest

of the night, I'm Ben Folds," I told Brandon. We tested out my likeness in a bar in the East Village. We entered separately and after ten minutes of me drinking alone, Brandon approached and identified me as the famous pianist. Before we knew it a gaggle of British girls were snapping photos and asking for autographs.

We realized that Ben Folds had the perfect level of celebrity to imitate. Most folks knew who he was, but only his true fans would be familiar with his face. The experiment was so successful that we decided to repeat it the next night. Our friend Jon Karpinos joined us as we made a second attempt at a West Village bar. I again sat alone at the bar and drank quietly, this time for twenty minutes. Brandon and Jon ate a meal on the other side of the room and then approached me to request an autograph. The moment they walked away, I instantly became Ben Folds to everyone in that bar.

The two girls sitting next to me, who hadn't once glanced my way, immediately turned around and became my new best friends. As the story spread, others in the bar approached and asked for autographs and posed for photos. By the end of the night one of the girls I had been talking to gave me her phone number, and I promised to call the next time I was in her town on tour. Brandon and Jon became increasingly rowdy fans and were eventually kicked out of the bar for "stealing Ben Folds's wallet." The bartender gave me free drinks to apologize for their behavior.

As I walked home at four A.M., I couldn't believe what we had done. The whole scene had lasted nearly three hours and had been a total blast, not only for us but also for the bar full of people who had a crazy encounter with a celebrity. We never broke character to reveal it had all been a lie—instead we chose to give everyone in the bar an interesting story to tell about the

night they met a rock star and helped him get his wallet back from a drunk fan. Sure, some folks might have gone home and Googled "Ben Folds" to find out that he was actually on tour in Australia that very night, but even then they had the more incredible story about how three guys fooled them into thinking they met Ben Folds, for no apparent reason at all.

I had moved to New York to be an actor but quickly realized that for a recent college graduate being an actor meant answering phones all day and sending headshots to people who would toss them in the trash before even opening the envelope. Rather than wait for some sort of mythical big break, I decided I'd make all of New York my stage and perform anywhere and everywhere. Pretending to be a celebrity in a bar wasn't the type of acting I studied in college, but it sure as hell was a lot of fun.

When I went back to work at Messner Vetere Berger Mc-Namee Schmetterer that Monday morning, I decided to write down my Ben Folds story and put it on a website to share with friends. I named the site Improv Everywhere, probably in part because I was about to start taking improv classes at the Upright Citizens Brigade Theatre. But in many ways what we had done *was* a form of improv—we certainly had no script, and everyone else didn't even know a script was a possibility. I called our prank a "mission," and the three of us involved were "agents." This too was probably ripped off from the UCB, whose TV show used similar terminology. The term "prank" just didn't seem quite right for what we had done.

Having a website of course inspired me to cause more scenes. As we got better and better at pulling them off we realized we had stumbled onto a new idea: pranks that didn't need a victim. It was very easy to cause a scene by getting into some type of argument or conflict (as we did in the bar when Ben's fans stole his wallet). It was much more challenging to come

up with ideas that actually gave the people we encountered a good experience—an amazing story they could tell for the rest of their lives.

I also got excited about the idea of refusing to break character, even after a mission was over. Rather than have a "reveal" moment like on TV prank shows, it was much more interesting to simply leave the scene of the crime, giving no explanation for what had happened. This too helped us create events that provided others with an amazing story. Rather than being able to write it off as a dumb prank or a publicity stunt, people would be left to draw their own conclusions.

It's been nearly eight years since Ben Folds had his wild night in the West Village. Today we've grown from three kids getting drunk and pulling one over on a bar to a worldwide network of pranksters. We've done over seventy-five missions involving thousands of people in New York. Others have duplicated our missions in over forty different countries involving thousands more around the world. Our videos have received more than fifty million views online, and we've been covered by pretty much every media outlet on the planet. This book gives you a behind-the-scenes look at the missions that made us famous and invites you to join in on the fun yourself with Agent Assignments. Along the way you'll hear insider tips from our senior agents and learn about our favorite pranksters from around the world. I hope you enjoy it, and I hope to see you at the next mission. Just be sure to watch your back, because I'm coming at you with a green balloon.

Agent Charlie Todd
May 2009

causing a scene

mission 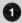 **1**

date / may 21, 2005

number of agents / approximately 100

objective / Fool hundreds of U2 fans and pedestrians into thinking that U2 is playing a surprise concert on my rooftop.

Fake Bono (Agent Ptolemy Slocum) rocks the rooftop.

Believe it or not, but U2—the legendary Irish rockers with more than 170 million albums sold to date—has *a lot* in common with Improv Everywhere. Although we've never headlined a Live Aid concert or performed for millions during a Super Bowl halftime show, the agents of Improv Everywhere, like U2, fully believe in the power of impromptu public events. For years, U2 has gained notoriety for staging unannounced, free concerts. For example, back in 1987, Bono, the Edge, Larry Mullen Jr., and Adam Clayton performed "Where the Streets

Have No Name" on a liquor store rooftop in Los Angeles for a video shoot. Many saw the stunt as a nod to the Beatles' infamous rooftop concert during the filming of 1970's *Let It Be* in London. Regardless of who U2 was paying homage to on that Los Angeles rooftop, their performance thrilled thousands of random passersby, angered the authorities, and created chaos on what would have been just another humdrum afternoon—the exact same results of any successful Improv Everywhere mission.

Since wreaking havoc from that Los Angeles rooftop, U2 has treated fans to additional impromptu shows in Dublin, Ireland (on a rooftop in 2000), and New York City (on a flatbed truck in 2004). To promote their album *How to Dismantle an Atomic Bomb* in 2005, U2 announced that their Vertigo Tour would be coming to Madison Square Garden on May 21. Improv Everywhere World Headquarters (a.k.a. my old apartment) was just one block away from MSG, where U2 would be rocking a sold-out audience who had paid top dollar to see their heroes perform. This got me thinking. My four-story apartment building overlooked Eighth Avenue—a bustling street where twenty thousand concertgoers would stroll by on their way to see U2. Since I had access to my rooftop, and U2 has a penchant for playing rooftop shows, why not treat the good people of midtown Manhattan to an unannounced, free "U2" concert?

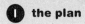 **the plan**

I want to feel sunlight on my face
I see the dust cloud disappear without a trace . . .

—"Where the Streets Have No Name" by U2

Unfortunately, it turns out that U2 is a very difficult band to book for rooftop concerts—especially when they're traveling around the world on a sold-out arena tour. So I was forced to improvise and create my own U2—a band that would be, to borrow a phrase from Bono himself, even better than the real thing. My plan was to have a band of U2 imposters play an electrifying live rooftop concert to unwitting pedestrians on Eighth Avenue, shortly before the *actual* U2 took the stage at nearby Madison Square Garden. It seemed plausible that the real U2 might pull off such a stunt—after all, the last time they were in New York, they played a concert on the back of a flatbed truck while driving over the Brooklyn Bridge.

Thankfully, I didn't have to look very far for faux Irish rockers. My roommate, Agent Chris Kula, is a talented drummer who played for a local cover band (with Agent Terry Jinn on guitar and Agent Dan Goodman on bass) called Enormous Television. They had been performing U2 covers at their recent gigs, so Enormous Television seemed primed for the prank. They all signed on to imitate Bono's backing band—never mind that none of them looked anything like the members of U2. Agent Jinn, who would be playing the Edge, is Korean-American.

"I was kind of nervous," he admitted. "I thought about the possibility of getting arrested. However, the opportunity to play live music on a New York City rooftop was too hard to pass up."

The biggest challenge in assembling a fake U2 proved to be finding the right "Bono"—someone with enough swagger, confidence, and charisma to convince the people of New York that this *was* U2. I decided on Agent Ptolemy Slocum, not because he resembled the megastar front man (he looks nothing like Bono) or because of his vocal abilities (he's not the greatest singer), but because he could project the "attitude" of a man who can rock thousands of fans and save Africa in his leisure time.

No detail was spared to create the illusion that this was, in fact, a U2 rooftop concert. I compiled a list of all the "tip line" phone numbers for New York television and radio stations. This list was distributed to several agents so they could tip off local media outlets that "U2" was gearing up to play a rooftop show about thirty minutes before the Improv Everywhere agents plugged into their amps. Several months before the mission, NHK, a major Japanese television network, contacted me about doing a story on Improv Everywhere. I invited them along to the mission as well, figuring it would lend legitimacy to the hoax if a professional film crew was on site. I routinely tell camera crews that they can't film our missions for news stories, but the presence of a giant TV camera would only make our fake U2 concert look more realistic. And to create pandemonium on the streets, I sent out an e-mail to all agents, asking for their help. On the day of the concert, anybody willing to participate was asked to run amok down Eighth Avenue, screaming wildly like teenage girls straight out of *A Hard Day's Night*.

Since Enormous Television was comfortable covering U2 songs, there was no rehearsal until the day of the mission. The band decided on a four-song set:

"Vertigo" / It was the first single off U2's latest album and the name of their current tour. Also, it seemed like an appropriate song to play at a rooftop gig.

"Where the Streets Have No Name" / This song would be played as a tribute to U2's infamous Los Angeles rooftop performance.

"Even Better than the Real Thing" / Obviously.

"Pride (In the Name of Love)" / The epic breakdown in this song would provide the perfect opportunity for fans on the street to sing along.

After rehearsing the songs, the band slipped into costume. Agent Slocum donned a black leather jacket, a wig with slicked-back hair, and giant "fly"-style glasses like the ones Bono wears while performing songs off *Achtung Baby.* Agent Jinn put on the Edge's trademark black knit cap and a fake goatee, and Agent Goodman cut his hair and then dyed it gray to closely approximate Adam Clayton's current look. Agent Kula was the only band member who didn't alter his look, because, he explained, "My drums would be positioned out of view from the street, and no random passerby would ever say, 'Hey, on drums, isn't that . . . *Larry Mullen?*' Even if the drummer *was* Larry Mullen."

Meanwhile, a few blocks away, Agents Alan "Ace$Thugg" Corey and Andrew Wright gathered with approximately seventy-five agents on the steps of a nearby post office and gave them instructions. When I sent out the call for them, the throng of agents was to stampede down Eighth Avenue. With the Japanese television crew filming on the roof and the band members in place, I gave the call for the stampede to begin.

"My group took a long loop around Madison Square Garden en route," Agent Wright said, "so as many people

as possible would overhear us yelling into our cell phones, "*Holy moley, U2 is playing! No,* I know *they're playing a concert tonight. But they're playing a rooftop right* now! *Where? Right around the corner! Yes! To sum up, U2 is playing a free rooftop concert right this second on Eighth Avenue between Twenty-ninth and Thirtieth streets!*" Boy, that friend on the other end of the phone sure needed a lot of explanation."

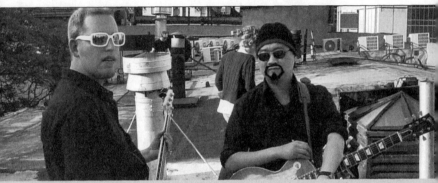

Agent Dan Goodman and Agent Terry Jinn—not exactly dead ringers for members of U2.

Although the weather had been absolutely perfect all day, ominous rain clouds began gathering overhead right before our start time. I started panicking about losing my three-hundred-dollar deposit on a water-damaged PA system. The band members grew tense while waiting for their fake fans to arrive. Agent Slocum got particularly jumpy as he anxiously awaited the start of our show. "Pestilence. Pestilence. Pestilence," he muttered into the microphone over and over for some bizarre reason. Pacing the roof like a caged tiger before feeding time, Fake Bono was ready to rock.

I remained perched on the roof's edge for several minutes, waiting with bated breath for our "fans" to come stampeding

down the avenue. I wore a black Apple Computer T-shirt—U2 had recently been all over TV in an advertisement for iPods that was getting heavy rotation—hoping that my shirt might fool people into thinking we were filming a follow-up to their famous Apple commercial.

After keeping the band on standby, eagerly awaiting the arrival of our fans, I finally spotted the mass of agents charging down the avenue with dozens of real U2 fans that they had swept up in their path. Total pandemonium erupted on the street—it looked like the running of the bulls in Pamplona. Waiting with his drumsticks in hand, Agent Kula could sense the excitement. "When Agent Todd looked over the edge of the roof and was like, 'Okay, they're coming. *WOW!* Let's go!' I couldn't see the street scene from my drums, but just from the sound of his voice—kind of a giddy awe—I could tell it was something big."

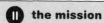 **the mission**

Uno, dos, tres, catorce!
Turn it up loud, captain! —"Vertigo" by U2

I signaled to the band that it was go time, and with my megaphone in hand, I screamed to the crowd of people down below. "Hello, New York! Please welcome the number one band in the world, playing a free concert for all of New York City . . . U2!!!" I handed the megaphone off to Fake Bono just in time for him to belt out the opening lyrics of "Vertigo." The show was off with a blast of energy. Our rented PA sounded surprisingly good. It was distorted just enough to help mask the fact that Agent Slocum didn't exactly have the same vocal range as Bono.

By the time the band reached the first chorus of "Vertigo," the audience on the street had already doubled. Hordes of people frantically jaywalked across Eighth Avenue, scrambling to catch a glimpse of the band. Cabs began making sudden stops in the middle of the block as their passengers quickly paid and ran out onto the street. To add to the chaos, I posted a "bouncer" at the front door of the wrong apartment building as a decoy. Agent Justin Lang played the part of this security guard on the street, hoping to confuse people about what rooftop U2 was actually playing on. "A few of the regular vagrant people walking by and some of the surrounding bar patrons asked me if that was the real band," Agent Lang said. "My response was, 'I wouldn't be here if this was some joke.'"

The scene on the rooftop was just as chaotic as down on the street. The Japanese television crew that I invited to film the concert was swarming all over the place. Everything was a jumble of instrument cables and speaker wires, with the Japanese cameramen scurrying around alongside our own cameramen. It looked just like a real video shoot.

The band was intently focused on playing their instruments during "Vertigo," so during "Where the Streets Have No Name," I wanted them to play it up for their fans on the street and move closer to the edge of the roof. "I was a little apprehensive about the audience seeing me, because I was afraid that people would immediately know I wasn't Adam Clayton," Agent Goodman said. "In retrospect, not only was that a totally stupid thing to think—I mean, how many people could recognize Adam Clayton if he were standing in front of them, much less four floors up—but it made it all real for me, seeing all those people on the street cheering, clapping, chanting, even just for the five seconds that I could see them."

As Agent Jinn began strumming the soaring opening notes of "Where the Streets Have No Name," people started to crowd rooftops and hang out of the windows of neighboring buildings. Starstruck fans on Eighth Avenue were chanting for Bono. Cars slowed to a stop in front of my building as drivers rubbernecked, trying to catch some of the show. Agent Ace$Thugg, who had been directing the agents on the street, realized that tying up traffic would probably incite the wrath of the cops, so he started

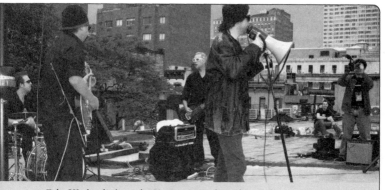

Fake U2 shreds through "Vertigo," U2's latest hit single.

directing traffic to help move things along and keep us out of trouble. "Several people came up to me on foot throughout my traffic duties and asked me if that was really Bono on the roof. My reply was, '*Yes! Stay on the sidewalk! We are filming!*' It always seemed to satisfy the curious gawkers, and then they would look at their friends and say, 'See, I told you!'"

Throughout "Where the Streets Have No Name" and "Even Better than the Real Thing," Fake Bono occasionally launched into one of Real Bono's trademark political sermons. His Irish accent was a little bit shaky, which started to tip off some of the fans on the street that they weren't watching the

real thing. However, one actual Irishman not only fell for it, but he apparently had a beef with the real Bono. "Fucking moron! He's a flag-burning fucking asshole!" the belligerent Irishman shouted at the roof while saluting the band with his middle finger. "Fuck you, Bono!" (Although, as far as we know, Bono has never burned a flag.) Agent Kurt Braunholer, who was snapping photos from the street, was approached by a girl who asked him, "Do you think that's the real U2?"

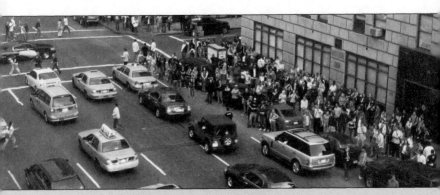

Where the streets have no shame—hundreds of fans are fooled by Fake U2.

When he said he was unsure, she responded, "Well, Bono is not that skinny, and he doesn't have that dorky haircut, and the Edge isn't Hispanic." Our Asian Edge's extremely fake goatee may have tipped off that girl that she wasn't watching the real U2, but it somehow fooled her into thinking that Agent Jinn was Hispanic.

For the most part, people on the street seemed to buy into the idea that they were watching U2. Even those savvy few who knew they were witnessing a hoax seemed to be enjoying the spectacle. "There were more believers than disbelievers," Agent Ace$Thugg noticed. "I remember one guy talking on a

cell phone saying that U2 always plays last-minute secret locations in New York. He went on saying it was definitely them and he couldn't believe it." And despite the great distance between Fake U2 and their fans on the street, members of the band felt the adulation of the fans four stories below. "I couldn't see the street crowd from my drums, but, man, I could certainly hear them," Agent Kula said, "especially their hilarious 'recognition applause' at the beginnings of 'Where the Streets Have No Name' and 'Pride.' They loved the hits!"

As the band tore through an inspired version of "Pride (In the Name of Love)," another equally entertaining spectacle was unfolding down on the street. Like a scene out of a Three Stooges movie, a bumbling patrol of policemen was trying to gain access to the roof to stop the show. Because we'd placed Agent Lang as a "security guard" in front of the wrong door, no one knew how to actually get into Fake U2's building. The crowd watched with glee as the police stormed into building after building and comically stormed right back out when they realized they couldn't reach Fake U2's roof.

Throughout the four-song set, Agent Slocum completely committed to being Bono. He shouted, *"In the name! Of love!"* with such conviction that fans on the street were pumping their fists and singing along with his every word. Our crowd even nailed the call-and-response section at the end of the song, shouting, *"Oh oh oh ohhh"* right back at us. As Fake Bono, Agent Slocum perilously perched himself on the edge of the rooftop, straining to hit high notes while making sweeping arm gestures. It didn't matter if the people four stories below thought he was Bono or not. In the world of improv comedy, commitment to your scene is crucial, and on that afternoon, Agent Slocum truly believed that he *was* Bono.

When the band wrapped up their set, the audience still wanted more Fake U2. *"One more song! One more song!"* We could hear their chants from the street loud and clear. With the police in hot pursuit of our renegade band and rain clouds quickly forming overhead, I called an audible and had the band play "Vertigo" one more time as an encore. Fake U2 ripped into the song, and the crowd went wild. Midway through the song, five New York City police officers climbed the fire escape of my building. Agent Slocum didn't even break character as the police raided the rooftop and the amps were unplugged.

"I didn't want to stop the last song, and for the most part, I didn't," Agent Slocum said. "Even after the cops showed up, and after the music stopped . . . I was left up there singing on my own. I mean, you might as well keep going, right?"

"Shut this down!" the police captain yelled as he signaled for the PA to be unplugged. I tried to reason with him. "There are just twenty seconds left in this last song," I pleaded. The cops wanted none of it. It was time to face the law.

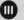 **the aftermath**

One man come he to justify
One man to overthrow . . .

—"Pride (In the Name of Love)" by U2

As soon as the music was silenced, the police wanted answers and identification from everyone on the roof. They made a beeline for Fake Bono, assuming he was the ringleader of the operation. "Agent Slocum was being a dick, and he wouldn't drop character," Agent Jamey Shafer, our rooftop cameraman, recalled. "The cops were incredulous when he was unable to

produce ID. 'I never need an ID,' he explained. 'People just know who I am.'" The police captain eventually got Agent Slocum to surrender his driver's license. "He's got an out-of-state ID," the cop barked. "Cuff him!" There was no way I was going to let Agent Slocum take the fall alone, so I walked up to the captain and declared, "I also have an out-of-state ID." He looked at me like I was a total idiot. "You've got an out-of-state ID, too? Then you're also getting cuffed!" Back in 1987, the police broke up U2's Los Angeles rooftop concert; now the cops were shutting down our prank, too—this reenactment was getting more authentic by the minute. The only difference is that the real U2 never got carted off in handcuffs.

On cue, the clouds burst and the rain came pouring down just as the agents were packing away our equipment; it almost seemed as if the weather waited for our prank to end. The police escorted Agent Slocum and me downstairs to the front hallway of my building. These cops knew better than to take us outside where a crowd of adoring fans was waiting to see the "celebrities." It would have caused pandemonium on Eighth Avenue if the police led a handcuffed Fake Bono out the front door. The cops didn't want to rile up our audience.

Eventually, six other agents were brought down to our holding area in the hallway of my apartment building, where we were detained while they performed background checks on us. Agent Slocum's ID was a source of confusion, as he was still in full Bono costume and looked nothing like his driver's license photo. I explained that he was wearing a wig. This cleared up the confusion—for half an hour, the cops hadn't realized the hideous clump of hair on Agent Slocum's head was a wig.

The mood was still tense until the cops started questioning Agent Jinn. "And who are you supposed to be?" one cop asked him. "The Edge . . . ," he sheepishly confessed. Agent Jinn's response caused all five cops to break into laughter. "A police officer looked at my ID and then looked back at me," Agent Jinn remembered. "He said, 'Aren't you too old to be doing this kind of thing?' When I told my friend Curtis this, his response was, 'That's worse than getting hit with a nightstick!'"

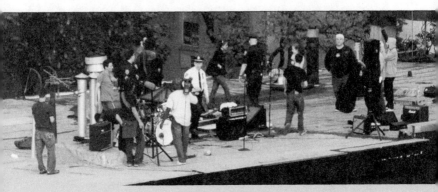

Just like in the U2 video, police stormed the rooftop and shut down the mission.

One month after Fake U2's infamous concert, the eight agents who were stationed on the roof during the prank (the "Vertigo Eight") had their day in court. The description of our criminal offense on the court summons was "Unreasonable Noise." We all shared the same court-appointed lawyer, who informed us that we'd probably get charged with an ACD— adjournment contemplation decision—a slap on the wrist that meant if we kept out of trouble for six months, our case would be dismissed. He also told us that we would probably be forced to watch a video called *The Quality of Life* as a part of our sentence. When our moment in court finally arrived, it

turned out that our attorney was wrong. The Honorable Judge Eileen Koretz immediately dismissed all charges and let us walk. After she dismissed me from the courtroom, the judge turned to her clerk and said, "They were playing music on a roof!" I don't think she even knew that we had impersonated U2 as it wasn't explained on our ticket. She probably figured that no one should get in legal trouble for something as innocuous as playing live music.

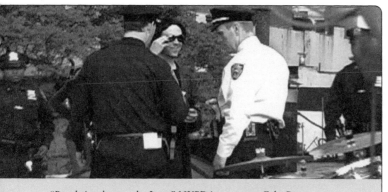

"People just know who I am." NYPD interrogates Fake Bono.

To this day, a bar owner on my block stands outside his pub and tries to attract business by saying, "Come inside and have a drink at the bar where U2 once played on the roof!" (Even though we weren't playing on his rooftop.) I always keep to myself as I walk by, staying true to the Improv Everywhere rule to never reveal ourselves as performers, even after the mission is completed.

People often ask me if U2 ever found out about the prank. Since I never hang out with or talk to any members of U2, the honest answer is: I don't know. However, this mission was extensively covered in the media; it was featured in the *New York*

Times, it made *Rolling Stone*'s annual "Hot List," and it was included on VH1's "40 Greatest Pranks" show. With all that exposure, I'd like to imagine that at some point, Bono was able to take a break from rocking arenas and meeting with world leaders to check out a group of pranksters who put on a show that was even better than the real thing.

↑ | **mission accomplished**

> **agent assignment / fake rock star**
>
> **objective /** Pose as a rock star and stage a concert.
> Try to fool unwitting fans into thinking they're watching
> their rock 'n' roll idols.

To paraphrase a lyric by the great Jon Bon Jovi, have you ever seen a million faces and rocked them all? Well, now's your chance. Create some classic rock confusion by imitating one of these musicians:

Simon & Garfunkel / In 1981, the legendary folk duo reunited and played for more than five hundred thousand fans in New York City's Central Park. This concert can be easily reenacted if you have curly hair and a short friend who can sing.

Bruce Springsteen / For those of you who look like the Boss, throw on a leather jacket and somberly stroll through the streets of Philadelphia while singing "Streets of Philadelphia."

Sex Pistols / In 1977, Johnny Rotten and company celebrated the release of their single "God Save the Queen" by playing a show on a barge floating down the river Thames in London. The authorities quickly shut down the Pistols' gig, just like U2's rooftop show. If you have a purple mohawk and access to a barge, try causing a little anarchy of your own.

The Rolling Stones / Glam up your friends like Mick, Keef, and the rest of the Stones. Play a raucous show in the middle of a giant speedway. To make this concert truly authentic, hire the Hell's Angels for your security detail.

Spinal Tap / *For advanced agents only:* Fly to England. Have your friends dress up like David St. Hubbins, Nigel Tufnel, and Derek Smalls. Plug in your amp. Turn it up to eleven. Play a concert in front of the real, full-scale Stonehenge.

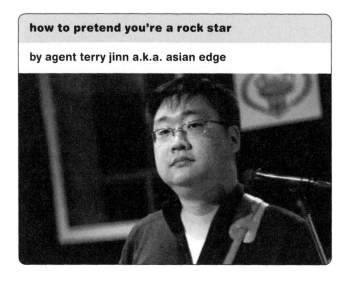

how to pretend you're a rock star

by agent terry jinn a.k.a. asian edge

When executing your own rock 'n' roll mission, the key is a convincing transformation into the rock star of your choice. Here are some pieces of advice that might come in handy.

01 / Fully commit . . . but with caution. At no point should you allow yourself to actually believe that you are a rock star. This can get you into a lot of trouble. For example, you might end up in a long-term relationship with Marianne Faithfull, which, I can tell you, is a huge mistake. Huge!

02 / Look scruffy. A fake goatee is an instant rock star costume and can be made from almost any material. Some great "goat-erials" (which is a portmanteau of the words "goatee" and "materials" in case you were confused) are: hot tar, the actual recording media from inside a VHS cassette, bees, chocolate

milk, those fluffy dandelion seeds, a Russian Blue cat held up to your face, and gunpowder. Or experiment! Rock stars are creative!

03 / Make ridiculous demands. One way to add a little rock star to your daily routine is to add "riders" to the unwritten social contracts of your life. Like, "I demand only green Skittles in my candy bowl or I will no longer use deodorant." That particular request assumes you actually like green Skittles and that your friends have a sense of smell.

urban prankster global network / rooftop king of pop

Scene Diego, a San Diego–based branch of the Urban Prankster Global Network, pulled a page from the IE playbook and successfully pulled off a Fake U2–inspired mission. In June of 2008, eighty-five agents crowded outside a posh downtown San Diego nightclub that featured a rooftop bar replete with classy cabanas and costly cocktails. Posing as a horde of rabid Michael Jackson fans, the agents convinced dozens of people that the King of Pop was, in fact, hanging out on the roof of the nightclub. "Michael Jackson is on the roof!" agents told passersby.

Soon, the crowd on the sidewalk doubled in size. Nearly two hundred people were chanting, "We want Michael! We want Michael!" The people who were on the roof peered down at the street below, unsure what to make of the massive mob that was demanding an appearance by Michael Jackson. As the crowd of fans began singing his hits, trying to beckon Wacko Jacko down from the rooftop, a limousine with tinted windows drove by. "There goes Michael!" an agent shouted. The crowd dispersed, thinking they just had a brush with the biggest pop star in the world.

mission 2

date / march 22, 2003

number of agents / 7

objective / Have a group of agents create a time loop in a Starbucks by repeating a five-minute sequence of events twelve consecutive times in one hour.

Agents Ken Keech, Porter Mason, Flynn Barrison, Chris Kula, Charlie Todd, Anthony King, and Katie Dippold just before pulling off The Möbius.

When thinking of the world's most creative art forms, most highbrow critics tend to leave pranks off the list. Let's face it: taping a Kick Me sign to someone's back or placing a whoopee cushion on their chair usually fails to inspire in the same way as, say, a beautiful song or a brilliant film. However, with Improv Everywhere, my objective has always been to push the boundaries of pranks beyond sophomoric high jinks. Instead of embarrassing someone with a practical joke, why not use a prank to create chaos, make people stop and observe their

surroundings, and send them on their way with a fascinating story to tell? These were precisely our motives when we pulled off a mission called The Möbius.

Any junior high school student can explain the concept of the möbius strip. A möbius is created by taking a strip of paper, making a loop, and then flipping one side over before taping the two ends. The result is a never-ending loop with one continuous side. In 1858, two German mathematicians, August Ferdinand Möbius and Johann Benedict Listing, discovered this mind-boggling contraption. Almost 150 years after their discovery, seven Improv Everywhere agents attempted to boggle some minds of their own by creating a living möbius—a pattern of events that would repeat as a time loop—in a Manhattan Starbucks. For years, movie audiences have been entertained by temporally repetitive plots, like Bill Murray living the same day over and over again in *Groundhog Day,* the *Enterprise*'s uncanny tendency to encounter temporal rifts in *Star Trek,* or the flux capacitor creating time loops in the *Back to the Future* series. With The Möbius, Improv Everywhere attempted to create a time loop in the real world . . . and boldly go where no prankster has gone before.

the plan

There is the theory of the möbius—a twist in the fabric of space where time becomes a loop, from which there is no escape.
—Lieutenant Commander Worf, *Star Trek: The Next Generation*

In early 2003, Improv Everywhere was still in its infancy and I was acquiring a reputation on the New York comedy scene for being a prankster. As Improv Everywhere's fan base

grew, a steady flow of ideas for pranks started trickling into my e-mail inbox. One of the first missions submitted to me came from Mark Hoffman, who, along with his pal Kevin O'Bryan, concocted the following idea: what if a group of actors replayed the same five minutes as a time loop in a public place?

As a longtime Trekkie, I was immediately intrigued by their idea. It reminded me of an episode of *Star Trek: The Next Generation* where the crew slowly realizes they are trapped in a time loop and the *Enterprise* keeps blowing up. Creating our own *Star Trek*–style möbius of events in a public place wouldn't be your typical childish prank—we'd be attempting to fool people into thinking that the space-time continuum had been shattered.

I chose the Starbucks on Astor Place in Manhattan as the site for this mission. A roomy coffee shop with two entrances, this particular Starbucks was an ideal setting—it provided lots of space and NYU students tend to hang out there for hours on end, reading and studying. Essentially, they'd be our captive audience and our stage would play like a theater in the round with eyes watching us from all sides. For one hour, we would transform this peaceful coffee shop into a freaky Twilight Zone.

I recruited six agents for the mission and assigned each of them a specific action to replay over and over again. These six choreographed segments of our möbius would play out over the course of five minutes and would be repeated twelve times consecutively in one hour. The six major components to our time loop were:

01 / The Argument. Agent Katie Dippold and I enter the Starbucks holding hands. While standing in line and debating what to order, Agent Dippold reaches for her cell phone in her purse, revealing a pack of cigarettes in her handbag. We then initiate the following dialogue:

Agent Todd: You can't smoke in here, Katie.

Agent Dippold: I'm not smoking, I'm just getting my phone.

Agent Todd: Give me those! [*I attempt to snatch her cigarettes.*]

Agent Dippold: Stop it!

Agent Todd: You promised you would never smoke around me. [*I make a second attempt to grab her smokes.*]

Agent Dippold: I'm not!

Agent Todd: You promised you wouldn't let me see these. [*Agent Dippold storms toward the door in frustration and turns to address me.*]

Agent Dippold: I can't believe you're doing this!

Agent Todd: [*yelling*] Come back! Come back here, Katie! [*Agent Dippold exits the Starbucks and I chase after her.*]

02 / The Spill. Agent Porter Mason sits and writes at a nearby table. Shortly after Agent Dippold and I enter and stand in line, he spills his cup of coffee. Agent Mason then trots across the Starbucks, grabs a handful of napkins, and returns to his table to clean up the mess.

03 / The Cell Phone Call. Agent Flynn Barrison also sits and reads at a table. Directly after Agent Dippold and I exit, he receives a cell phone call (his ringtone is set to *loud* and plays "The Entertainer" by Scott Joplin). He gets up and walks to the window for better reception. After finishing his call, Agent Barrison returns to his table.

04 / The Bathroom Line. Agent Anthony King sits at another table, sipping his coffee and writing. Shortly after Agent Barrison takes his phone call, Agent King rises and heads to the bathroom line, stumbling and bumping into Agent Mason on the way. After apologizing to Agent Mason, he asks the patron at the back of the line, "Is this the line for the bathroom?" After

briefly waiting in line, he returns to his table. Upon sitting back down, Agent King turns to Agent Barrison and remarks, "That bathroom line is too long."

05 / The R.E.M. Song. Agent Ken Keech then enters from outside with a boom box playing "Shiny Happy People" by R.E.M. After strolling through the Starbucks while blasting the song, Agent Keech exits through a door on the opposite side of the coffee shop.

06 / The Sneeze. Agent Chris Kula sits and reads a copy of *ESPN The Magazine*. After Agent Keech exits, he sneezes loudly, waits two beats, then clears his throat. Moments after his sneeze, Agent Dippold and I reenter the Starbucks and the loop starts again. (Agent Kula is also responsible for placing the cell phone call that makes Agent Barrison's phone ring.)

Our goal was to seamlessly repeat this five-minute sequence of events for one hour. "I didn't know the *Star Trek* reference, but I did recognize that this was definitely the highest-concept prank I'd ever participated in," Agent King said. "There was a lot of anticipation and excitement leading into it, because we didn't know if we could pull off something this elaborate."

At around 4:40 P.M. on the afternoon of the mission, Agents Mason, King, and Barrison entered the Starbucks. There were two open tables in the coffee shop; Agent Mason claimed one, and Agents King and Barrison sat down at the other. After a few minutes passed, Agent Kula entered and, posing as a stranger, asked to sit at Agent Mason's table. Soon, all four agents were sitting silently, sipping coffee, and minding their own business. At 4:47 P.M., Agent Dippold and I waited outside for the agents to get in place. Everything seemed humdrum inside the coffee shop, but little did the Starbucks patrons know, they were about to enter a bizarre

vortex where Improv Everywhere would obliterate the dimensions of time and space.

❚❚ the mission

If Time is really only a fourth dimension of Space, why is it, and why has it always been, regarded as something different? And why cannot we move in Time as we move about in other dimensions of Space?

—H. G. Wells, *The Time Machine*

4:48 p.m.—The First Loop

Agent Dippold and I entered the Starbucks. Ever the gentleman, I held the door open for three ladies before walking in (I repeated holding the door for the same length of time at every subsequent loop, despite there being no ladies to hold it open for). We held hands and slowly approached the register, carefully memorizing every step we made, as we would have to repeat each of them eleven more times. As I considered what drink to order, Agent Dippold fumbled through her purse looking for her cell phone. I glanced down in her handbag and spotted the pack of cigarettes.

"You can't smoke in here, Katie," I said.

"I'm not smoking, I'm just getting my phone."

"Give me those!" I snapped, trying to wrestle the cigarettes out of her purse. Agent Dippold slapped my hand away and cried out, "Stop it!"

"You promised you would never smoke around me," I said.

"I'm not!"

I tried to grab the cigarettes again, seething with anger. "You promised you wouldn't let me see these."

Agent Dippold grew frustrated with my attempts to confiscate her cigarettes and stormed out of the Starbucks. But before walking out the door, she turned to me on the verge of tears and said, "I can't believe you're doing this!"

"Come back! Come back here, Katie!" I shouted after her, and then chased her out of the coffee shop.

As we exited, Agent Mason spilled his coffee and yelled, "Goddamn it!" He jumped up to get napkins and collided into Agent King on his way back to clean up his table. Agent King was, of course, on his way to the bathroom.

"After Agent King got in the bathroom line, Agent Kula covertly called my cell phone," Agent Barrison said. "I let it ring, playing 'The Entertainer' for twenty seconds. It was really annoying. Then I answered it and moved near the door to get better reception. During a thirty-second fake phone call, I made plans to meet a friend at a bar at nine P.M., and then I went back to my table and resumed reading."

Agent King returned to his table when Agent Barrison sat back down and remarked, "That bathroom line is too long." At this point, Agent Keech entered the Starbucks with his boom box blaring "Shiny Happy People." He walked in one door, slowly strutted across the store, and exited through a door on the opposite side. "I came awfully close to cracking up the first time Agent Keech walked in," Agent Kula said. "Not so much because, you know, here's a dude in a Starbucks with a boom box kicking out the jams, as it was, here's a dude in a Starbucks with a boom box kicking out 'Shiny Happy People.'"

As soon as Agent Keech was out of the Starbucks, Agent Kula sneezed loudly, looked up from his copy of *ESPN The Magazine*, and cleared his throat. On cue, I held the front door open for three invisible ladies and reentered the Starbucks with Agent Dippold.

4:53 p.m.—The Second Loop

As soon as we stepped back in line, Agent Dippold and I repeated our argument about her on again/off again smoking habit word for word and then stomped out of the Starbucks in a huff. Only a few people stopped what they were doing to watch our second tiff, but for all intents and purposes, it most likely appeared that Agent Dippold and I had resolved our first conflict, reentered the store, and had another flare-up. As we exited, Agent Mason howled, "Goddamn it!" yet again as he spilled his drink, and we sloshed through the puddle of coffee he created on our way out. I heard "The Entertainer" ring on Agent Barrison's phone as the door shut. As Agent Dippold and I circled the block, Agent King waited in line in vain for the bathroom, and Agent Keech grooved through the store once more to the pleasing sounds of "Shiny Happy People." A few heads turned to observe the oddity of an identical five-minute chain of events occurring twice in ten minutes, but nobody seemed to be too concerned by it. That is, not until Agent Kula cleared his throat and Agent Dippold and I entered the Starbucks for a third time.

4:58 p.m.—The Third Loop

When Agent Dippold and I got in line for the third loop, it felt like every pair of eyes in the coffee shop was watching us. Every movement we made was identical to our first two trips through the Starbucks.

"You can't smoke in here, Katie," I said for the entire coffee shop to hear. As Agent Dippold and I launched into our argument for a third time, two curious men moved to another table so that they could get a better view of our altercation. After Agent Dippold exited the Starbucks, an old man turned to his buddy and announced, "Katie's gone out of here three times!"

"On the third loop, things got interesting," Agent King recalled. "A lot of people recognized that something weird was going on, but they were apprehensive to say anything out of fear that maybe this bizarre repetitive pattern was all in their own heads."

5:03 p.m.—The Fourth Loop

As soon as I opened the door, I heard the old man say to his friend, "Uh-oh! Look who it is! Here comes Katie again!"

"You can't smoke in here, Katie," I said, reinitiating the loop.

The old guy turned to his friend. "Watch this. She's gonna go stormin' outta here." On cue, Agent Dippold ran out of the Starbucks.

"Come back! Come back here, Katie!" I shouted. The old men started laughing. "See, I told you," one of them said. "'Come back, Katie!' *Ha! Ha!* It's like that *every* time!"

"What are we, in some sort of time warp?" the other old man asked.

After Agent King gave up on waiting in line for the bathroom and right before Agent Keech entered with his boom box, a Starbucks patron called out, "Here comes the radio guy!" And sure enough, Agent Keech walked through the door playing "Shiny Happy People."

5:08 p.m.—The Fifth Loop

"They always come back holding hands," the old man told his buddy as Agent Dippold and I walked in yet again.

"Wouldn't you give up after the second time?"

"If I was him, I'd say, 'Fine! Leave! I'll just be right here.'"

Another table of onlookers pointed at Agent Keech as he entered for the fifth time blaring R.E.M.'s feel-good song. "Look! The guy with the boom box keeps coming in that door. Here he comes! Here he comes!"

5:13 p.m.—The Sixth Loop

A Starbucks employee, obviously hip to our antics, approached me and asked for the time.

I glanced down at my watch and replied, "Five twenty-five." He smiled and said, "Thanks. I hope everything is going okay." For the remaining five loops, I looked at my watch and said, "Five twenty-five," at the exact same moment. It had now been incorporated into our sequence.

5:18 p.m.—The Seventh Loop

After spilling his drink on himself for six consecutive loops, Agent Mason was sopping wet by the seventh go-round. As soon as his puddle of coffee was cleaned up, he'd go right ahead and spill his drink again.

"It was the perfect blend of hilarious and pitiful," Agent Kula said. "People wanted to laugh, but at the same time they felt so bad for this poor guy whose shirt kept getting more and more soaked. Every single time after Agent Mason brought back the napkins and toweled himself off, I'd look up from my magazine and we'd share one of those half-smile/half-shrug looks as if to say, 'Yep, it's just one of those days . . .'"

5:23 p.m.—The Eighth Loop

"And it all begins again!" I heard someone shout out as Agent Dippold and I entered.

By this point, some people started freaking out. Total strangers were chatting across tables, acknowledging that something really weird was happening.

"This is scary," one man said. "Everything is happening over and over again."

5:28 p.m.—The Ninth Loop

As Agent Dippold and I barged out of the Starbucks for the ninth time, a woman turned to her boyfriend and asked, "Would you chase after me like that over and over again?"

"Hell no!" he said. "You can chase your own damn self around the block!"

5:33 p.m.—The Tenth Loop

Because my argument with Agent Dippold and Agent Keech's "Shiny Happy People" stroll through the Starbucks were the most noticeable patterns in the möbius, many people didn't notice the more subtle loops until our tenth repetition.

"There was a young girl sitting beside Agent Barrison and me," Agent King said. "She noticed the lovers' quarrel repeating on the third time through but didn't notice me repeating, 'That bathroom line is too long,' until much later. As the loops continued to progress, she started rubbing her face and shaking her head. She looked really confused."

5:38 p.m.—The Eleventh Loop

"What is going on in here?" I heard someone say in frustration during my argument with Agent Dippold. "The same thing is happening over and over again!"

The sense of fear and confusion had totally evaporated. Everyone in the Starbucks began calling out what was going to happen next, as if they were a band of psychics with the ability to forecast the future.

"He's gonna run after his girlfriend!" one man predicted right before I bolted after Agent Dippold.

"Cue the guy spilling his drink!" a woman said, like a symphony conductor, just before Agent Mason made a mess of his coffee.

At the end of this loop, nearly everyone in the Starbucks shouted in unison, "Here comes the radio guy!" And in walked Agent Keech playing "Shiny Happy People."

5:43 p.m.—The Final Loop

Another Starbucks employee approached Agent Dippold and I upon our twelfth entrance into the shop.

"Hello there," he said. "I just wanted to make sure that everything is okay with you guys."

"We were just going to get something to drink, if that's okay," Agent Dippold said.

"Yes, of course," the Starbucks employee said. "I'm so sorry to bother you . . ."

"No problem."

"It's just that all these people back there," he said, pointing at the other agents, "it feels like this is some kind of *instant replay*. Anyway, I'm sorry to bother you."

As soon as the employee walked away, I spotted Agent Dippold's cigarettes again and we engaged in our final fight of the afternoon. For one last loop, Agent Mason spilled his coffee, Agent Barrison answered his cell phone, Agent King waited for the bathroom, Agent Keech blasted "Shiny Happy People," and Agent Kula let out a big sneeze. Without acknowledging our stunt or each other, the agents exited the coffee shop, leaving behind a Starbucks full of puzzled people.

Ⅲ the aftermath

We have all some experience of a feeling, that comes over us occasionally, of what we are saying and doing having been said and done before, in a remote time—of our having been surrounded, dim ages ago, by the same faces, objects, and circumstances—of our knowing perfectly what will be said next, as if we suddenly remember it!

—Charles Dickens, *David Copperfield*

After the mission, all of the agents met up at a Starbucks across the street from the one where we had just pulled off our hour-long time loop. It was exciting to hear how well the mission

had gone. I really had no idea whether our living möbius had worked or not because I spent about 75 percent of the mission running around the block chasing after Agent Dippold. "When I stormed out each time, I'd walk around the corner and fix my hair in the window of the Gap," Agent Dippold said. "I wonder if the Gap employees had their own déjà vu thing going with this girl who kept appearing in the window every five minutes to fix her hair."

While time was looping over and over again in the Starbucks, Agent Dan Winckler filmed the entire stunt with a camera hidden in his duffel bag. Even though the quality of the video is pretty terrible, this mission went on to become one of the most popular pranks on Improv Everywhere's website.

The Möbius resonated with a lot of people because it's a simple, victimless prank that gives innocent bystanders a great story to tell. Other prank collectives in Newberg, Oregon; Clemson, South Carolina; and Ann Arbor, Michigan, have performed their own versions of this prank in public places. Thanks to these spin-off missions, The Möbius is a loop that will never end.

The Möbius resonated with a lot of people because it's a simple, victimless prank that gives innocent bystanders a great story to tell. Other prank collectives in Newberg, Oregon; Clemson, South Carolina; and Ann Arbor, Michigan, have performed their own versions of this prank in public places. Thanks to these spin-off missions, The Möbius is a loop that will never end.

↑ | **mission accomplished**

do the time warp

by agent chris kula

Want to create your own time loop and shatter the space-time continuum with your friends? Just follow these nine easy steps . . .

01 / Start the loop. Do something in public that draws attention to yourself; then five minutes later . . .

02 / Start the loop. Do something in public that draws attention to yourself; then five minutes later . . .

03 / Start the loop. Do something in public that draws attention to yourself; if anything unexpected happens during the mission, incorporate it into all subsequent time loops; then five minutes later . . .

04 / Start the loop. Do something in public that draws attention to yourself; if anything unexpected happens during the

mission, incorporate it into all subsequent time loops; then five minutes later . . .

05 / Start the loop. Do something in public that draws attention to yourself; if anything unexpected happens during the mission, incorporate it into all subsequent time loops; if any spectator asks you what's going on, say, "Sorry, I don't know what you're talking about," and then incorporate *this* interaction into subsequent time loops; then five minutes later . . .

06 / Start the loop. Do something in public that draws attention to yourself; if anything unexpected happens during the mission, incorporate it into all subsequent time loops; say, "Sorry, I don't know what you're talking about," to thin air; then five minutes later . . .

07 / Start the loop. Do something in public that draws attention to yourself; if anything unexpected happens during the mission, incorporate it into all subsequent time loops; say, "Sorry, I don't know what you're talking about," to thin air; make note of any overheard comments from freaked-out spectators; then five minutes later . . .

08 / Start the loop. Do something in public that draws attention to yourself; if anything unexpected happens during the mission, incorporate it into all subsequent time loops; say, "Sorry, I don't know what you're talking about," to thin air; make note of any overheard comments from freaked-out spectators; then . . .

09 / Vanish from the scene, leaving the audience with no explanation of the time loop they just witnessed.

mission 3

date / april 23, 2006

number of agents / 80

objective / Invade a Best Buy with dozens of agents dressed like Best Buy employees.

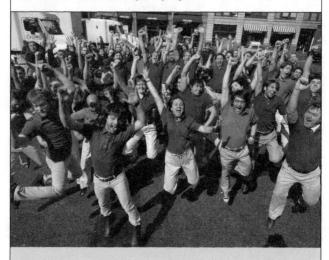

Eighty agents in Best Buy uniforms jump for joy.

Imagine the following scenario: It's just another humdrum Saturday afternoon, and you've decided to do some shopping at a Best Buy, maybe for a digital camera or a DVD player. As you browse through the merchandise, you notice a few Best Buy employees scattered throughout the store, all wearing blue polo shirts tucked neatly into khaki pants—their mandatory work uniform. Nothing seems out of the ordinary as you go about your business and stroll through the store.

Then something unexpected happens. The number of Best Buy employees starts growing exponentially. First, you spot ten of them, then twenty, then thirty, then forty employees, all wearing royal-blue shirts and khaki pants. Suddenly, there are so many of them that you lose count. You feel like you're in a hall of mirrors at a carnival, but this army of Best Buy employees is not an optical illusion; they're for real. You ask one of them a question about a plasma-screen TV, and he responds, "Well, I don't actually work here, but I'll try to help you." Store managers start freaking out all around you. "They're coming in droves!" one clerk shouts into a headset.

You notice that these fake Best Buy employees, whose ages range from nine to fifty-nine, are continuing to help customers and make themselves useful during the chaos and confusion. Other than the store managers and the security guards, most shoppers seem to be having a pretty good laugh watching eighty Best Buy "employees" swarm the store—even the lower-level Best Buy salespeople are in stitches. Then, as quickly as they arrived on the scene, the massive battalion of phony employees vanishes from the store, leaving dozens of bewildered shoppers and workers in their wake, wondering what just happened.

What happened was one of Improv Everywhere's most notorious missions. Our invasion of a Best Buy store in 2006 caused a massive scene of chaos and joy (for most). It also resulted in a visit from the police, a cease-and-desist letter from Best Buy's legal department, more than one million views of the mission on the Internet, and continued confusion to this day about who *really* works for Best Buy. Here's how it all went down and how you can create similar chaos in your hometown.

Agent Ryan Slavinsky, an Improv Everywhere fan who lives in Texas, submitted the idea for our Best Buy mission. He wrote in to suggest that I should assemble either a multitude of people in blue polo shirts and khakis to enter a Best Buy or a group of agents decked out in red polo shirts and khakis to enter a Target. Wearing clothing almost identical to the store's employee uniforms, the agents would never claim to work at the store but would simply be helpful and friendly if any customer had a question. Agent Slavinsky's idea was perfect for an Improv Everywhere mission—it was a benevolent joke with no victim and almost certain to wreak havoc. Since there aren't any Targets in Manhattan, I marked the Best Buy on Twenty-third Street in Manhattan as our target.

In the days leading up to the mission, I staked out the store several times. I wanted to see how many employees worked on the floor (about fifteen at any given time, by my count) and I wanted to note the exact shade of blue they used for their uniforms (it looked like royal blue to me). Another important detail I picked up on was that all of the employees wore belts and black shoes. While casing the store, I contemplated one of the biggest hurdles standing in the way of making this a successful mission. I knew with certainty that Best Buy would not allow us to bring cameras into the store to film our mission—retailers generally frown upon filming inside their stores. So I came up with a sly way to sidestep that dilemma: we would capture the event on film by using Best Buy's own demo cameras that are on display throughout the store. I would simply have a group of agents bring in blank tapes and memory cards, insert them

into Best Buy's video and still-photo cameras, and document our high jinks without being hassled by security guards.

One week before the mission, I contacted everyone on the Improv Everywhere mailing list (which was a tiny fraction of what it is today) to recruit a team of agents. I didn't want to give away the exact nature of the prank for fear of word spreading to Best Buy employees ahead of time, so I tried to keep the e-mail as vague as possible:

In order to participate in this mission, you must arrive adhering to a very specific dress code:

1) Blue polo shirt. Short sleeved. Any brand. Preferably with no logo. As close to royal blue as possible.
2) Khaki pants. Any shade of khaki is fine. No shorts.
3) Belt. Any belt is fine.

Other Instructions:
—If possible, please wear black shoes. This is not required, but please wear them if you have them.
—You must also bring a NEWSPAPER (any newspaper is fine—just grab a free one on the street).
—If possible, do not bring a backpack or any type of bag. This is not a huge deal, but it will work better without bags.
—Do not bring any type of camera. This mission is, as all IE missions should be, participatory. We are covering it with our own small staff of camera people and do not need any more cameras or journalists. Only show up if you are wearing the proper dress and are ready to participate and have fun!

On the afternoon of the mission, everyone met in Union Square Park, just a few blocks south of our targeted Best Buy location. Eighty agents showed up, most of them dressed like crisp, clean, hardworking Best Buy salespeople. A few of the

agents came dressed in navy or teal, instead of royal blue like I specified, but with a belt and a pair of khakis, they could still pass for employees. After everyone arrived, I explained the mission through a megaphone. The first step was for the agents to throw away their newspapers. My instruction to bring a newspaper was a red herring meant to throw people off the scent of the mission's true objective.

"We're all heading up to the Best Buy on Twenty-third Street," I informed everyone. Agents laughed and cheered once they learned our plan. "We'll enter the store one by one. Once inside, spread out and stand near the end of an aisle, facing away from the merchandise. Don't shop, but don't work either. If a customer comes up to you and asks a question, be polite and help them if you know the answer. If anyone asks you if you work there, say no. If an employee asks you what you're doing, just say, 'I'm waiting for my girlfriend (or boyfriend) who is shopping elsewhere in the store.' If they question you about your clothing, just explain that it's what you put on when you woke up this morning and that you don't know any of the other people dressed like you."

After my briefing, we walked a few blocks north to Best Buy. To anyone who passed us in the park, we probably looked like some kind of church group on a retreat. I stopped everyone on Twenty-second Street—one block south and around the corner from the store—and sent in our camera crew, Agents Erik Martin, Lauren Reeves, Jamey Shafer, Chad Nicholson, and Thomas Carlson.

Agent Martin hid his camera inside an Xbox 360 box, cutting a hole in the side for his lens. His plan was to act like he was returning his Xbox and get the security guard to tag it with a pink sticker. Once inside, he would be able to walk around freely with what appeared to be store merchandise. Agent

Carlson entered the store with one mini-DV tape. He beelined directly to the video camera section of the store, located on the ground level, right next to the front door. After locating their best camera, Agent Carlson inserted his tape and positioned it to film our agents entering the store. Agent Nicholson brought his own memory cards to insert in Best Buy's demo digital cameras, and his assignment was to discreetly snap pictures while pretending to peruse the merchandise. Once all the cameras were in place and rolling, I started sending my Best Buy "employees" into the store one by one.

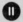 **the mission**

After about twenty minutes of staggered entrances, all eighty of the agents had infiltrated the store. Not noticing the lack of a Best Buy logo or a name tag on their shirts, customers immediately started asking our agents for help. "Where are your landline phones?" one customer asked Agent Nate Shelkey as soon as he walked in the store. "Are they downstairs?"

"Yeah, I think so," he replied.

"Oh, and where are the bathrooms?"

"Actually, I don't work here," Agent Shelkey confessed.

The customer looked puzzled. "The blue shirt?" he said, trying to figure out what was going on. Agent Shelkey just shrugged and walked away.

A young couple approached Agent Alan "Ace$Thugg" Corey, who was stationed in the stereo speakers section. "Could you point us in the direction of the calculators?" the woman asked.

"Ah, you know, I'm not exactly sure where they are," Agent Ace$Thugg said. "I think they are on the other side of the—"

"They're right in front of you!" the man said before Agent Ace$Thugg could finish his sentence. Apparently, Best Buy shelves their calculators alongside their stereo speakers. Who knew?

As soon as Agent Dan Gregor entered the store, an elderly man approached him. "Excuse me, would you mind getting that box down from that top shelf for me?" he asked. Agent Gregor began jumping up and down, trying to reach the box, but he just couldn't get to it.

"I think I'm too short to reach it," Agent Gregor said. "I'm afraid I'd just knock it off the shelf. Let me find an employee for you. You do know that I don't work here, don't you, sir?"

The old man looked perplexed for a few seconds. He pointed at Agent Gregor's shirt and then started laughing. "I'm so sorry! I just thought . . . oh my goodness, that is too funny." The man walked over to an actual Best Buy employee and turned and pointed to Agent Gregor. "He looks like your twin!" the man said, laughing. The Best Buy employee was not amused.

We had a really diverse group of agents that afternoon, which added to the fun. For some of our missions, there are very specific requirements for agents to participate (for example, in Human Mirror, you needed to have an identical twin, or in Redheads, you needed to have red hair); however, in missions like No Pants! Subway Ride, Frozen Grand Central, and Best Buy, anybody who's game can join in on the excitement. As I surveyed the eighty agents who invaded Best Buy that afternoon, I saw people of all shapes, sizes, colors, and ages. Agent Scott Lynch even brought his nine- and eleven-year-old daughters along for the mayhem. "It's take your daughters to work day," he explained to me with a laugh. With agents' ages ranging from nine to fifty-nine (Agent John "Wimpy" Ward, a.k.a. Anton Chekhov, was our most senior agent), I was confident that Best Buy's actual employees would see the humor in our

prank and recognize that there was nothing malicious in our mission. I would soon be proven wrong.

I spent most of my time wandering throughout the store, checking out other agents, and making sure everything was going according to our plan. Every now and then, I would stand for a bit at the end of an aisle, and even I ended up helping a few customers. One woman wanted to know where she could find *The Sound of Music* on DVD, so I happily walked

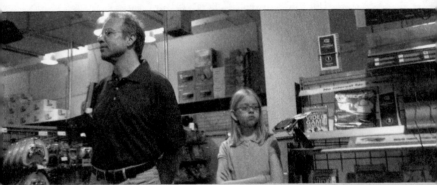

"Bring Your Daughters to Work Day"—Agent Scott Lynch is accompanied by Boat, his eleven-year-old daughter.

her over to the DVD section. It felt gratifying to lend a hand. One employee passed me with a broad smile on his face. "All you guys have *got* to get together for a photo, because no one is going to believe this!" he called out. Another Best Buy salesclerk came up to me and said, "Let me guess, you're waiting on your friend? *Good answer*." I guess at that point, he had heard that response more than a few times.

The reaction from employees was pretty typical compared to other missions I've pulled off in retail stores. Usually, the lower-level employees get a kick out of the chaos, while the store managers and security guards freak out; our Best Buy mission

was no exception. I overheard some salesclerks speculating that maybe we were a cult or political protesters. I overheard one bold employee try to finagle a date out of the prank. "Go tell that girl in the blue shirt in the computer section that Mike says hi," he said to one agent. Another employee, after being told to go get some merchandise from the stockroom, snapped back at her boss, "You should ask one of these other fifty people to go get it!"

Agent Randy Hill looked like he actually worked at Best Buy.

While the lower-level employees were mostly having a good laugh at the prank, the store's managers and security guards were becoming increasingly agitated. They frantically ran around the store, talking to each other through walkie-talkies and headsets. "This is absolute chaos!" I heard one store manager yell into her walkie-talkie. "Do not let them approach customers!"

Another store manager kept touching and counting all of the digital cameras on display, irrationally fearing that we might try to steal them. "Keep your cool. Everybody just *keep your cool*," he kept repeating to all of his employees. One manager yelled, "*Thomas Crown Affair!*" over and over, referring to

either the Steve McQueen movie or the Pierce Brosnan remake about a thief who pulls off a complicated heist involving matching outfits. "I want every available employee on the floor *right now*!" she shouted. Several agents began worrying that Best Buy's management was not amused by our prank.

"Having recently seen *V for Vendetta* and *Inside Man*—both of which feature robberies and escapes involving lots of people in identical outfits—I definitely identified with the growing anxi-

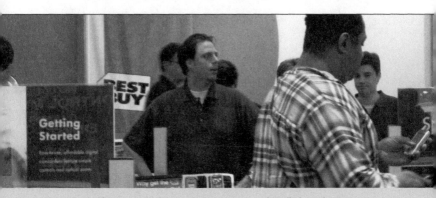

Agent Todd Simmons looking to assist customers in the cell phone department.

ety of Best Buy's security and managerial staff," Agent Lynch said afterward. Yet with agents from ages nine to fifty-nine participating in the fun, I figured Best Buy's employees would think that we were silly rather than sinister. I was wrong.

Best Buy's management clearly wanted to boot us from the store. The first agents they targeted to eject from the premises were our photographers. Agent Martin's Xbox 360 video camera was the first to be discovered.

"Do you need some help returning that Xbox?" a store manager asked.

"Not right now," Agent Martin said. "I'm just doing some browsing. I'll return it in a little bit."

"Well, do you mind telling me why there is a giant camera lens sticking out of the box?" she asked, then explained to Agent Martin that it was illegal to film in Best Buy and that he was violating her "civil rights" by filming in the store. She escorted him to the front door, where he was detained by security. Then, she instructed the security guards to call 911. Agent Nicholson, who had been taking photos at the hip to avoid detection, was caught as well, but he was able to leave the store freely.

With two of our photographers busted, I took out my own camera and started taking covert snapshots. One employee caught me in the act and rushed toward me, ordering me to stop.

"Excuse me!" he shouted. "You *cannot* take pictures in here!" He was fuming with anger, so I tried to disarm him by asking an innocuous question.

"Oh, okay. Um, do you know where I can find the right memory cards for my camera?" I asked.

He was caught off guard by my query, stammered for a second, and then said, "Sure, they're right over here. I'll show you." I thanked him and resumed taking pictures as soon as he left. Another employee stopped me moments later in the DVD section, and I used the same tactic with him.

"Sorry about that," I said, apologizing for my camera, "but could you please tell me how much the *Star Trek: Deep Space Nine* DVDs are? They don't have a price tag." We chatted for a minute or two about *Star Trek* and how expensive the set was, and by the time I walked away, he had forgotten all about the camera.

Unfortunately, Agent Martin was not as lucky as I was. After the manager dialed 911, the cops arrived on the scene and immediately began grilling him, trying to figure out why he was filming in the store. He claimed he didn't know us but just thought the people in blue shirts milling around the Best

Buy looked funny, so he started filming (inexplicably, out of his Xbox). While Agent Shafer was filming the altercation between Agent Martin and the police, his camera was also discovered, and the cops began questioning him as well. Already booted, Agent Nicholson began snapping photos through the store's front window.

While the cops were questioning Agents Shafer and Martin, we had two other videographers filming the heated confrontation. Agent Carlson went undetected as he filmed the altercation with the police using a Best Buy demo camera. Nobody questioned Agent Reeves, even though she made little effort to disguise her camera while filming—maybe the fact that she's tall, blond, and female had something to do with her camera going unnoticed.

As the cops interrogated Agent Shafer, he tried to convince them that he wasn't doing anything illegal. "There is no law that says I can't film in here," he proclaimed, "and you can't accuse me of trespassing because no one has asked me to leave. I'd be perfectly willing to leave if you would just let me go!"

"We're gonna get to the bottom of this first," a police officer said.

"Listen," a store manager interjected. "I don't come to your house and film you!"

"Who lives here?" Agent Shafer said.

The cops argued with each other for a bit but finally realized there was nothing they could do. They let our photographers go and informed the Best Buy manager, "The worst you can do is ask them to leave. There's not a law saying you can't wear a blue shirt and khaki pants."

Amid all of the chaos surrounding our confrontation with the cops, our eighty agents in blue polo shirts and khaki pants were still causing mass confusion throughout the store. They

helped customers, they were berated by staff, and they befuddled everyone in the store.

"I was lingering near the audio equipment at one point when a middle-aged couple asked me if I knew the price of some speakers," Agent Todd Simmons said. "I looked for a price tag and then saw 'Ninety-nine dollars and ninety-nine cents' labeled on the shelf by the product.

"'Ninety-nine dollars and ninety-nine cents?' I said, unsure.

"'No,' the man pointed out. 'That is the price of the wireless speakers.'

"'Oh,' I said. 'Maybe it's been labeled wrong.'

"'Well, do you work here?' the man asked.

"And I replied, 'No, but I thought they looked like really good speakers.' The couple looked really puzzled. A little while later, an older woman carrying an armful of products walked past me and was muttering to herself, 'Everyone in this goddamned store is wearing a blue shirt and nobody knows a thing!'"

After forty minutes of wreaking havoc in the Best Buy, I decided it was time to gather my eighty agents and get out. As I was giving everyone the signal to split, I decided to snap a few more photos before heading for the door. An angry employee approached me (again) and delivered a harsh reprimand.

"You better stop taking pictures and get out right now, or else . . . ," the employee said.

"I'm on my way out," I reassured him.

As I continued herding agents up the escalators and toward the exit, the angry employee decided that he wasn't done with me. "All right, which one of you had the camera?" he shouted. I stood in the middle of a sea of blue-shirted agents, and none of us answered. "C'mon, which one of you was taking photos?" he yelled. I could see his frustration increasing, like he was playing a real-life game of *Where's Waldo?* by trying to

spot me in a throng of Best Buy employees. As I boarded the escalator, I glanced behind me to make sure that I didn't leave any agents behind, and I accidentally made eye contact with the angry employee. He glared at me and shouted, "That's him!" I worried that he would radio my physical description to the front-door security team so that they could intercept me, so I picked up the pace and hurried out the front door, undetected and with my camera safely in my pocket.

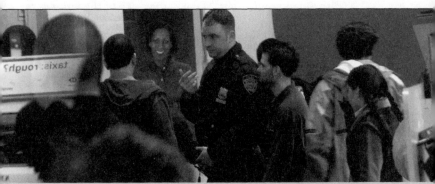
An NYPD officer explains to the Best Buy manager, "It is not illegal to wear a blue shirt."

All eighty agents made it out of the Best Buy unscathed—the cops didn't ticket any of us and all the photographers and videographers still had their cameras. We were walking as a group down to a rendezvous point to swap stories and share the experiences we had just had when I noticed a Best Buy manager running after us while screaming into a walkie-talkie, "They're headed down Sixth Avenue!" I looked back at her and laughed. I knew there was nothing she could do, because like the police said, there's not a law saying you can't wear a blue shirt and khaki pants.

Shortly after the mission, I edited the video footage from the prank down to a one-minute-and-thirty-second clip. There was no dialogue on the video, just various shots of the agents milling around the store dressed like Best Buy employees. I posted the video on the Improv Everywhere website and on YouTube, which in early 2006 was a fairly new site. The video and the mission report exploded virally on the Internet. Hundreds of bloggers reposted the video, and people around the world e-mailed the Best Buy clip to their family and friends. Hundreds of comments started pouring into my website, many of them from actual Best Buy employees. While some of the employees weren't amused, the majority of Best Buy workers from around the country expressed strong approval of the mission. "I work at Best Buy and I see how this would freak everyone out, but it's so lovely," wrote one commenter. "I wish I could have been working. I would have thought it was hilarious."

Reaction to the mission was so positive on the Internet that I decided to create a royal-blue polo shirt emblazoned with a yellow tag that would read Improv Everywhere instead of Best Buy. I contacted Neighborhoodies, a Brooklyn T-shirt company, and they agreed to make the shirts. I wasn't going to turn a profit on the venture, I just wanted to offer something to fans of the prank and maybe assist others in re-creating the mission at their local Best Buy. Not long after I began selling the shirt on the Improv Everywhere website, I received the following letter in the mail:

14 November 2007

Re: Notice of Copyright and Trademark Infringement

Dear Sir or Madam:

It has come to our attention that you are using the tag design on shirts promoted via your website www.improveverywhere.com and sold on www.neighborhoodies.com . . . This unauthorized use is in violation of Best Buy's trademark, trade dress and copyright infringement, therefore entitling Best Buy to federal and state statutory as well as common law remedies . . .

Moreover, Best Buy does not authorize, sponsor, endorse, or approve of your business. Your unauthorized use of our mark may cause confusion as to any affiliation between you, Best Buy, and/or Best Buy's marks . . .

Best Buy therefore demands that you and the entities operated by you or under your control immediately cease and desist from this activity and immediately remove all infringing content, including all shirts depicting the BEST BUY logo.

In addition to asking me to stop selling the shirts, Best Buy's lawyers also slapped Neighborhoodies and Laughing Squid (a San Francisco–based blog that merely reported on the shirts and was not selling them) with cease-and-desist letters. I thought that the shirt would be safe from legal action because it was a parody; apparently, that wasn't the case. I didn't want Neighborhoodies or Laughing Squid to get in trouble, so I agreed to stop selling the shirts and removed them from the Improv Everywhere website. Best Buy's legal action over the shirts caused a minor controversy. The story was featured on the evening news

in Minneapolis, where Best Buy is headquartered. Eventually, Best Buy apologized to Laughing Squid for serving them with a cease-and-desist letter. As a blog, Laughing Squid had every right to reference the shirts in a blog post. Unfortunately, we are still not allowed to sell the Improv Everywhere Best Buy shirts. Neighborhoodies only sold about ten of the shirts before being asked to stop selling them, so if you have one, you've got a collector's item on your hands.

Improv Everywhere's Best Buy mission became so popular that if you Google Best Buy on the Internet, our mission report page sometimes comes up on the first page of results, just below the official Best Buy site. It's pretty funny to see Improv Everywhere still nipping at the heels of the largest retailer of consumer electronics in the United States.

↑ | **mission accomplished**

objective / Pose as a rock star and stage a concert.
Try to fool unwitting fans into thinking they're watching
their rock 'n' roll idols.

Our Best Buy mission left store employees and shoppers completely bewildered. But Best Buy isn't the only store with matching employee uniforms. Here are a few suggestions of other stores to raid:

Target / By naming their store Target, this retail giant is practically begging us to prank them. Posing as a Target employee is easy enough; all you need is a red polo shirt, khaki pants, and an extensive knowledge of discount merchandise.

Blockbuster Video / Ever need help finding a new DVD release to rent at Blockbuster? What if there were a hundred employees crammed in the video store, all wearing the company's blue-shirt-and-khaki-pants uniform? If you want to pull off this mission, you'd better act fast—with the rise of Netflix and on-demand television, video stores are going extinct faster than Betamax tapes.

The Home Depot / The Home Depot's slogan is "You can do it. We can help." We can help, too! If you and your agents consider yourselves to be handymen and women, then this might be your ideal target. Just don an orange apron emblazoned with Home Depot's logo and instantly become a Mr. or Ms. Fix-It.

Foot Locker / It's always game time at this chain shoe store, where employees are required to dress like referees. Get a group

of your friends to throw on zebra striped jerseys and whistles, crowd into your local Foot Locker, and help customers try on basketball sneakers.

Wal-Mart / In 2007, Wal-Mart created mandatory uniforms for their employees. One Wal-Mart employee's misery is another prankster's mischief! If you have a massive group of agents, why not throw on Wal-Mart's new requisite employee uniform (navy-blue shirt and khaki pants) and invade the colossal superstore?

Starbucks / Although there's not a lot of retail action going on at America's favorite corporate coffee chain, by donning a black shirt, khaki pants, and a green apron, you and your team of agents could storm a Starbucks, bus their tables, and convince customers that what they really need is a brand-new French press and the latest Alanis Morissette CD.

Remember to always be friendly and assist customers to the best of your ability. If you can't answer a question, get an actual store employee to help. When people ask you what you are doing, just say you are waiting for a friend.

how to act like you work at best buy

by agent ben rodgers

1 / Wear a blue shirt.

2 / Wear khakis.

3 / Walk around a Best Buy.

↓ | That's the sound of the Police!

I hate it whenever the cops get involved in our missions. It drives me crazy to see them wasting their time policing our fun when surely there's more important work to be done. It's usually not their fault—some overzealous store manager dialed 911 and they had to respond. Improv Everywhere does not break the law, but sometimes we might break a store policy or a park regulation.

Remember that if you're pranking on other people's property, there is always the chance the law might show up. Even if you're not doing anything wrong, it doesn't mean they won't stop you. Remember to be polite and cooperative with the police in the unfortunate case that they do show up. We find that in the situations when they get called, we've probably already had our fun by the time they show up. Here are all of Improv Everywhere's encounters with the fuzz.

The Amazing Mime / The first time the cops showed up to an Improv Everywhere mission was one of our very first outings in the summer of 2001. I pretended to be a mime who could mime *anything* and worked by request. Agent Nathan Blumenthal served as my barker, drumming up a crowd. We did this in the middle of Times Square where hundreds of tourists. Pretty soon, fifty people crowded around me and watched as I mimed abstract concepts like "red" and "hope." If you block street traffic, as our audience did, the cops will be there lickety-split. We apologized and were on our way. The most awkward part about it was the mime had to *speak* to the cops.

New Cheerios / In the fall of 2001, Agent Richard Lovejoy and I set up a table in Central Park claiming to be representatives from

General Mills conducting a taste test. We wanted to see if people preferred regular Cheerios or our latest product, New Cheerios. What the taste testers didn't realize was that both samples were exactly the same. Still, more people preferred the taste of the "new." After about fifteen minutes a park ranger shut us down. Apparently it's against the rules for random people to give food out in the park. C'mon! We're not going to poison anyone!

Megastore / In the summer of 2004 we got forty agents to take over the listening stations at the Virgin Megastore in Union Square. The stations were lined up on one long wall and numbered one through forty. Once everyone was in place, I gave the signal and the agents did a ridiculous line dance choreographed by Agent Ken Keech. The customers thought it was hilarious; the managers, not so much. The first thing they did was cut the power to the listening stations. In theory, if we weren't listening then we weren't shopping, and they could charge us with loitering. They called the cops on us, but by the time the police got there we had already left. I overheard a hilarious exchange between the manager and a cop:

Megastore guy: They were all just standing there.
Cop: What were they doing?
Megastore guy: Just standing, and then they all danced.
Cop: Did they say anything?
Megastore guy : No.
 [*Pause*]
Cop: Why are we here?

Anton Chekhov Lives! / I'm not sure if the Barnes & Noble manager called the cops on us during our fake Anton Chekhov reading or if one just happened to be there, but I definitely had to

escort Mr. Chekhov past a man in uniform on the way out of the building. I wonder if it's possible to arrest a dead man.

Even Better Than the Real Thing / Our U2 mission was our first real experience with the law. By the end of the fake concert there was a swarm of very real cops on the roof. I was handcuffed along with Agent Ptolemy Slocum (still in his Fake Bono wig and shades). The entire band along with a few cameramen were issued a ticket and charged with Unreasonable Noise. A month later the Honorable Judge Eileen Koretz let the eight of us walk out of Manhattan Criminal Court free men. It was truly a beautiful day.

No Pants! 2006 / Our fifth annual No Pants! Subway Ride was rudely halted by an NYPD officer at the Fifty-ninth Street Station. He encountered our group of 150 pantless riders and decided the best course of action was to stop the train, make everyone get off, and call for backup. Pretty soon dozens of cops were on the platform trying to corral the huge mob of commuters and pranksters. They put handcuffs on the first eight pantless people they could find. A month later the charges were all dropped—it's not illegal to go sans pants in New York City. Just ask the Naked Cowboy in Times Square. The arresting officer's name? Officer Panton. No joke.

Best Buy / A manager at Best Buy decided dialing 911 was the best way to handle our blue shirt invasion. She even screamed, "*Thomas Crown Affair!*" into her walkie, implying that we were involved in some elaborate heist. We started leaving one by one after the cops arrived. The NYPD explained there was really nothing they could do. After all, it's not illegal to wear a blue polo shirt and khaki pants.

mission 4

date / july 29, 2005

number of agents / 3

objective / Convince a cabbie that he's just reunited two star-crossed lovers.

Agents Anthony King and Kate Spencer pose with their taxi driver.

Paris may be considered the most romantic city on the face of the earth, but New York City is, without a doubt, the world capital of romantic comedies. From Marilyn Monroe's white skirt flying high on Lexington Avenue in *The Seven Year Itch,* to Woody Allen and Diane Keaton gazing up at the Fifty-ninth Street Bridge in *Manhattan,* to the "I'll have what she's having" scene in Katz's Deli from *When Harry Met Sally,* to the destined meeting of Tom Hanks and Meg Ryan at the top of the Empire State Building in *Sleepless in Seattle,* the Big Ap-

ple has served up the scenery for the most iconic moments in romantic comedy history. Unfortunately, sugarcoated courtships only exist in the movies, not in the real world. But what if one of those achingly sweet yet highly improbable scenes stepped off the silver screen and into reality? What if an unsuspecting New Yorker heroically reunited two star-crossed lovers, just like in a romantic comedy? As Nicolas Cage might say, *It Could Happen to You!*

❶ the plan

Boy meets girl. Boy loses girl. Boy gets girl. Every romantic comedy—from Shakespeare's *A Midsummer Night's Dream* to any Hugh Grant movie—can be boiled down to these three conventions. For this mission, I wanted to challenge a random New Yorker with the task of helping "the boy" get "the girl." If this person successfully reunited the couple, he or she would feel like the star of a feel-good "happily ever after" Hollywood ending. But how could I set up a stranger to become the hero of a real-life romantic comedy?

For a long time, I toyed with the idea of pulling off a mission involving multiple agents taking the same cab consecutively. With a detailed plan for pickup and drop-off points, I could ensure that a cabbie would drive a series of agents without realizing that the passengers were connected. This seemed like the perfect device for my romantic comedy mission. After casting two agents as star-crossed lovers, I would have them take the same taxi in the same hour and in separate trips tell the driver all about their lost love. Then we'd see if the driver could make the connection and reunite the couple. I was thrilled with this premise; in keeping with the Improv Everywhere philosophy,

this mission would cause a scene of joy and give a stranger, our unwitting cabbie, quite a story to tell.

My first task was to cast the agents to play the lovestruck couple. I chose Agents Anthony King and Kate Spencer, two fellow improvisers from the Upright Citizens Brigade Theatre. Casting these two actors was a no-brainer; Agent King is a tall drink of water with a permanent five o'clock shadow, and Agent Spencer has enough charm and beauty to put Meg Ryan to shame. I knew they would make the perfect romantic comedy couple. These two dashing agents are also veteran comedic performers, so I was confident that they'd have the acting chops to convince a cabbie of their missed love connection.

My three-part plan for the mission was simple:

01 / Agent King hails a cab on the corner of Fourteenth Street and Union Square West at seven P.M. He tells the driver that he met the most amazing woman the night before, but he lost her phone number and the name of the restaurant where they were supposed to meet. He asks the driver to take him to the bar where he met her, located at Nineteenth Street and Seventh Avenue.

02 / I wait for him at Nineteenth and Seventh Avenue. When Agent King gets out of the cab, I get in without acknowledging him. I ask the driver to take me to the corner of Sixteenth Street and Fifth Avenue. Then I remain silent for the duration of the ride.

03 / Agent Spencer waits for me to arrive at the corner of Sixteenth and Fifth. She gets in the cab after I exit. She tells the driver that a great guy who she met at a bar located on Nineteenth Street and Seventh Avenue stood her up.

At this point, it would be up to the taxi driver to connect the dots and reunite the couple. Would he speed across town and take Agent Spencer directly to her lost love? Or would he take no interest in their sob story?

Agent King loved the idea for the mission, but Agent Spencer was a little bit skeptical. "I'm not convinced this is going to work," she said. "Do cabbies ever listen to what you say to them? Half the time, I can't even get them to take me to the right address, they're so busy chatting on their cell phones." She had some good points. For many cab drivers, English is a third or fourth language, so selling our story might be difficult. In the end, we all agreed that this plan was too much fun not to try.

On the night of the mission, Agents Spencer and King dressed up like they were going out on a date. We planned on using a digital video camera to capture audio from the cabbie; if we passed the camera inconspicuously from passenger to passenger in the back of the taxi, the driver hopefully wouldn't notice. We set an early start time at seven P.M. because we figured this mission might take a few tries. What were the odds that our comedy of errors would even work? At six thirty P.M., we dispersed to our pickup points. It was time to see if a taxi driver could help love find a way.

❚❚ the mission

Agent King stood at the corner of Fourteenth Street and Union Square West. He checked his watch; it was seven P.M., our designated start time. An open cab approached. The driver's window was down, so Agent King hailed the taxi and tried to get the cabbie to aim toward me. "Can you make a right-hand turn here? I'm going across town."

"Hurry up! Get in!" The cabbie, a tall man with a thick African accent, seemed angry for no apparent reason.

Agent King hopped in the taxi. "Would you please take me to Nineteenth Street and Seventh Avenue?" The driver took note of Agent King's destination, then immediately started yelling at a stream of pedestrians in front of his car. "It's a red light!" he screamed at passersby in the crosswalk. "Get the hell out of the way!"

With such an agitated cabbie behind the wheel, Agent King figured that we'd have to scrap this trip and try again with a different driver. But as long as he was in the car and in character, he decided to launch into his saga about missing his date with Agent Spencer anyway.

"I'm having an awful night," Agent King began. "I was supposed to meet this girl for a date, but I lost her number *and* the name of the restaurant."

"That's terrible, man," the driver said. "Just terrible."

"We talked for more than two hours at this bar last night. We totally clicked. I just loved everything about her."

"What did she look like, man?"

"She's a brunette, she's tall, she's—"

"She was tall?" the cabbie asked.

"Yeah! She was perfect!" Agent King said.

"Nice, man. That's real nice."

"But I'm just so stupid! I mean, she wrote down her number on a napkin and where she wanted to meet me for dinner tonight, and I lost the damn napkin."

"You should have saved her number in your cell phone! Do you have any idea where this restaurant is?" All of the anger the cabbie displayed at the start of the drive quickly evaporated. Suddenly, he was consumed by Agent King's dilemma and he wanted to help. "You know, there are a lot of restaurants on Sixteenth Street," the cabbie said. "Maybe she is there." Ironically, Sixteenth Street was exactly where Agent Spencer was waiting to be picked up.

"I don't know. I looked everywhere and I couldn't find her," Agent King said. "We met last night at a bar called McManus on Nineteenth and Seventh. She said she goes there a lot, so I'm just gonna go there now, wait there all night, and hope that she shows up. I can't believe I'm so stupid! I mean, we *really* hit it off last night. She's everything I look for in a girl. Smart, funny . . . she had this amazing laugh . . . tall, brunette. She was just beautiful. I've never felt so strongly about a woman in my entire life."

"She sounds amazing. I really hope you can find her," the cabbie said. At that moment, Agent King realized we had the perfect hero for our mission. If this taxi driver couldn't save the day, no one could. The taxi pulled up in front of McManus, where I was waiting. Agent King paid the driver. "Good luck tonight," the cabbie said to Agent King as I slipped into the taxi's backseat. "I wish you the best."

"Can I go to Sixteenth Street and Fifth Avenue?" I asked the driver. He nodded and we were on our way. As soon as I got in the taxi, the driver immediately started talking on his cell phone in another language and paid zero attention to me. I started to worry. Had he listened to Agent King's story? I had no idea if the cabbie had taken the bait. All I could do was sit silently in the back of the taxi until I reached my destination, where Agent Spencer would be waiting. I sent her a text message to let her know I was on my way: *In cab. Will be there soon.*

After exiting the taxi, Agent King took out his cell phone and called Agent Spencer. "I think he bought it," Agent King said. "I told him we met at McManus last night and that you had written on a napkin where to meet for our date. I told him that I lost the napkin and couldn't find the restaurant."

"Sounds good," Agent Spencer said. "I can work with that."

Everything was running smoothly for my portion of the mission. My ride was pretty uneventful, as I had planned. But then, as we were nearing my destination (and Agent Spencer's pickup point), disaster struck. I was supposed to get out at Sixteenth Street and Fifth Avenue, but the cabbie came to a screeching halt at Sixteenth Street and Union Square West.

"Sorry, man. I missed the turn onto Fifth," the cabbie said. "It would be easier for you to just get out here and walk down the block." His suggestion made perfect sense, but getting out of the cab on the wrong block would effectively end the mission. I couldn't let that happen. "No . . . would you mind driving back to make that turn? I need to get out at Sixteenth and Fifth." I looked in the rearview mirror and saw the driver roll his eyes. He wasn't budging. My request was ludicrous, but I needed to be dropped off directly in front of Agent Spencer. It would take me thirty seconds to walk over one block and about ten minutes for the driver to loop around and cover the same distance in downtown traffic.

"Please," I begged. "You'd really be doing me a favor."

"All right," the driver said as he pulled away from the curb. Crisis averted.

Ten minutes later, as we were approaching my drop-off point, I spotted Agent Spencer wearing a black top and a lime-green skirt. I waited until the cab pulled up right in front of her.

"This will be fine. I'll get out here," I said. "Sorry about making you loop around like that. I just should have gotten out over there."

"No problem. Have a good night," the cabbie said. I paid him the fare and got out of the taxi. Agent Spencer stepped in the car without acknowledging me. It was time to see if our cabbie would take the bait.

"Hi, how are you?" Agent Spencer said. "I'm going to Twentieth and Eighth Avenue."

"What?" The driver seemed slightly irritated after dealing with me.

"That's *two-zero* and Eighth Avenue. How's your night going?"

"Ah . . . pretty slow."

"I just got stood up on a date. I met this guy last night and we were supposed to meet at this restaurant . . ."

The cabbie immediately perked up. "Where?" he asked.

"Right back there . . ."

"When! When! When!"

"I met him last night at a bar," Agent Spencer said.

"Last night?"

"Yeah."

"I just dropped the guy off!"

"Are you serious?"

"Yes! Are you tall?"

"Am I tall? Yeah, I'm five-nine. He has, like, dark black hair . . ."

The cabbie had no time to listen to Agent Spencer describe her date. He was giddy with excitement, his voice rising with every question.

"You met him where? *Where did you meet him?"*

"I met him at this bar on Nineteenth and—"

"Seventh! Seventh! On the west side!"

"Shut. Up." The driver looked in his rearview mirror to see Agent Spencer's jaw drop with astonishment.

"The guy was here! I am telling you. We went all around looking for you. We don't see you. He didn't know what restaurant."

"I wrote it down on a napkin."

"Exactly! He lost it!"

"Wait. Did you *just* drop him off?"

"I dropped him off, like, twenty minutes ago."

"He had black hair?"

"Yeah! Yeah! He said he met you last night."

"Yes, last night! We talked for two hours."

"He said he told you everything and that he really likes you. I talked to him myself!"

"Oh. My. God. And you *just* dropped him off?"

"Yeah! He wanted to go to the place where he met you. So I dropped him off there."

"At McManus? At Nineteenth and Seventh?"

"Yes!"

"All right, let's go!"

The cabbie gave the steering wheel a hard turn and peeled out. "I know where he is. I will take you to this man!"

"I can't believe this," Agent Spencer said.

The cabbie maneuvered his taxi through the traffic like a streak of lightning, making a beeline straight for Agent King. "This man, he really, really likes you. He told me so," he said. "And I am not a gay man, but he was very attractive and very kind. I can see why you like him. I know it was this man. He said he likes tall girls, and you are a tall girl. I will find him!"

Agent Spencer took out her cell phone and discreetly text messaged Agent King: *All good. On my way.*

After receiving Agent Spencer's text message, Agent King walked out to the curb in front of the bar. I was laying low a couple of blocks away, completely out of sight. Agent King pretended to look busy by talking into his cell phone. A few minutes into his imaginary phone call, he looked up to see a taxi come flying around the corner. The driver was honking repeatedly and flashing his headlights. It was our cabbie deliv-

ering Agent Spencer to her man. He stuck his head clear out of the window, speeding toward Agent King. "I have her!" he shouted. "This is her! I have her!"

Agent Spencer flung open the cab door and ran into Agent King's arms. After hugging each other for a few seconds, they turned to the cabbie, who was grinning from ear to ear.

"We can't thank you enough," Agent King said. "This is amazing. I can't believe you found her!"

"This is her! I have her!" Agents King and Spencer are reunited by their heroic cabbie.

"It is no problem, my friends," he said.

Agent Spencer took out her wallet, paid her fare, and topped it off with a 40 percent tip. "Would you mind taking a picture with us?" she asked. The cabbie grabbed his taxi ID card and medallion and leapt out of the car. As he had his picture taken with the happy couple he proudly displayed the medallion. The cabbie was still beaming a high-wattage Hollywood smile as he got back into his car. "All the best to you," he said with a wave and drove off, leaving Agent King and Agent Spencer locked in a tender embrace at the corner of Nineteenth Street and Seventh Avenue.

After the taxi was out of sight, Agent King called me and gave the all-clear. I met up with Agents King and Spencer, and we listened to the audio of the mission. I had never heard so much joy in a man's voice before as I listened to the cabbie exclaim, "There he is!" to Agent Spencer, and then "I have her!" to Agent King. In retrospect, I wish I would have had a fourth agent ride in the taxi after Agent Spencer to document the cabbie's excitement at what had just unfolded.

I've often wondered what the cabbie's reaction would be if he found out about this mission on the Internet or in this book. I haven't heard from him at any point since the mission took place, so I assume he's still unaware that the events were fabricated. I sort of hope he never finds out the truth and always has the story of the time he reunited two young lovers. On the other hand, if he does find out, he has what's arguably a more interesting story: *A group of comedians went to great lengths to make me feel like I was the hero of a romantic comedy.* I can only imagine that he would be extremely satisfied with his actions. We took a total stranger and put him in a high-pressure situation; his natural instinct was to rise to the occasion and act like a hero.

In the end, our cab driver wasn't the only person in this mission who experienced a "happily ever after" ending. On August 23, 2008, I attended the real-life wedding of Agent Kate Spencer and Agent Anthony King.

↑ | **mission accomplished**

mission 5

date / february 29, 2004

number of agents / 18

objective / Host a reading and book signing by famed (and dead) Russian author Anton Chekhov.

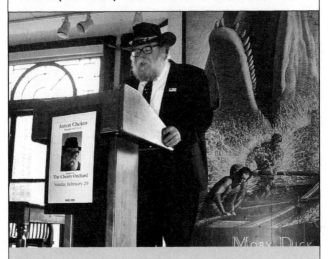

Back from the grave: Chekhov reads at Barnes & Noble.

As anyone who has taken a high school English course
can tell you, Anton Chekhov has earned a place among the great-
est writers in all of literature. A celebrated Russian author and
playwright, Chekhov wrote the grim but masterful tragedies *The
Cherry Orchard* and *The Seagull.* What you probably didn't learn
in English 101 is that Chekhov wasn't some gloomy Gus who spent
his days penning depressing plays; he was actually a notorious
prankster. To amuse himself, Chekhov often pretended to be a
butler in the hotels of Moscow; or he would wear a turban and

a robe and impersonate a mysterious emir from the Middle East; or on train journeys with his mother, Chekhov liked to pretend that she was a countess and he was her bumbling servant, much to the bewilderment of other passengers on the train.

Although the plays he wrote were dark and disturbing, Chekhov was quite the clown. "He adored buffoonery," notes Chekhov biographer Robert Payne. "He had the trick of making a walk in the country an adventure in high drama. Everything excited him." Anton Chekhov sounds like just the kind of person who would make the perfect agent for an Improv Everywhere mission. Unfortunately for us, Chekhov died in 1904 after a long bout with tuberculosis. However, I felt that Chekhov's death more than a century ago shouldn't stop the brilliant writer from having some fun with his fans.

 the plan

Try to be original in your play and as clever as possible, but don't be afraid to show yourself foolish.

—Anton Chekhov

In 2002, Agent Ross White, a college friend of mine from North Carolina, developed an idea for a mission that was inspired by my Ben Folds impersonation. Agent White wanted to tackle an even bigger challenge than posing as a rock star: impersonating a dead person. "I thought it would be fun to have a famous, dead author make a public appearance and see if people recognized whether this guy was dead or not," Agent White recalled. "I thought up a list of dead authors who might work out. I knew it couldn't be an American writer, and for some reason, Russians seemed funnier. I thought maybe Nabokov

would work, or Tolstoy. Maybe Dostoyevsky. But then it came to me: the dead guy had to be Anton Chekhov."

Chekhov's plays are taught in nearly every high school and college's English and drama departments, so most people know his name. He died so long ago that a public appearance by "Anton Chekhov" in New York City would be an obvious joke, yet there was a chance that a handful of people would be fooled. There was only one major obstacle in pulling off this mission: finding the right person to play the long-dead Russian playwright. In his portraits, Chekhov's intense gaze is distinguished by penetrating eyes and a bushy beard—a feature that isn't common among my comedian friends in their twenties. Also, our Chekhov needed to be portrayed by an older man; a young actor playing Chekhov would be a dead giveaway that our mission was a fake, whereas an older actor could fool some New Yorkers into believing that Chekhov was actually still alive.

Two years passed after Agent White pitched the Chekhov mission without any sign of a person who could play the part. Yet I never gave up hope because the prank seemed so perfect. Finally, in 2004, my patience paid off when I met Agent John "Wimpy" Ward. A fifty-nine-year-old retired computer systems designer from New Jersey, Agent Wimpy was taking improv classes at the Upright Citizens Brigade Theatre in New York City, where I perform and teach improv comedy. As soon as I spotted him in the theater, I knew I had found my "Anton Chekhov." A cross between Santa Claus and the lead singer of ZZ Top, Agent Wimpy's look was tailor-made for the part. I approached him and pitched the idea. With a little reluctance, he agreed to take on the role of a lifetime. "I had never heard of Improv Everywhere, and I expected to get into trouble for

doing this," Agent Wimpy admitted. "But I was honored to be asked. I guess I was the only person at the UCB Theatre who looked like a dead writer."

With Agent Wimpy cast in the lead role, all of the pieces were finally falling into place for our Anton Chekhov mission. The original idea for the prank was to set up a card table in Washington Square Park with a sign that read Meet Anton Chekhov, where the impersonator could sign a stack of books.

MEET THE WRITERS
Anton Chekhov
READING/DISCUSSION

author of
The Cherry Orchard
Sunday, February 29

Agent Peter Olson's poster for the Chekhov reading is identical to the Barnes & Noble "Meet the Writers" flyers.

I wanted to raise the stakes a little bit, so I thought it would be even funnier if I staged a reading by Chekhov as a part of the Barnes & Noble Meet the Writers series. After scouting out several Barnes & Noble locations, I marked the Union Square store as our target. Their Meet the Writers area on the fourth floor provided an ideal setting—a large stage with a podium in front of approximately 150 seats. Store patrons tend to sit in that area and read quietly when there is no presentation happening. These unwitting customers would be Chekhov's captive audience. To add to the authenticity of the reading, I had Agent Pete Olsen design a poster for the event using a

photo of Agent Wimpy that almost exactly matched the other Meet the Writers posters in the store.

On the day of the mission, I planted eleven undercover agents in the Meet the Writers seating area. There were already about forty actual Barnes & Noble customers seated in front of the stage, silently reading books and magazines. Several agents strategically positioned themselves to take covert photographs of the mission. I wore a suit and tie and would be playing the part of Anton Chekhov's literary agent. With the audience in place, our undercover agents planted, and Agent Wimpy waiting in the wings, I quickly taped up one copy of our poster to the sign at the entrance to the area and another copy on the podium. I stepped behind the podium and made a very brief introduction, speaking into a microphone that wasn't turned on. "Good afternoon! Welcome, everyone. Please give a warm welcome to the Russian-born, but now an American citizen, Anton Chekhov!" Led by the planted agents, the entire audience put down their books and applauded. It was time for Anton Chekhov to take the stage.

 the mission

Don't laugh at me! If my father and grandfather could only rise from their graves and see what happened . . .

—*The Cherry Orchard*

"Hello, my friends! I am so happy to be here with you in New York City," Anton Chekhov announced in a booming voice. Our Barnes & Noble audience was startled but surprisingly respectful. As soon as Chekhov took the stage, the majority of

the crowd put their books aside and gave the famed Russian playwright their full attention. It seemed as though everyone in the seating area took the bait and truly believed that, out of nowhere, none other than Anton Chekhov was suddenly addressing them. One man even scrambled to get out a notebook and was soon jotting down notes on the reading.

Agent Wimpy had selected two of Chekhov's short stories—"The Threat" and "In the Graveyard"—to read aloud. "The stories I picked were *very* short," Agent Wimpy explained. "I wanted to make sure I could finish them before we could be evicted from the store." Agent Wimpy nailed his performance as Chekhov. His accent was a little bit silly sounding, but it fooled most of our audience. "I work with a lot of foreign nationals, so I was just trying to imitate them," Agent Wimpy said. "But I think I just ended up sounding like Chico Marx doing a fake Italian accent." Regardless, Agent Wimpy captivated our ambushed Barnes & Noble audience with his boundless charisma and charm. As customers from other floors happened upon Chekhov's reading, many of them immediately burst into laughter. Yet the captive audience in the seating area remained transfixed by his spellbinding performance.

Chekhov received a hearty round of applause for his reading of "The Threat," and before launching into "In the Graveyard," he shared the following anecdote with the audience:

Under communists in Russia, I could not talk to my friends like I am talking to you, my friends. KGB was everywhere. If you went to restaurant to eat and talk, the waiter was probably KGB. If you went to the library to talk, then the librarian went, "Shhh . . ." [*Agent Wimpy held one finger in front of his lips*]. And if librarian did not say shush, she was listening [*Agent Wimpy cupped his hand around his ear as if to hear a whisper*] because

she was KGB! The only safe place to walk and talk was the one place nobody was listening or watching . . . the graveyard.

Chekhov then began a haunting reading of his short story. A larger crowd began to gather on the outskirts of the reading area, most of them smiling in recognition at the joke. However, I noticed that not everyone in the crowd was smiling. Two security guards and a police officer appeared in the back of the room along with the Barnes & Noble assistant store manager. I decided to cut the reading short and move on to the question-and-answer portion of the event. Basically, I wanted to make it clear to the authorities that our high jinks would soon be over.

"Ladies and gentlemen, Mr. Chekhov is on a very tight schedule today," I announced from the podium. "We unfortunately have to leave in just a few minutes. We have time for just a few questions from the audience." Right when I was about to start the Q&A session and take the first question for Chekhov, Tom Fuller, the Barnes & Noble assistant store manager, began walking swiftly to the stage. "Again, we have just a few minutes for questions," I said. This time, Tom interrupted me, announcing, "Very few minutes! In fact, you're done. Take it down." I was still in a position of power as I was on a raised stage and standing at a podium. I smiled at Tom and took the opportunity to address the crowd.

"Ladies and gentlemen, it seems we are, in fact, all out of time," I said. "Thank you for coming today to hear Mr. Chekhov. Please come back for future 'Meet the Writers' programs, which happen at this store several times a week. We would like to thank Barnes & Noble Union Square for having us today. Thank you."

After finishing my statement, I exited the stage to boisterous applause from the audience. Tom instructed me to take our sign

down from the podium and then walked over to the other sign and politely handed it to our Anton Chekhov. I approached Tom and shook his hand. With a broad grin on his face, Tom clearly saw the humor in our stunt, but as assistant store manager, he had no choice but to give us the boot.

"Thanks for having us," I told Tom before leaving the store.

"You bet," he said, smiling. "Please come back the next time he writes a new play."

As Agent Wimpy and I were escorted out of the Barnes & Noble, still in character as Anton Chekhov and his literary agent, a chaotic scene broke out in our wake. Security guards stood around looking befuddled, muttering things like, "Well, *that* was interesting." Assistant Store Manager Tom guffawed as we exited and exclaimed, "We got Chekhov!" Some of our planted agents with cameras led the security guards on a wild goose chase throughout the store; security had caught on to the fact that there were more than just two people involved in the caper and they tried to nab anyone they could. One customer turned to Agent Zohar Adner and expressed that she was shocked and outraged that Barnes & Noble would kick out such a famous author in the middle of a reading. At this point, by creating a scene of chaos and joy in the Barnes & Noble, we had already achieved a successful mission. But the fun with Chekhov wasn't even close to being done.

After escaping the melee in Barnes & Noble, I led Anton Chekhov across the street to Union Square, a park in Manhattan on Fourteenth Street that takes up a few city blocks. Agent Wimpy never broke character once; he continued talking in his distinct foreign accent as we walked into the park together. "He sounds like a cross between Ronald McDonald and Krusty the Clown," one onlooker observed. I regrouped all of my agents at our meeting spot in the park, near a statue

of George Washington on horseback, and prepared everyone for phase two of our Anton Chekhov mission. In the middle of the bustling park crowded with subway commuters and hippie protesters, I set up a small table next to a sign on an easel that read BOOK SIGNING with a picture identifying Agent Wimpy as Anton Chekhov. Prior to our Barnes & Noble reading, I had purchased fifty copies of *The Cherry Orchard*, a play that many literary scholars consider to be Chekhov's masterpiece.

"This is gonna be worth a lot of money someday!"

The copies of the play cost me a mere $1.50 each. Since we were no longer welcome in Barnes & Noble, my contingency plan was to host an Anton Chekhov book signing in Union Square Park and have the Russian playwright sign and sell his books to the public for $2 a pop.

With a large stack of books in front of him, Anton Chekhov took a seat behind the table and beamed a jovial smile through his bushy beard. "Woo vould like me to sign zer play?" he asked. To generate interest, I had several agents get in line, purchase a copy of the play, and have Chekhov autograph their books. Sure enough, a line immediately formed behind the agents. The first few people who jumped into line fell for the gag completely. I

stood next to Chekhov the entire time, still acting as his literary agent. One young man insisted that Chekhov only sign his name, rather than making it out to anyone specifically. "When you die, this is going to be worth a lot of money," the young man said, starstruck to be in Chekhov's presence. Another woman in line was bursting at the seams with excitement. "I didn't think he was still *alive*!" she shrieked. "*Really!?!* This is *really* the *real* Anton Chekhov?" Her face was glowing with so much joy that I almost felt bad about assuring her that he was. Almost.

The unwitting civilians who stumbled upon Chekhov's book signing in Union Square that afternoon can be classified into four categories:

01 / Clueless people who had never heard of Anton Chekhov and had no problem believing Agent Wimpy was a famous Russian playwright.

02 / Misinformed folks who knew who Chekhov was but didn't know that he had been dead for a hundred years.

03 / Confused people who knew about Anton Chekhov but were unsure whether he was dead or alive.

04 / Well-read New Yorkers who were sharp enough to know that Chekhov is long dead and that Agent Wimpy was a fake.

People who fell into that third category were constantly badgering me with questions, trying to figure out why Anton Chekhov, who should probably be dead, was doing a book signing in a park. I gave everyone the same justification. "Well, I just represent Mr. Chekhov in New York, so I don't know his financial situation exactly, but between us, I'm pretty sure he is a millionaire," I said with a straight face. "So he's not doing this for the money. He doesn't make much off of his plays

these days, anyway. Mr. Chekhov didn't want to deal with a big corporate chain like Barnes & Noble. He just wants to meet his fans. What better way than to come right out to the park himself?"

My justification satisfied some people, but others were tougher to fool. One customer noticed that the first sentence on the back cover of the play read, "*The Cherry Orchard* was first produced on Chekhov's last birthday, January 29, 1904."

"Doesn't this mean he died a hundred years ago?" the man asked me.

"What an embarrassing typo! I'll definitely bring this to the publisher's attention," I assured him.

I relished every opportunity to talk with confused onlookers and convince them that this was, in fact, Anton Chekhov in Union Square. A middle-aged man in line approached me and very quietly began asking me questions about Chekhov's life and current living situation. I politely answered his queries and was thrilled that he seemed to be completely falling for the bit, until he coyly revealed that he was the one doing the fooling.

"So where does he live now?" the man asked.

"Mr. Chekhov recently relocated to Washington, DC."

"I see. And what is he now, two hundred? Three hundred years old?"

"Yes. About that. Two hundred or three hundred."

Whether or not they knew he was an imposter, everyone in Union Square seemed to get a kick out of seeing our "Anton Chekhov" signing copies of *The Cherry Orchard* for his fans. One man turned to Agent John Montague, one of our plants, and said, "It's pretty amazing. I mean, Anton Chekhov! The most important man in Russian literature, right here in Union Square." The man then took out his cell phone and jubilantly called a friend.

"You'll never believe who's in Union Square right now . . . Anton Chekhov . . . Isn't that weird? . . . I don't know, I'd say he's around sixty-five . . . Yeah, it's him. He has the beard and everything . . . Really? That's funny . . . Yeah. That's weird. Well, I think it was . . . nineteenth century, you think? I don't know . . . This is weird . . . Well, he's here . . . No, it's definitely him. It must have been the *nineteen* sixties . . . It only sounds old because he's Russian . . . I don't know. This is weird."

We were in Union Square for a little more than an hour, and Chekhov and his literary agent sold twenty-six autographed copies of *The Cherry Orchard*. I almost made my money back. Agent Wimpy's warm and friendly demeanor won over everyone in the park that afternoon, both those who were in on the joke and those who were completely fooled. For a guy who died in 1904, Anton Chekhov put on a pretty good show.

 the aftermath

Once in a hundred years, my lips are opened, my voice echoes mournfully across the desert earth . . .
—*The Seagull*

After his starring role in the Anton Chekhov mission, Agent Wimpy instantly became one of the most recognizable Improv Everywhere agents. After all, his bushy white beard and over-sized black horn-rimmed glasses make him fairly easy to spot in a crowd. "About two weeks after the mission, I was using the restroom at Penn Station," Agent Wimpy recalled. "A young man came up to me as I was washing my hands and shouted, 'It's Anton Chekhov!' He grabbed a friend and pointed at me. 'This is the guy who does Chekhov!' I must admit, it was flattering to get recognized in public. But it doesn't happen that often."

To this day, the employees of the Union Square Barnes & Noble remember our mission fondly. "Oh yeah, I got Chekhov'd!" Assistant Store Manager Tom Fuller said recently, recalling the incident. "It was an impressive sight to see. Working in New York City, you see a lot of crazy stuff, but that's something I won't soon forget." And down in North Carolina, Agent White, the man who thought up the Anton Chekhov mission, was equally impressed with the outcome. "I wish I could have been there to see it," he said. "I've got a framed autographed poster of Agent Wimpy playing Chekhov hanging in my bedroom. Wimpy was absolutely perfect to play the part. The whole thing turned out even better than I imagined."

 mission accomplished

objective / Enter your local bookstore claiming to be an author who has shuffled off this mortal coil. Perform a reading of the dead author's work, and then conduct a book signing for your fans.

Anton Chekhov proved to be an excellent choice for our mission—shockingly, most people believed he was still alive! Here is a list of alternate expired writers to choose from for your mission:

Christopher Marlowe (deceased in 1593) / Sure, Marlowe was stabbed to death more than four centuries ago, when William Shakespeare was still alive and writing, but I'd be willing to bet that you could fool most people into believing that this great Elizabethan playwright is still penning plays today.

Sir Arthur Conan Doyle (deceased in 1930) / Put a tweed jacket on your back, doff a houndstooth cap from your head, crack open a volume of *The Hound of the Baskervilles,* and entertain an audience with the adventures of Sherlock Holmes. Oh, and don't forget to wear a monocle.

Edith Wharton (deceased in 1937) / Although she died more than seventy years ago, Wharton keeps cropping up in modern pop culture. Martin Scorsese directed a film based on her novel *The Age of Innocence,* and in a recent season of HBO's *Entourage,* Vincent Chase considers acting in an Edith Wharton adaptation. If you choose to play Wharton, you can mention how much fun you had working with "Marty" Scorsese and Adrian Grenier.

Flannery O'Connor (deceased 1964) / This darkly comic author, who wrote *A Good Man Is Hard to Find,* might be a fun writer to pose as because of her thick Southern accent. When O'Connor, a Georgia native, went to visit her publisher in New York, her accent was so difficult to decipher that he couldn't make out a single word she was saying.

Vladimir Nabokov (deceased in 1977) / Like Chekhov, this Russian scribe (who wrote *Lolita* in 1955) would make a perfect dead author to impersonate. Some fun facts to incorporate into your performance: Nabokov wrote most of his fiction on three-by-five index cards and was an avid butterfly collector.

J. D. Salinger (still living) / So at the time of publication, Salinger—the author of *The Catcher in the Rye*—is actually still alive and living in Cornish, New Hampshire. Salinger's last book was published in 1963, he hasn't granted an interview since 1980, and he rarely ventures out in public. Staging a reading of a "brand-new" Salinger novel will be sure to cause a stir in any bookstore.

Remember, once you choose which dead author to play, fully commit to that character. And purchase a stack of thrift editions by your author to autograph during the book-signing segment of your mission. For more advice on how to pull off a successful impersonation of a dead writer in a bookstore, here's Improv Everywhere's own Anton Chekhov, Agent Wimpy, with some helpful pointers.

how to pose as a dead author

by agent john "wimpy" ward

01 / If you are not seen, it's not a scene. Say you are sitting in a bookstore reading. Not a scene. Say you are sitting in a bookstore reading aloud, sounding out hard words and asking people how to pronounce this word and that word. Scene! Part of the fun is watching the watchers trying to figure out just what they are seeing.

02 / Close but no cigar wins the cigar! Keep your performance as a dead author normal and grounded but with one oddity. You don't need the funny voice, bizarre clothes, clever patter, many collaborators, and to be a wild and crazy guy all at once. One deviation from normal will get you noticed but not immediately dismissed.

03 / It's their ball and bat and their backyard, so they get to make the rules. In our litigious society managers and secu-

rity personnel avoid overstepping their authority. Don't make it too easy for them to throw you out by breaking obvious rules. If accused of wrongdoing, politely ask that they identify and explain your violation. Push back no more than once before agreeing. Then either slide back into the same behavior again or shift to plan B. If a manager asks you not to read out loud, just say, "Okay, sorry!" Then begin telling your audience the plot of a great novel you just wrote.

04 / Ask for help. Asked by management not to read out loud, you respond by asking how to pronounce this Russian character's name. Let them be helpful and they will like you for it.

05 / Feed them a straight line. Let management look smart and entertaining in front of colleagues and customers and they will love you for it.

06 / Stay in character! Stay in character! Stay in character!
Even as the police are fitting you with handcuffs—stay in character! Think of the booking sergeant as just another bemused watcher—make him smile. Judges are nothing less than social managers—amuse and entertain them. Send them home to their friends and families with a great but puzzling story. And if worse comes to worst, think of your fellow prison inmates as perhaps the most laugh-deprived members of our society; give them what they want, give them what they need—make 'em laugh.

Fans of Improv Everywhere frequently suggest ideas about pranking television shows. In theory it sounds awesome, but it's incredibly difficult to actually get something on the air, especially if it's not live. Our heroes, the Upright Citizens Brigade, were the masters at getting their pranks on TV when they arrived on the New York comedy scene in the mid-1990s. They often visited morning talk shows, like the *Today* show and *Good Morning America,* and could be seen doing sinister things in the studio audience. They even managed to get a dildo on live television, much to the frustration of Al Roker.

Live newscasts are a great spot for TV pranks. The Rochester, New York, group the Newsbreakers have ambushed dozens of newscasts with their antics, driving to a "live on the scene" location and getting on camera doing something absurd. The Yes Men have managed to get themselves *invited* to speak on several newscasts. They trick networks into thinking they're a corporation's spokesmen, but their appearance is really a huge hoax to expose corporate greed. Veteran pranksters Alan Abel and Joey Skaggs have also fooled the media time and time again with too-good-to-be-true stories like Abel's campaign to clothe animals or Skaggs's celebrity sperm bank. Here are two pranks where Improv Everywhere invaded the wonderful world of television:

Millionaire / In 2006, Agent John "Wimpy" Ward learned that he was going to be a contestant on *Who Wants to be a Millionaire?* and he enlisted the help of his friends at Improv Everywhere to pull one over on the popular quiz show. Agent Wimpy was allowed three companions in the audience, so I formed a fictitious barbershop quartet called the Seagulls, as a tribute to the Anton Chekhov play.

I sat in the studio audience with the two other members of the Seagulls, Agents Eric Appel and Ben Rodgers. We were all decked out in candy-stripe blazers and straw hats. When Wimpy sat in "the hot seat," Meredith Vieira, the host of the show, introduced the Seagulls. We sang the word "hello" wildly off-key to Meredith. The audience had a good laugh, and Agent Wimpy ended up walking away with a cool $16,000.

Hug Patrol / Back in 2003, Fox 5 in New York asked us if they could come cover one of our missions live. Having the media show up to film a prank is generally a pretty terrible idea. It's almost guaranteed that their giant cameras will give away the joke. We decided to have some fun and stage a fake mission where the only person not in on the joke would be the Fox 5 crew. We told them we'd call ourselves the Hug Patrol and knock on random New Yorkers' doors to tell them they had won a hundred free hugs. What they didn't know was that the apartment we chose actually belonged to Agent Brian Fountain. Agent Fountain answered the door and proceeded to invite all twenty of us into his home along with the crew, and we all had an amazing time. Since this was an Improv Everywhere mission we wanted to give the crew a good experience, even if it was fake. As we were walking away the producer remarked, "Well, that couldn't have gone better if it was scripted." Indeed. The ridiculously cheesy piece aired a month later on the evening news.

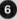

mission 6

date / february 24, 2007

number of agents / 207

objective / Freeze in place for five minutes on the main concourse of Grand Central Terminal, the world's largest train station.

The main concourse of Grand Central Terminal while frozen in time.

From the Statue of Liberty to the Empire State Building,
from Times Square to Central Park, New York City has no
shortage of iconic landmarks. But if you're visiting the Big Ap-
ple and looking for a dose of that trademark New York hustle
and bustle, you're not going to find a busier tourist attraction
than Grand Central Terminal (popularly referred to as Grand
Central Station). On any given day, more than 700,000 people
visit or travel through Grand Central. Tourists flock to see the
famous four-sided clock atop the main information booth (which

is valued at $10 to $20 million), the vast mural of the constellations on the ceiling, or the forty-eight-foot-high sculpture of the Roman gods Minerva, Hermes, and Mercury gracing the building's façade. Even though the train station is chock full of famous sites to see, most tourists simply come to witness the mad dash of commuters scurrying through Grand Central like mice on a kitchen floor. More than 120,000 commuters dart across the main concourse every day, rushing to or from one of station's forty-four train platforms (more platforms than any other train station in the world). Grand Central is so famous for the breakneck speed at which travelers hustle across its concourse that the words "Grand Central Station" are often used as a metaphor for anything that moves at a frenzied pace. This got me to thinking, *What would happen if Improv Everywhere visited the world's busiest train station, the building that is the heartbeat of New York City, and made it freeze in place?*

On a bitter cold Saturday afternoon, more than two hundred Improv Everywhere agents did just that—they made Grand Central come to a sudden and complete halt. By freezing in place at the exact same second for five minutes on the Main Concourse, our agents made everyone around them—commuters and tourists alike—stop in their tracks and observe the surreal sight of a train station frozen in time. Before most people could figure out why two hundred people were frozen in place, the agents unfroze and dispersed without acknowledging the fact they hadn't moved for five minutes.

When I posted the video of this mission online, Frozen Grand Central became an Internet sensation and a global phenomenon. Here's what inspired the Improv Everywhere freeze, a behind-the-scenes look at the infamous mission, and how the freeze craze spread like wildfire around the globe.

Most true Improv Everywhere fans know that Frozen Grand Central was not the first time I orchestrated a freeze; the original freeze took place during a mission called Slo-Mo Home Depot about one year prior to Frozen Grand Central. For Slo-Mo Home Depot, I planned to have a large group of agents shop in slow motion for five minutes in a Home Depot. I had wanted to try a mission that either slowed down or stopped time just because it seemed like an absurd thing to do. I picked Home Depot because they had just opened their first store in Manhattan, and I figured, *Why not have some fun in this ridiculously huge store on our tiny island?* Also, I just liked the way Slo-Mo Home Depot sounded.

I had a hunch that a big group of agents might turn up to do some slow-motion shopping, so I wanted to think of one more fun thing for the agents to do. The first thing that popped into my head was, *Why not have everybody just freeze in place for five minutes?* It seemed like a pretty simple idea, and it would be sure to get a reaction from Home Depot's employees and shoppers.

On the day of Slo-Mo Home Depot, 225 agents assembled outside the huge store in midtown Manhattan to help pull off the mission. Everyone synchronized his or her watch so they would know when exactly to start shopping in slow motion and when to begin freezing in place for five minutes. Our plan was to shop in slow motion for five minutes, then walk around at a normal pace for five minutes—tricking everyone into thinking that our little stunt was over—and then, bang!—we'd surprise them with the five-minute freeze.

We entered the home improvement superstore, and soon after, the agents began the slow-motion shopping segment of the mission. As I had hoped, it looked surreal to see our agents skulk around the store at a snail's pace. After five minutes of slo-mo shopping and five minutes of regular-speed browsing ended, everybody froze in place as planned. Shoppers laughed and gawked at the spectacle of a Home Depot populated with human statues. Shortly after the agents froze, by some freaky coincidence, Home Depot's sound system began playing the soft-rock song "Standing Still" by Jewel. Other than the Jewel song piping through the store's speakers, Home Depot became deathly quiet during the freeze. I never stopped to think that 225 people frozen in place are *a lot* quieter than 225 people moving around and talking. Seeing the mess of frozen agents was far more impressive than I anticipated.

After the mission ended, dozens of agents approached me and gushed about how much fun they had during the freeze and wanted to know if I had hacked into the store's sound system and played that Jewel song. I assured everyone that I had no part in playing "Standing Still" during the freeze—that was just serendipity—and that I also thought freezing in place was really fun—so much so that I wanted to do it again.

I scoured New York City looking for a location to do another freeze. Times Square seemed like it might work for a mass freeze—it is extremely recognizable and the hordes of tourists who hang out there would surely be startled by our stunt. Ultimately, I ruled it out because the taxi traffic that rips through Times Square would make the mission too hazardous. Then I thought about having our follow-up freeze at Rockefeller Center, but the plaza outside 30 Rock didn't seem big enough for what I wanted to pull off. The third location I considered

was Grand Central Terminal. Envisioning two hundred or so frozen agents on the main concourse of the world's most famous train station seemed like it would be impressive enough to stop any tourist or commuter in their tracks.

One of the best parts of hosting a freeze mission is that it doesn't require any elaborate planning. Once our location was secure, I sent out an e-mail to all of my New York agents:

Agents,

Our next mission will take place this Saturday at 2 p.m. You must bring a watch with a second hand (or a digital watch that displays seconds). We are going to synchronize our watches for the mission, and it's important that we sync up to the exact second.

Do not bring any type of camera. This mission, as all IE missions, should be participatory. We do not need any photographers, videographers, or members of the media. Only show up if you are ready to participate and have fun!

This transmission is intended for IE Agents only. Feel free to bring friends. Please do not forward this message or blog about this event before it occurs. This should be tons of fun. Everything will be explained at Bryant Park, our meeting point.

Thanks!

Agent Todd

Bryant Park is located behind the Public Library on Forty-second Street, just a couple blocks west from Grand Central. It was an extremely cold Saturday afternoon, but thankfully a

little more than two hundred agents showed up to participate—about the same number as for Slo-Mo Home Depot. As soon as everyone had arrived, I hopped up on the edge of a fountain and addressed the crowd with a megaphone.

"All right, thanks for coming out, everybody," I said. "I'm really excited that you all are here because we've got a really cool mission to do today. We're going to be freezing in place for five minutes down the street at Grand Central. We need time to set up hidden cameras, so we're going to start the freeze at two thirty. At two thirty-five, I want everyone to unfreeze and move around for five minutes. Then at two forty, I want everyone to freeze again for another five minutes. After that, simply unfreeze and do not acknowledge other agents. If onlookers ask you what you were doing, just say, 'I don't know what you are talking about.' Then just leave the station."

I had all 207 agents synchronize their watches, and then they dispersed and left Bryant Park. I wouldn't see them again until the freeze was under way. After my briefing, I hurried over to Grand Central with my camera crew. By two P.M., all of the hidden cameras were in place—some of the photographers were stationed on the balcony and others would roam the concourse with hidden cameras peeking out of holes in rolling suitcases. During the freeze, I wanted to walk around and solicit reactions from onlookers. About fifteen minutes before the freeze was scheduled to begin, I noticed agents trickling into the station. A mass of familiar Improv Everywhere faces were milling around the main concourse, but none of them were acknowledging each other. Some agents were looking at a newspaper, others were asking for directions to a particular track, a few were strolling around the station with their significant other, and some were in the middle of eating

a snack. The throng of commuters was moving at its usual lightning-quick pace across the concourse. I kept my eye on the great gold clock in the middle of the concourse, and when the minute hand struck two-thirty, the blur of people whizzing through the station came to a sudden stop.

⏸ the mission

Even after all of the planning that went into the Grand Central freeze, seeing it actually happen was remarkable. It must have been shocking for tourists and commuters to see hundreds of people hustling across the concourse one second and then, in a flash, see time stop for more than two hundred of them. When I saw the freeze happen, it looked like somebody hit the pause button on a DVD player. Not only did our agents completely freeze, but everyone else around them stopped and tried to figure out what was going on. The eeriness of the situation was magnified by the dramatic silence that fell over the train station. It was amazing to see the massive, noisy main concourse enveloped by absolute quiet.

Much of the humor in Frozen Grand Central came from what the agents chose to do as they froze. One agent dropped a stack of papers and bent over to pick them up as he froze. Two agents froze during a kiss for the entire five minutes. Many agents were checking train schedules. Others were looking at their cell phones. Eating was probably the most popular activity to do while freezing; one agent froze while munching on a hot dog, another while eating a cookie, and another while eating yogurt. After the mission, Agent Jesse Good regretted his decision to freeze midbite while eating an apple. "I thought it would look funny, which it did," he said, "but I didn't anticipate the

juice from the apple running down my chin and my arm for five minutes. I even noticed that my apple starting browning by the end of the freeze. It was pretty gross."

As I walked around poking and prodding at frozen agents, the reactions I solicited from random passersby ranged from amusement to shock at the still-life scene they were witnessing. "The onlookers in Frozen Grand Central were fairly similar to spectators in other Improv Everywhere missions," Agent Todd

This frozen couple stayed lip locked for the entire five minutes.

Simmons, observed. "They couldn't decide whether we were crazy or if they had gone crazy."

Agent Simmons helped cause one of the most chaotic moments in the freeze by coming to a halt directly in the path of a motorized maintenance cart that was trying to cross the concourse. "I had a train schedule in my hands and I was frozen while staring at it," Agent Simmons remembered. "I didn't mean to do it, but I froze in the path of that maintenance cart. The guy driving the cart kept beeping his horn at me, trying to get me to move, but I wasn't budging. He must have thought I was the most self-absorbed commuter in the world. That cart driver was clearly exasperated with me just standing there in

front of him." Fortunately, the cart driver was stopped by Agent Simmons and other agents with only about half a minute left to go in the mission, so we unfroze and were out of his way before he got too frustrated.

As the freeze kept going and going, visitors to Grand Central were clearly having just as much fun with the prank as we were. Total strangers started talking to each other, trying to figure out what was going on. Some hypothesized that we were

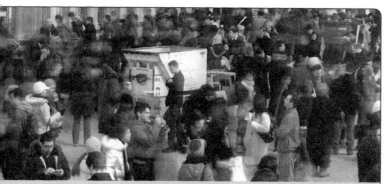

Maintenance carts were unable to cross the concourse due to the mass of frozen agents.

a drama class; others thought it was a protest. Several tourists took out cameras and snapped photographs of the frozen agents. These onlookers didn't seem to realize that when you take a picture of a frozen person, nothing will seem out of the ordinary in the picture. With hidden microphones tucked into our shirts, several agents joined me as we walked around and struck up conversations with witnesses to our stunt. I spotted one man staring at an agent who was frozen while checking a text message on her cell phone.

"This is crazy, isn't it?" I said.

"You're tellin' me! I've never seen anything like this. They're just frozen!" he said.

"Look at that lady with her cell phone. I bet you could just walk up and take it out of her hand," I said.

"You know, I bet I could," the man said and laughed.

"Go for it," I said. "She's not moving. Just see if you can pick it up and put it back in her hand. I'll bet you she won't move."

The man tiptoed over to the agent and slowly took the cell phone out of her hand and then put it back. The agent never

How many frozen agents can you spot?

batted an eyelash. The man walked back over to me and started laughing uncontrollably.

"That was insane!" he said. "I can't believe she didn't move!"

As the freeze was nearing its conclusion, I noticed a few police officers stationed at an NYPD recruitment booth harassing Agent Good (who still had that half-eaten apple in his hand). They were shouting at him and waving their hands in his face, trying to get him to move.

"I'm gonna crack apple guy! He's gonna break!" one of the cops shouted.

Then, without notice, the freeze ended and Agent Good abruptly walked away. This startled the cops.

"Whoa!" the cop shouted. "Oh my God, he's moving!"

I approached these police officers at the recruitment booth to get their reaction.

"Do you know what that just was?" I asked.

"I have no idea! That is the craziest shit I have ever seen . . . *and I'm a cop*!"

Our video of Frozen Grand Central has been viewed on the Internet by millions of people around the world, but one part of the mission isn't included in the video. As I mentioned earlier, I wanted to do two freezes back-to-back at Grand Central. In the Internet video, you only see the first freeze. When the first freeze ended, all of the onlookers erupted with thunderous applause and cheers. Many of them accosted our agents, asking, "Why were you frozen? Tell us!" The agents never broke character and simply responded by saying, "I have no idea what you are talking about." After five minutes of this chaos and confusion on the concourse, without notice, the agents froze again. The spectators on the concourse let out a collective groan; before they could figure out what was going on it had happened again. After another frozen five minutes, the 207 agents unfroze and received an even louder ovation from the hundreds of spectators. As the applause died down, the agents walked out of Grand Central Station without acknowledging each other or anyone else.

ⓘ the aftermath

Frozen Grand Central was an exhilarating mission, but I definitely wasn't prepared for the overwhelmingly positive

reaction the prank received when I posted the video online in January of 2008. Within days of putting the video on YouTube, I was inundated with requests to re-create Frozen Grand Central around the world. Many people who watched the video thought our mission was some sort of political commentary or a statement on the human condition (it's not—it's just a scene of chaos and joy like all of our other missions). The number of views the video received online rocketed far past all of our other missions. Only two weeks after I posted the video, a thousand Londoners gathered in Trafalgar Square to re-create the freeze (without our help). It was flattering to receive so much attention for what I consider to be our simplest mission.

Soon after the Frozen Grand Central video started getting millions of hits on the Internet, the producers of the *Today* show on NBC contacted me. They wanted Improv Everywhere to conduct another freeze on air outside their studio, in the plaza of Rockefeller Center (one of the sites where I originally wanted to do the freeze). I hemmed and hawed over whether to accept their offer; I almost always turn down media requests for Improv Everywhere to re-create missions (usually it's because some reporter will want to interview me about our No Pants! Subway Ride while I'm in my boxers). I was about to say no, but then I thought, *What if we pulled a prank while we were on the* Today *show?*

On YouTube, dozens of people noted in the comments section of the Frozen Grand Central video that if they were present during the mission, they would have robbed one of our agents. It was funny to see how many people had that reaction after watching the video, though I doubt any anonymous commenter would actually have the guts to commit robbery. It also seemed like something I could incorporate into the *Today* show freeze to turn the tables and prank the popular morning show. After coming up with a plan for an auxiliary prank involving a heist,

I called the *Today* show producers and said that Improv Everywhere would be delighted to do a freeze on the air.

On the morning of our *Today* show appearance, the producers told me that I was going to be interviewed inside the studio while our twenty-five agents froze outside on the plaza. Without telling anyone who worked at the *Today* show, I instructed Agent Jamey Shafer to stand outside and pretend to be a spectator watching the frozen agents. During the freeze, while cameras would be rolling live on national television, Agent Shafer was going to run up to a frozen Agent Ken Keech, rifle through his pockets, and run off with his wallet. Who knew what would happen next? Maybe NBC's security guards would chase Agent Shafer around the plaza? Maybe seeing a crime committed on live television would stir up a ruckus in the studio? It seemed like the perfect plan to cause a scene of chaos.

With twenty-five agents frozen in place outside the studio, my interview on the *Today* show began. The interview was going swimmingly, but I was waiting on pins and needles to see if my segment would be interrupted because one of our agents was robbed while frozen. The interview flew by quickly, and soon enough I was being thanked for coming on and then ushered out of the studio. As I stood in the *Today* show's greenroom post-interview, I was left to wonder, *Did Shafer and Keech not pull off the prank?*

It turned out that Agents Shafer and Keech executed the prank perfectly. Agent Shafer crept up behind Agent Keech, snatched his wallet, held it up for all to see, and bolted off the plaza in plain view of NBC security, the producers, and the cameramen. Unfortunately, the prank was not captured on camera, and the security guards and other NBC staff didn't seem to mind that one of our agents had just been pickpocketed. Even though Agent Shafer's robbery wasn't broadcast from coast to coast, having a

group of agents appear on the *Today* show was fun, and we still got a pretty good laugh out of our pickpocket prank.

A few months after Frozen Grand Central exploded on the Web, I was invited to host a freeze at the Futuresonic Festival in Manchester, England. I was concerned that I might start getting known as "the freeze guy," but so long as the freeze guy gets to travel to cool places around the world to organize freezes, I'll always be happy to make the trip. One night while I was in Manchester, I started getting flooded with e-mails and text messages. Most of them said something to the effect of *You're on Law & Order!!!* These messages struck me as strange, because I didn't recall ever appearing on an episode of *Law & Order,* which is something that I'd probably be able to recall.

As it turned out, I wasn't actually on the long-running crime drama, but that week's episode of *Law & Order: Special Victims Unit* featured a fictional group of New Yorkers that staged massive public events very similar to the ones staged by Improv Everywhere. The leader of the group, played by Robin Williams (*the* Robin Williams, of *Dead Poets Society* and *Good Will Hunting* fame), committed a murder and was loosely based on me (except for the murder part). In the climactic scene of the episode, Robin Williams is arrested in the middle of a freeze at Grand Central. *Law & Order* re-created several shots from our video: they depicted a frozen woman eating a cup of yogurt and a frozen man bending over to tie his shoe. The one difference between their Frozen Grand Central and ours is that they had Mo Rocca (formerly of *The Daily Show*) standing on a stepladder and shouting "No sheep!" at everyone on the concourse; I can personally guarantee that we will never have anyone yelling "No sheep!" at our agents during a mission. The producers of *Law & Order* never contacted us before or after this episode aired, but it was flattering that they used one of our missions

in a plotline, even if the leader of the prank group was a killer. When the Emmy committee nominated Robin Williams for his performance as the deranged leader of the prank group, I was rooting for him to win, but I was also kind of relieved when he lost. The last thing I want Improv Everywhere to be associated with is homicide.

The response to Frozen Grand Central has been truly unbelievable. The video has been viewed more than sixteen million times on YouTube, and in addition to the *Today* show, the prank has also been covered on *Good Morning America* and numerous news outlets around the world. But the most remarkable impact of Frozen Grand Central is that it has inspired people in nearly 200 other cities in dozens of countries to stage their own freeze missions. Thousands of global agents worldwide in places like Romania, Poland, Italy, China, Sweden, South Africa, and New Zealand have come together to make time stop for five short minutes. Here is a list of every city where a Frozen Grand Central–style freeze was re-created in the first six months after I posted our video on the Internet:

Afton, Wyoming	Bogotá, Colombia
Arcadia, California	Boston, Massachusetts
Arhus, Denmark	Bratislava, Slovakia
Atlanta, Georgia	Brisbane, Australia
Barcelona, Spain	Brno, Czech Republic
Beijing, China	Brussels, Belgium
Beirut, Lebanon	Calgary, Canada
Berlin, Germany	Chicago, Illinois
Berne, Switzerland	Coimbra, Portugal
Bielefeld, Germany	Constanta, Romania
Blacksburg, Virginia	Copenhagen, Denmark
Bloomington, Minnesota	Dublin, Ireland

Durham City, UK	Petrozavodsk, Russia
Edina, Minnesota	Portland, Oregon
Edinburgh, UK	Prague, Czech Republic
Erlangen, Germany	Pretoria, South Africa
Florence, Italy	Quebec City, Canada
Helsinki, Finland	Raleigh, North Carolina
Hong Kong, China	Riga, Latvia
Kuala Lumpur, Malaysia	Rome, Italy
Lausanne, Switzerland	San Diego, California
Leszczynski, Poland	San Francisco, California
London, UK	Santa Barbara, California
Los Angeles, California	Seattle, Washington
Luxembourg, Luxembourg	Shanghai, China
Madrid, Spain	Shreveport, Louisiana
Malmö, Sweden	St. Andrews, Scotland
Manchester, UK	Stockholm, Sweden
Manila, Philippines	Sydney, Australia
Mexico City, Mexico	Tel Aviv, Israel
Minneapolis, Minnesota	Tokyo, Japan
Montreal, Canada	Toronto, Canada
Newcastle-upon-Tyne, UK	Utrecht, Netherlands
Nuremburg, Germany	Vancouver, Canada
Orlando, Florida	Vienna, Austria
Oxford, Ohio	Wellington, New Zealand
Paris, France	Zurich, Switzerland

Part of the global success of this mission is due to the lack of language involved—freezing in place in public is funny no matter what your native tongue happens to be. It's remarkable that freezes have taken place in both Tel Aviv, Israel, and Beirut, Lebanon—two regions that have been warring for decades. And if you take a close look at that list of cities, you'll note

that freezes have taken place in North America, South America, Asia, Europe, Africa, and Australia. Only Antarctica, the *frozen continent,* has yet to host a freeze. Get to it, arctic explorers!

It's crazy to think that a harmless mission in a Home Depot has grown into a worldwide prank with thousands of people of all ages and races, from Beijing to Bogotá, participating in the fun.

 mission accomplished

As tens of thousands of global agents have shown, getting together with a group of your friends to hold a freeze mission is guaranteed to cause a scene. Here are a few steps to ensure that your freeze will be as cool as Frozen Grand Central:

01 / Location, location, location! Choose a highly visible and heavily trafficked site for your freeze mission. Bustling areas look bizarre when they come to a screeching halt. Some good locations that global agents have used for freezes in the past are shopping malls (as in Beirut, Lebanon; Pretoria, South Africa; and Toronto, Canada), public plazas (London, England; and Seattle, Washington), school campuses (Virginia Tech and Carson High School in Carson, California), and train stations (Stockholm, Sweden; Riga, Latvia; Rome, Italy; and, of course, New York City).

02 / Recruit your agents. Send out an e-mail to all your friends inviting them to join in on the fun. If any of your agents get antsy easily or have a tendency to laugh, tell them a freeze might not be the mission for them.

03 / Practice makes perfect. Before Frozen Grand Central, Agent Jesse Good went to a bar and practiced freezing for five minutes to warm up for the big event. "The bar patrons were slightly annoyed, but I'm glad I got that practice time in," Agent Good said. "Freezing is not as easy as it looks."

04 / Synchronize your Swatches. On the episode of *Law & Order: SVU* where they imitated Frozen Grand Central, comedian Mo Rocca blew a whistle and shouted, "No sheep!" through a megaphone to initiate the freeze. I prefer to have agents synchronize their watches at a meeting place beforehand and agree on the time when the freeze will start.

05 / Freeze! When you and your agents arrive at the freeze site, make sure you're not standing in a cluster. Spread out, and when the time arrives: *freeze!* Pick something creative to do while freezing, and kudos to anyone bold enough to freeze while waiting in line for something.

06 / Evacuate the premises. When the freeze concludes, have all of your agents leave without acknowledging each other. It's great if the onlookers applaud, but don't give yourselves a round of applause. If anyone asks why you and your friends were frozen, look confused by the question and say, "I'm sorry, I have no idea what you are talking about."

how to freeze properly

by agent cody lindquist

It may seem simple, but freezing in place can be physically and mentally exhausting if you don't plan ahead. Here are some things to help you keep your mind and body focused.

01 / Choose your position carefully. Don't try to do anything too physically strenuous. If you pause holding something heavy or even smiling too wide, you could end up in a lot of pain the next day. And trust me, there is nothing more embarrassing than being sore from *not* moving. If you are lazy, like me, I recommend trying the "Oops, I just dropped something on the floor and I better kneel down to get it" pose. This one is easy on the muscles.

02 / Use your location. If you are in a train station, stand in line to buy tickets or freeze while trying to open a door. If

someone has to awkwardly maneuver themselves around you, then you have succeeded.

03 / Use props. Props look cool. Just holding your arm up is boring, but freezing while putting on lipstick is awesome. Props make the difference and they also give passersby something to touch other than your body.

04 / Be aware that strangers will touch you. When this happens just stay still! People are like bears; if you play dead, eventually they will get bored and move on to someone else.

05 / Act natural. There is a reason you never see statues in an art museum giving a thumbs-up or playing air guitar. It's crazy enough to be frozen in public; you don't need to do anything else to stand out!

Over the years we've been invited to bring our missions to different places around the world. It's always a blast to have a new city to brainstorm ideas for, and seeing a new place for free is something we can't turn down. Here are some of our favorite missions we've done outside of New York.

Free Snow Cones / In March of 2006 we were invited to the U.S. Comedy Arts Festival in Aspen, Colorado. Agent Chris Kula and I were charged with causing a few scenes while we were in town. Walking around on our first day we noticed an enormous mountain of disgustingly dirty snow. We instantly knew what we had to do. The next morning we set up a sign proclaiming Free Snowcones and handed out the three available varieties: chocolate, vanilla, and "swirl." Amazingly, a couple of Aspen locals played along and actually took bites out of the dirt-filled globs of snow.

Meet a Black Person / While at the same festival, Agent Kula and I realized that there were almost no black residents in Aspen. We enlisted our friend Colton Dunn, another comedian in town for the festival, to set up a show in a Meet a Black Person booth. We hijacked an abandoned hot chocolate stand and threw up our sign inviting Aspen residents to meet an actual black person. People stopped and shook Agent Dunn's hand, and more than a few asked if they could pose for a photo.

Swimming Pool Poker / In November of 2006 Agent Kula and I went to the Comedy Festival in Las Vegas to give a live presentation about Improv Everywhere. They asked if we could also execute a mission, so we went and bought a $50 poker table

and threw it in the pool at Caesar's Palace. We got a few local Improv Everywhere supporters to come out and play the roles of dealer, player, and cocktail waitress. It was hilarious to see the waitress wading though the pool in high heels as the cards floated away from the table.

Furniture Store Sleepover / In September of 2008 I traveled to Russia for two weeks with an artist exchange program. I collaborated with a group of students in the northern town of Petrozavodsk. Our favorite mission from the trip involved twenty students infiltrating a furniture store one by one and falling asleep on the beds. The babushkas running the store had a fit. Though laughing to each other, they went around the store screaming, "This is not a hotel!" and banged on the beds to "wake" everyone up. They even called the cops. It was a little terrifying to be standing in the corner with a hidden camera as the Russian police busted in on the scene. Fortunately no one got in trouble.

mission

date / july 24, 2004

number of agents / 26

objective / Perform a synchronized swimming routine in Washington Square Park's fountain (which is only four inches deep).

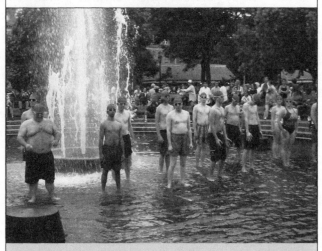

The New York City Synchronized Swim Team in Washington Square Park's fountain.

In the summer of 2004, the Olympic Games returned to their birthplace in Athens, Greece, for the first time in more than a century, and like everyone else, I got swept up in the excitement. Who could blame me? The Olympics are a celebration of athletic competition and goodwill between nations. From track and field to boxing to gymnastics, the Summer Olympics display the finest athletes from around the world competing in the most challenging sports. Yet as I watch all of the grueling Summer Olympic competitions every four years on television,

I always scratch my head and wonder, *How exactly did* synchronized swimming *become an Olympic sport?*

For those of you unfamiliar with synchronized swimming, it is a sport that combines elements of swimming, gymnastics, and dance; for many years, it was elegantly called water ballet. In Olympic competition, teams of female swimmers wearing matching swimsuits, swim caps, and goggles perform elaborate routines in swimming pools, accompanied by music. Afterward, a panel of judges scores their performance on a scale of one to ten. Depending on how you look at it, synchronized swimming is a display of either beauty or absurdity. Since absurdity is something that Improv Everywhere specializes in, I figured that a synchronized swimming routine performed in a public fountain would be the perfect way to bring the Olympic spirit to the people of New York City. Let the games begin!

 the plan

As soon as I thought about doing a synchronized swimming routine in a public place, I knew the perfect venue for the mission: the fountain in Washington Square Park. Located in the heart of Greenwich Village, Washington Square Park is central to NYU's campus and is always bustling with students, political activists, chess players, folksingers, break-dancers, and tourists. The gigantic fountain in the middle of the park only runs in the summer, and even then it's usually empty due to persistent maintenance problems or drought conditions. For a long time, I thought the empty fountain would be an ideal stage for an Improv Everywhere mission. I designed several missions specifically to be carried out in the fountain, but they always had to be relocated because another group had already been

performing in the fountain's drained pool. You have to wake up pretty early in the morning to lay claim to the empty fountain, and Washington Square Park's tireless teams of break-dancers always seemed to get there before us. Eventually, I came to the realization that the only time I'd get to use the fountain for a mission is when it was full of water. Just the idea of a fully choreographed synchronized swimming event in Washington Square Park's enormous murky fountain made me laugh.

During the mission, I wanted to have an agent play the coach of the synchronized swimming team. I would have gladly played the part myself, but I thought I should probably play one of the swimmers. The water in the fountain looks like a combination of sewage and toxic sludge; I wanted to participate as one of the swimmers and get just as dirty as everyone else. So to play the role of the "coach" of the synchronized swimmers, I cast my friend and old college roommate, Agent Ken Keech. I also charged him with the task of choreographing the swimmers' dance routine.

"Even though I was asked to choreograph the Synchronized Swimming mission, I had Agent Vanessa Rose, who was my girlfriend at the time, design the routine," Agent Keech admitted. "I was also asked to do the choreography for the Megastore mission. I have no idea why I am Improv Everywhere's official choreographer. I know absolutely nothing about dance."

Before choreographing the dance moves, we needed to choose a song to accompany the routine. We decided on the anthem "Come Sail Away" by Styx. "We chose it because it's this really triumphant song," Agent Keech explained. "It has this slow buildup. If you close your eyes while listening to it, you'd probably imagine synchronized swimmers popping out of a swimming pool . . . so I guess it's not really *triumphant,* per se."

While agents Rose and Keech planned out the synchronized swimmers' dance routine, I scripted the plot of our performance. Unlike other Improv Everywhere missions, our Synchronized Swimming routine was going to be solely for the enjoyment and entertainment of any onlookers in the park—we weren't going to try to fool anyone. I assembled fifteen agents to play the swimmers (I would join them, making a team of sixteen) who were all members of the "New York City Synchronized Swimming Team" (no such team, to my knowledge, actually exists). Agent Keech would play our coach, and Agents Flynn Barrison, Brandon Calhoun, and Katie Dippold would play a panel of judges. Before the NYC Synchronized Swimming Team would perform, I wanted "Coach" Keech to explain to the audience that we were trying to qualify for the Athens Olympics and the judges were there to tell us if we made the cut. "The arc of the story followed a sports movie," Agent Keech noted. "Just like in *Bad News Bears* or *The Mighty Ducks,* we were presenting ourselves as a ragtag group of athletes trying to obtain an impossible goal."

On the morning of the mission, all of the agents gathered at our meeting point in Union Square, just a few blocks north of Washington Square Park. I instructed the team on how to field questions from spectators. If anyone asked them, "Aren't synchronized swimmers only women?" they were to answer, "Not anymore." If an onlooker asked, "Aren't synchronized swimming teams made up of eight members?" they were told to say, "Not this year." And if someone asked, "Why on earth are you performing in a public fountain?" everyone was instructed to answer, "All the public pools in town are being used today."

After I gave a brief pep talk to the agents, Agent Rose and Coach Keech began our rehearsal. With a little boom box

blasting "Come Sail Away" and a tree standing in for the fountain, we practiced our routine with enthusiasm. Coach Keech and Agent Rose barked out directions as we circled around the tree. "Right hand up! Two! Three! Four! Left hand up! Two! Three! Four!" Passersby gawked at us as we danced to Styx while wearing swim caps and street clothes. It must have been a truly bizarre sight, but it was nothing compared to what was about to come.

As we started walking down to Washington Square Park, I received a call from Agent Nate Shelkey. "I was doing some light reconnaissance in Washington Square Park beforehand," he recalled. "There were some buskers right by the fountain with a huge crowd, probably more than a hundred and fifty people. I called in this information to the swimmers and then waited at our rendezvous site. As I sat on the edge of the fountain, I immediately overheard someone talking about what would happen if someone went swimming in the fountain. I remember thinking, *Well, you're about to find out!*"

Agent Shelkey's reconnaissance report was accurate. When we got to the fountain, there were approximately 150 people watching Tic and Tac, a break-dancing duo, perform about thirty feet from the fountain, which was full of dirty water that was shooting ten feet in the air. We didn't want to interrupt their show, so we watched the break-dancers' grand finale for a few minutes. When it was clear that their "grand finale" was probably going to last half an hour, I decided that it was time for the New York City Synchronized Swimming Team to perform. Our sixteen swimmers gathered on the north side of the fountain and stripped down to their suits. With everyone's red swim caps and goggles firmly in place, we formed a single-file line. Our panel of judges stood just

outside the pool. Coach Keech used a megaphone to address our audience.

"Ladies and gentlemen!" he announced. "The New York City Synchronized Swimming Team is about to perform in their Olympic trial. The team must beat a score of twenty-seven, set by another team yesterday, to qualify for the Athens Olympics. Please join us in cheering them on!" The large crowd of onlookers slowly turned away from Tic and Tac and focused

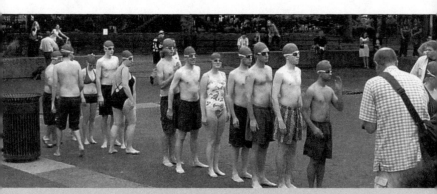

The swimmers line up and wait to enter the fountain.

their attention on the group of "synchronized swimmers" who were now wading their way into the germ-infested waters of the Washington Square Park fountain.

⓫ the mission

In front of a befuddled mix of tourists, students, chess players, and break-dancers, the New York City Synchronized Swimming Team splish-splashed their way into formation. "A-one-two-three-and-four!" Coach Keech shouted through his megaphone, and our well-rehearsed routine was under way. The soothing, piano-plinking opening of Styx's six-minute opus

blasted from the little boom box. Our audience of 150 strangers initially seemed confused.

"There was a moment of puzzlement and quiet as the crowd tried to discern what the hell we were doing in the fountain," Agent Maggie Kemper, one of the swimmers, recalled. It took our audience several seconds to register the joke, but once they did, they were fully supportive and cheered on our performance. Agent Dominic Dierkes, one of the youngest members of the

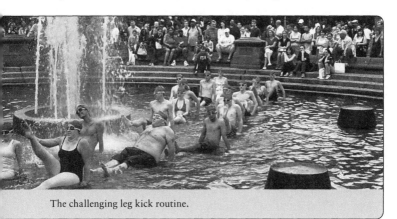

The challenging leg kick routine.

team, was feeding off the audience's enthusiasm while facing some personal fears. "I was self-conscious about being in a bathing suit in the middle of NYU's campus," he said. "I was still attending NYU at the time, and I was positive someone was going to spot me and mess up the mission. After spending several summers in that park and seeing many a homeless person take a bath in that fountain, it's a wonder I didn't develop some sort of disease."

For people in the park, our bizarre Olympic display caused quite a scene. We had sixteen exuberant synchronized swimmers splashing around in unison in a public fountain, an inspirational coach decked out in a blue sport jacket who was spurring us on,

a panel of three stern-faced judges closely scrutinizing our every move, and a huge crowd of strangers cheering us on, hoping that we would "make it to the Olympics." Most of the onlookers bought the joke and were enjoying every minute of it.

"If you walked by the fountain and watched us, you probably wouldn't think, *Ah yes, those must be Olympians,*" Agent Keech said, laughing. "We had synchronized swimmers of all shapes and sizes. It just looked really silly." Everyone seemed to be enjoying the spectacle, except for one humorless man who tried to spoil the fun. "Boo! This is fake! Boo!" the killjoy shouted at us from the edge of the fountain. Everyone, performers and spectators alike, ignored the heckler, and soon the cheers of the audience drowned him out.

As the momentum in "Come Sail Away" built up to a crescendo, so did the energy in our performance. After doing the backstroke in the water, we circled the fountain and ran toward it with our hands in the air. "Worship the fountain! Worship it!" Coach Keech directed. The audience howled with delight. As with all of Improv Everywhere's missions, the success of Synchronized Swimming hinged on being committed to our characters and keeping a straight face. For the entire performance no one dropped out of character, but some swimmers had a hard time fighting off the giggles. "I wanted to laugh so hard, but everyone was so committed," Agent Kemper said. "The routine was so absurd, especially since our movements mirrored what an actual synchronized swimming team would do, except our arms and bodies were wildly flailing around in the water. It gave me a giddy feeling."

At the end of our routine, the audience (which had swelled up to about two hundred spectators) went wild. After the applause died down, Coach Keech grabbed his megaphone and addressed the crowd. "Ladies and gentlemen, the fate of the

New York City Synchronized Swimming Team now rests in the hands of the judges. In order to compete in the Olympic Games in Athens, Greece, this summer, we need a score of at least twenty-seven." A hush fell over the crowd. The swimmers, still standing in the fountain, held hands in anticipation of the scores. Agent Calhoun, who played the first judge, wrote a number on a card and then revealed it to the audience. "It's a nine!" Coach Keech shouted. Everyone cheered. Agent Dip-

The synchronized swimmers flawlessly execute their triumphant finale.

pold, the second judge, held up her scorecard. "It's another nine!" Keech said. "That makes eighteen. We need a ten to advance to the Olympics." At this point, the crowd was putty in our hands. The audience began chanting, "Ten! Ten! Ten! Ten!" Agent Barrison slowly wrote down his score and then held it up for all to see. "It's a ten!" Coach Keech screamed. "We're going to Athens!"

The audience roared with approval, the swimmers rejoiced by splashing around in the water, and our boom box triumphantly blasted "We Are the Champions" by Queen. "My favorite moment was definitely the celebration after our victory," Agent Matt Shafeek said. "We knew we were go-

ing to win, but we weren't instructed to do anything beyond 'celebrate.' So we all just went absolutely crazy. We jumped around and we hugged." Coach Keech stood just outside the fountain and beamed with pride at his swimmers' performance, but we wanted him to get in on the celebration, too. A group of the swimmers picked up our fully clothed coach and dunked him in the slimy water. The spectators went even crazier with delight. "Coach Keech played it totally straight," Agent Shafeek said. "He resisted just long enough before finally coming in that disgusting fountain with us. That ending made it memorable for everyone."

As Coach Keech dried off after the celebration, a man from the audience approached him. It was the heckler who was booing vociferously throughout our performance. "You know, at first I thought this was total crap," the heckler said, "but then I saw how much work you put into it. You guys are okay. That was really funny."

"Thanks," Coach Keech said. "I really appreciate that. It was a lot of hard work. But what I've been trying to tell my athletes is that it's going to require even more hard work and dedication to get that gold medal in Athens." The heckler then shook Coach Keech's hand, wished him well, and walked away looking slightly confused and very amused.

⦿ the aftermath

While toweling off outside the fountain, the New York City Synchronized Swimming Team was mobbed by scores of onlookers who were curious and looking for answers. Our intention wasn't to fool anyone with this mission, but surprisingly, our routine befuddled dozens of our spectators.

"You filming a skit for *Saturday Night Live*?" one man asked, perhaps thinking of the classic synchronized swimming *SNL* sketch from the 1980s starring Christopher Guest and Harry Shearer.

"No, we had to have an official trial to qualify for the Olympics in Athens," I replied.

"If you are practicing for the Olympics, you should really try and find a more suitable pool," another onlooker told me.

"Okay, I'll make sure to do that," I said. "Unfortunately, all of the public pools were booked today."

After participating in numerous Improv Everywhere missions, Agent Keech now lives in Syracuse, New York, and works as a middle school teacher. "Sometimes I'll show my students the videos of missions like Synchronized Swimming, and they get a real kick out of seeing Mr. Keech doing some of the ridiculous things I did as an Improv Everywhere agent," he said. "But I also remember this mission fondly because at the time I had just started dating Agent Rose. I was really nervous about telling her that I participated in Improv Everywhere, because it's a little bit insane, you know? But when I told her about it, and I told her about this mission, she was like, 'Let's do it!' She was just as excited to do this mission as I was, and she helped out with all the choreography. It's rare to find a girl that's cool with being ridiculous—that's when I knew she was really special. And, you know, we're married now, so it all worked out."

Synchronized Swimming succeeded because we simply set out to put on a good show and ended up giving a huge crowd of onlookers a great story to tell. As we were preparing to

leave Washington Square Park, with everyone still in character as a swimmer, a judge, or a coach, an older man approached our group. "Great work! You kids make me proud to be an American," he said. "Bring home the gold!" The New York City Synchronized Swimming Team never actually made it to Athens, and the actual USA Synchronized Swimming Team ended up with the bronze medal that year; but on that afternoon in the fountain, Improv Everywhere's agents definitely gave a gold-medal performance.

 mission accomplished

how to deal with dirty water

by agent susannah becket

01 / Don't think about the water. Or, more specifically, don't think about what other liquids might be mingling with the water. Whether you're dancing in a fountain, swimming in a rarely cleaned public pool, or snorkeling in the East River, it's important to focus on the task at hand, not the nasty, nasty medium in which you're doing it.

02 / Double up your swim trunks or swimsuit bottoms. Scientifically speaking, two layers of Lycra isn't going to stop all manner of microbacteria from coming in contact with your most delicate of parts, but it will make you feel better and help you sleep easier that night.

03 / Protect yourself! Keep your eyes, nose, mouth, and ears away from the surface of the water. Keep your eyes, nose, mouth, and ears away from your wet hands. Wear goggles, earplugs, and a nose clamp if possible. I'm not a doctor, but I watch *House* and I'm pretty sure that most cases of fountain tuberculosis are contracted through those mucous membranes, so protect them as if your respiratory health for the next six months depends on it. *Because it does.*

04 / Disinfect yourself! Proceed directly to the hottest shower you can find and scrub yourself down with antibacterial soap. Don't go out for pizza at a quaint pizzeria in Greenwich Village, don't stand around chatting with your friends in Washington Square Park, don't go for a leisurely stroll up Fifth Avenue because it's such a pretty day, just GO. *Trust me.*

One day, we envision urban pranksters from around the world competing in a prankster Olympiad. Synchronized swimming is just one of the thirty-five Olympic sports to choose from. Two other urban prankster collectives have successfully turned Olympic sports into spoofs.

GuerilLA, a group of pranksters based in Los Angeles, pulled off a mission called The Strand Race that turned casual bicyclists into victorious Lance Armstrongs. The group went down to the Strand, a twenty-two-mile bike path that runs along the Southern California coast, and created a giant FINISH LINE banner that they held above the path. Dozens of agents cheered wildly as bikers pedaled through the finish line, encouraging them with signs that said KEEP GOING and supplying them with cups of water. Bicyclists (and a few joggers) enthusiastically crossed the finish line and were surprised that they had just won a "race."

Another group of urban pranksters, Michigan Improv, also staged an Olympic event in an unlikely place with their Mall Marathon mission. On a Monday afternoon, approximately twenty-five agents dressed in running gear ran a "marathon" through the retail stores and food courts of a massive Michigan mall. The group ended their race in front of a shoe store called Finish Line.

mission

date / annually

number of agents / thousands

objective / Have everyone press play at the same time.

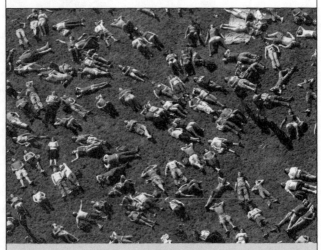

Hundreds of agents listening to the same MP3. "I was looking for the comet to come pick you up!" an onlooker said.

One of our most popular missions isn't really much of a
prank, but it certainly causes a pretty huge scene. The MP3
Experiment has become an annual event for Improv Everywhere;
Agent Tyler Walker and I put an MP3 online (usually around
forty-five minutes long) and agents download and transfer it
to their iPods. Everyone then synchronizes their watch to an
atomic clock on the website and then heads out to the same
public location. At the predetermined time, everyone presses
play. Hilarity ensues as participants carry out ridiculous

instructions delivered to their headphones via narrator Steve (a.k.a. the Omnipotent Voice from Above) and folks passing by try to figure out why a mass of people are all silently jumping around. This mission is sometimes confused with a Silent Rave or Mobile Disco, a type of flash mob popularized in England where mobbers arrive in a public place to dance silently to their own iPod. The key difference with our event is that everyone is actually listening to the *exact same thing,*

The MP3 Experiment III in 2006: The Sun, the Cloud, the Raindrop, and the Snowflake lead a six-hundred-person conga line through Central Park.

which makes it all the more fun. Here is a recap of MP3 Experiments past:

The MP3 Experiment (2004) / The original MP3 Experiment took place indoors at the Upright Citizens Brigade Theatre. The audience watched a projected countdown clock and then all pressed play together. A few minutes later the seats were empty, as the entire crowd was dancing on the stage. Participants blew bubbles, hit balloons in the air, and hugged each other before being led by Santa Claus (Agent Wimpy in costume) out of the theater and down the street to a nearby bar.

The MP3 Experiment 2.0 (2005) / For the second installment participants met up in the Sheep Meadow in Central Park. A few minutes after pressing play, two hundred participants suddenly rose from their seats on the field as everyone else in the park looked on in shock. Listeners had unknowingly downloaded four separate MP3s and were thus divided up into groups, led by a ridiculous cast: a Sea Captain, a Bumblebee, a Dolphin, and an Astronaut. The event ended with a

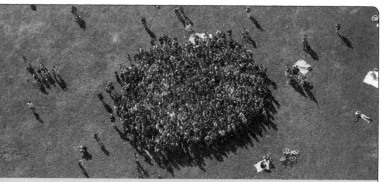

The MP3 Experiment Four in 2007: 826 agents form a color-coordinated bull's-eye in a Manhattan park.

rock-paper-scissors battle and two hundred beach balls being tossed into the air.

The MP3 Experiment III (2006) / Six hundred participants gathered in four different locations in the northwest corner of Central Park. Led by more ridiculous costumed characters (this time a giant Sun, a Cloud, Raindrop, and Snowflake), the groups paraded through the woods to meet up with each other by a beautiful lake. An epic battle among the elements took place, and everyone celebrated by forming a six-hundred-person conga line.

The MP3 Experiment Four (2007) / Eight hundred and twenty-six people wearing blue, red, yellow, or green shirts pressed play by the yacht harbor in Lower Manhattan. They followed a German tourist up the river and played freeze tag in Rockefeller Park, much to the confusion of the girls sunbathing there. The group formed a massive color-coordinated bull's-eye, which looked amazing from above.

The MP3 Experiment 5 (2008) / Last year the MP3 Experiment went out on its first tour, hitting Toronto, San Francisco, and Chicago in addition to New York City. Participants engaged in a Revolutionary War–style battle using balloons as weapons and created a massive canopy with umbrellas.

Pranks involving large groups of people have been around ever since a band of Greek soldiers jumped out of a giant wooden horse and slaughtered a bunch of Trojans. Actually, pranks probably go back even earlier than that. Here are some pranksters from the past and present whose work shares a kindred spirit with Improv Everywhere.

Alan Abel / Abel has been staging elaborate media hoaxes for fifty years. He got his start in 1959 when he created SINA (Society for Indecency to Naked Animals). The fake group fooled *The Tonight Show* and *CBS Evening News,* among others, into believing they really wanted to clothe all animals. In 1999 Abel convinced an HBO documentary that he had the "world's smallest penis." The producers fell for his story and made him a featured subject in their film *Private Dicks.*

Abbie Hoffman / Hoffman was known for his political protest pranks in the 1960s. On August 24, 1967, he led a group of pranksters to the gallery of the New York Stock Exchange and threw hundreds of dollar bills (most fake) onto the exchange floor. Many traders went nuts, frantically trying to grab as much money as they could.

Joey Skaggs / Skaggs is another notorious media hoaxer. In 1976 his Cathouse for Dogs project fooled the mainstream media into thinking he had opened a brothel for dogs. In 2000 his Final Curtain hoax fooled the *L.A. Times* and many others into writing about his made-up amusement park/cemetery mash-up.

The Suicide Club / The Suicide Club was a secret society of counterculturists who formed in 1977 in San Francisco. They're most

known for getting thirty people to ride a San Francisco cable car completely naked, an extreme precursor to our No Pants! Subway Ride. The Suicide Club ended in 1983, but its members went on to start similar groups like the Cacophony Society, famous for the annual Santacon Santa–mob events, which now happen all around the world, and the Billboard Liberation Front, a group dedicated to altering billboards to display subversive messages.

Spencer Tunick / Spencer Tunick's installations look a lot like Improv Everywhere missions, except everyone is naked from head to toe. He's famous for getting enormous groups (sometimes in the thousands!) of people together to pose nude for his photography. What's more, he often does it without authorization. His participants just show up and disrobe.

The Yes Men / Andy Bichlbaum and Mike Bonanno are the Yes Men, an organization dedicated to "identity correction." The duo makes spoof websites of corporations and political figures designed to look like the real deal. When someone from the media carelessly requests an interview through a spoof site, the Yes Men show up and pretend to be representatives of the company. It's media hoaxing with an activist angle, and they've wound up on major news networks making major announcements on behalf of huge corporations. When asked for his opinion about their fake site gwbush.com, the former president told reporters, "There should be limits to freedom."

Chengwin / Each year from 1999 to 2004 Chengwin (half-chicken/half-penguin) battled Chunk (half-chicken/half-skunk) on the streets of New York City. Kurt Braunholer and Matt Murphy met at the Upright Citizens Brigade Theatre and hatched a plan to build the seven-foot-tall bird costumes. Hundreds of people attended their

events to cheer Chengwin on in his battle against the evil Chunk. Spin-off characters included Chixon (half-chicken/half-Nixon) and Chabio (half-chicken/half-Fabio).

Cockeyed / Rob Cockerham has been pulling off hilarious pranks in Sacramento, California, for the past ten years. My all-time favorite is his TGI Friday's menu prank, where he made a fake insert that anyone could slip into a menu at any Friday's around the world. His menu page perfectly matched the graphic design of the other pages but featured a ridiculous sampling of "Atkinz" items, like a stick of butter wrapped in bacon. Rob's fans executed the prank all over and sent in photographic evidence.

Zug / Boston's John Hargrave documents his pranks on his website Zug, which he claims is the oldest comedy site on the Web (since 1995!). One of John's most hilarious series of pranks involves him leaving ridiculous signatures on credit card receipts. Rather than sign his own name, he'd draw silly pictures or use someone else's name, like "Mariah Carey" or "Beethoven." Amazingly, clerks would always accept his signature, even when he wrote "Not Authorized" on the line.

Newmindspace / Newmindspace operates out of both Toronto and New York and calls itself a member of the Urban Playground Movement, focused on bringing fun back to city life, much like Improv Everywhere. Founders Kevin Bracken and Lori Kufner have organized some massive events in both cities, including pillow fights and bubble battles.

mission 9

date / february 13, 2005

number of agents / 1

objective / Provide quality bathroom-attendant service in a McDonald's lavatory.

At your service, McDonald's customers . . . Agent Simmons practices his classy paper towel snap.

If you're in the mood for an extravagant dinner at a restaurant with stellar service and a five-star menu, I'd bet that the last place you'd go would be a McDonald's. No offense to the Golden Arches, but McDonald's built its fast food empire on being quick and cheap, not formal and refined. McDonald's founder Ray Kroc, one of the great entrepreneurs of the twentieth century, achieved success with his hamburger chain by promoting "quality, service, cleanliness, and value." Kroc's business plan certainly worked wonders for him, but I thought,

Why not add a touch of class to that list? After all, don't the loyal customers of McDonald's deserve the same amenities as, say, the diners at an exclusive restaurant? I certainly thought so. That's why I decided to pamper the patrons of a local McDonald's by placing a full-service, tuxedo-clad bathroom attendant in their public restroom.

❶ the plan

For a while, I had an idea kicking around in my head for a mission called Five-Star Fast Food. The plan was to take a cruddy fast food joint and spruce it up with all the trappings of a five-star restaurant. I envisioned a maître d' standing behind a podium asking for reservations, a hostess to seat the guests, a waiter to take orders from the diners, and an attendant in the bathroom. It had all the makings of a hilarious mission; the only problem was that any restaurant would shut down our prank before it even began. After further brainstorming sessions with a few friends, I decided that we could pull off the fast food bathroom-attendant aspect of the mission, figuring we could draw out the stunt much longer in a secluded men's room.

The next step in the planning process was to pick the perfect restroom. The challenge with this task is that nearly every fast food restaurant in New York City has a single-occupancy bathroom, many of which require a key for entry. For the mission to work, I needed to find a single-gender, multiple-occupancy restroom. After spending a week scouring the city and surveying various disgusting locations, I stumbled upon the Cadillac of public restrooms in the McDonald's on Forty-second Street.

Fancy bathrooms aside, the McDonald's on Forty-second Street is a sight to behold. Its façade is made to look like the

marquee of a Broadway theater and uses 7,500 lights to spell out McDonald's. In fact, the restaurant is located right next door to the theater where the *Lion King* musical ran for many years and where *Mary Poppins* is currently playing. This epic Broadway McDonald's stands three stories tall, features menus on flat-screen TVs, and projects movies on its walls. Tucked away on the third floor in the very back corner, I discovered a super-sized men's room, complete with three urinals, two stalls, and four sinks. Jackpot! This men's room deluxe also had a diaper-changing station, which, when folded out, would perfectly double as our bathroom attendant's amenities table.

After finding the ideal bathroom for the mission, my next task was to cast an agent to play the McDonald's bathroom attendant. My friend Agent Todd Simmons worked as a bathroom attendant for three years in Manhattan while pursuing a career as a writer and actor; with his résumé, he was the logical choice to play the part. I pitched the idea to Agent Simmons, and he said he was ready to don his attendant's tuxedo once again for the prank. "Having paid my bills for several years as an actual restroom attendant, I was curious to see if I still had my chops," Agent Simmons said. "I'd always been forced to deal with a wide range of characters in my lavatory work at nightclubs and restaurants in New York City, and I felt I'd handled the curveballs fairly efficiently." With his experience, Agent Simmons would be totally comfortable and natural throughout the mission. He knew all the tricks of the trade.

In preparation for the mission, I spent about $50 gathering supplies for the fold-out diaper-changing station that would be converted into our amenities table. I wanted to make sure our attendant was well stocked with travel-size toiletries. I purchased cologne, deodorant, mints, gum, dental floss, Tyle-

nol, Advil, condoms, shaving cream, disposable razors, Q-tips, baby powder, Gold Bond, Band-Aids, cough drops, mouthwash, plastic cups, hair gel, Kleenex, and (our crown jewel) a Barbicide canister filled with actual Barbicide and several combs. I also bought two silver trays and a lace tablecloth to present our wares upon.

We arrived at the Broadway McDonald's at one forty-five on a Sunday afternoon. In addition to Agent Simmons, several other agents would be assisting with the mission. Agent Chris Kula would be setting up undercover cameras to document the prank, and Agents Belisa Balaban, Laura Krafft, and Ted Skillman would be joining me just outside the bathroom to get reactions from people as they left.

All of the agents ordered food and trekked up to the third floor and sat at tables close to the bathrooms. Just a few tables away, two police officers, one male and one female, were finishing up their lunch. We figured the male cop would probably use the facilities before leaving, so we waited it out. "I was not overly concerned with the civilians we'd encounter in the McDonald's men's room," Agent Simmons said. "No, it was the NYPD and the McDonald's management that had me concerned. I *knew* we'd be discovered. It was simply a matter of time." Soon enough, our hunch proved correct and the male cop got up to use the bathroom.

After he finished his business and the two police officers departed, we sprang into action. Agent Simmons removed his winter overcoat to reveal the tuxedo he had been concealing beneath it. Agent Kula set up a hidden camera inside a Kleenex box and pointed it at the door (we were a little concerned about filming in a bathroom, so we made sure to direct the camera away from the action, so to speak). I hauled all of our supplies into the bathroom in a giant Kmart shopping bag.

We folded out the diaper-changing station, covered it with our lace tablecloth, and then put the two silver trays holding all of the toiletries in place. Within two minutes, the amenities table was set up, and Agent Simmons was ready to provide quality bathroom-attendant service to the patrons of the McDonald's on Forty-second Street.

❚❚ the mission

Agent Simmons, looking like Jeeves or a young Mr. Belvedere, stood at attention directly in front of the hand dryers, essentially blocking access to them. Armed with a dispenser of antibacterial hand soap (much classier than the pink industrial soap on the wall) and a roll of nice paper towels, he was determined to make sure that any customer who had to wash his hands would require his services. My small group of agents all sat just outside the bathroom among the McDonald's diners, eagerly waiting to see who would enter. Agent Simmons's first customers were a group of British schoolboys, who were visiting the United States on a class trip. The first two boys were giddy with excitement over their unexpected encounter with a bathroom attendant. They cheerily washed their hands and took peppermints on the way out. The two boys then came running out of the bathroom, anxious to report back to the rest of their group.

"Heather!" one of the boys cried out to a classmate. "They've got a butler in the loo and he gave us sweets!"

The group's chaperone raised an eyebrow at the boys' claim and entered the bathroom to investigate. His British accent was almost indecipherable, but it was clear that he was delighted that there was someone in the lavatory to "help the boys wash up." The chaperone shook Agent Simmons's hand and explained, "The kids are astonished because they don't do

this in England." Several more British schoolboys entered the bathroom to take part in the fun. The original boys returned twice to get more sweets and then stood outside the door bragging to their female classmates.

About ten minutes into the mission, the first McDonald's employee entered the men's room. His name tag read Roman, and he didn't seem to speak much English. Agent Simmons approached Roman warmly.

Agent Simmons prepares his amenities table on the diaper-change station.

"Hey there, I'm Todd," he said. "I'm from corporate. We're trying out a new promotion today." Roman swiftly shuffled out of the bathroom without saying a word. He made several visits to the bathroom to sweep throughout the mission, ignoring Agent Simmons each time.

In addition to the British schoolboys, a number of international visitors passed through the bathroom, making the Broadway McDonald's seem like the United Nations of fast food. Agent Simmons greeted foreign nationals with charm, wit, and quality service. He engaged a South Korean tourist in a two-minute conversation about the weather. "I always carry an umbrella because I hate the rain," the South Korean

confessed. A German man wanted to know if Agent Simmons worked for McDonald's or for himself. Once Agent Simmons explained that it was a McDonald's promotion, the German man decided, "I like the idea. Sounds good."

A Japanese man spent more than five minutes brushing his teeth (he brought his own toothbrush and toothpaste). After some small talk, Agent Simmons learned that the man was the chief financial officer of Hitachi in Tokyo and had just come from seeing the Broadway musical *Mamma Mia!* "It was so-so," the CFO said of the musical. "The songs were very clever, but that's all. I like the ABBA songs, but the plot is very simple." He went on to say that "you can see good musicals in Japan, but in the United States—especially New York—they're fantastic." Throughout the course of the mission, Agent Simmons attended to people from the United Kingdom, Russia, Germany, Japan, South Korea, and even two men from the far-off land of New Jersey.

While Agent Simmons was serving a vast array of nationalities, another McDonald's employee, Rafael, entered the bathroom. Rafael tiptoed in, did a little sweeping, and slowly backed out the door, all while glaring at Agent Simmons with a suspicious eye. Agent Simmons tried to engage him with some friendly banter, but Rafael didn't respond.

A steady stream of McDonald's customers continued using the lavatory and our luxurious bathroom-attendant services. One man picked up his toddler son so that Agent Simmons could dry his hands and then kindly left a $1 tip. Another man badgered Agent Simmons with a lot of questions, trying to figure out why there was a bathroom attendant in a McDonald's. Agent Simmons convinced the man that he was legit, and then the man revealed that he was curious because his stepfather was a bathroom attendant in Brooklyn. As he and Agent Simmons

were conversing about the attendant trade, a third McDonald's employee started shouting just outside the door.

This time around, it was a female employee, dressed in the same uniform as Roman and Rafael. She didn't speak much English either, so Agent Simmons had a difficult time communicating with her. "Only muchachos in here," he tried to explain.

"Nobody else?" she responded. "I go in?" She waited until all of the men had exited the room and then came in to get a closer look at our bathroom-attendant setup. She seemed confused, so Agent Simmons tried to calm her. "We work together," he said. "*¿Te llamo* Evelyn?" She did a quick about-face and scurried out of the men's room.

Evelyn must have alerted the management, because a few minutes later, as Agent Simmons was explaining the McDonald's philosophy to a customer, a gentleman wearing a tie entered the bathroom. "We don't want to be a part of the same fast food culture as everyone else," Agent Simmons said to the customer. "McDonald's is the biggest and the best . . . and this is Broadway!"

The manager was not impressed and was at a loss for words. "Y-y-you don't have any authorization to do this!" he stammered.

"Yes, I do," Agent Simmons said. "I'm Todd. I'm from the corporate office."

"Well, I'm Ted, and I am the manager of this McDonald's. I don't know anything about this."

"This is part of a special promotion," Agent Simmons said. "They didn't send you a memo or a fax?"

"I'll call them," Ted the manager said. "They didn't tell me anything about this. Lemme call."

"We started in Akron, Ohio," Agent Simmons continued. "And then Los Angeles and Portland, Oregon."

"You're sure you're in the right McDonald's?" Ted the manager asked, seeming more and more confused by the second.

"I hope so! I sure hope so!" Agent Simmons said.

Ted the manager left the bathroom to place a call to corporate. After Ted exited, Agent Kula darted in the bathroom and grabbed our hidden Kleenex-cam. We couldn't risk losing our footage at this point. Agent Simmons remained in the bathroom and continued doing his job. Ted the manager returned about five minutes later.

"My regional manager hasn't heard anything either," Ted the manager said.

"You know, I told them it was a bad idea to do this on a Sunday," Agent Simmons said. "Why not a Friday or Saturday?"

"You're sure you got the right place?"

"Are there other McDonald's in the city?"

Ted the manager's jaw dropped. "Yeah!"*

"Oh."

"Maybe you meant to go to Thirty-fourth Street?"

"Could be!" Agent Simmons said. "That definitely sounds familiar."

"Okay. Well, I have a message in with corporate," Ted the manager said. "Let's wait and see what they say when they call back."

I didn't want to get Agent Simmons in any serious hot water, so I knew it was time to pull the plug on the mission. The team of agents waiting outside the bathroom swooped in, disassembled our amenities table, then threw the lace tablecloth, the silver trays, and the toiletries in our shopping bag and returned the diaper-changing station to its upright and locked position. We then vanished from the McDonald's without being noticed by

*Fun fact: there are 246 McDonald's restaurants in New York City.

Ted the manager, who was still trying to contact the corporate offices in vain. The only evidence of our high jinks was a plastic bowl of peppermints that we left behind by the sink.

the aftermath

Agent Simmons provided exemplary attendant service for nearly an hour in the Broadway McDonald's. Almost everyone he encountered (more than fifty customers) enthusiastically used his services, and many patrons were kind enough to leave a tip. In fact, Agent Simmons pocketed $6.92 in tips for his services that afternoon. "Even though I made nearly seven dollars in tips that day the pressure was really not on me to earn," Agent Simmons said. "It was all about keeping a straight face and not getting thrown out before we'd accomplished our goals. It was a little surreal to be passing out soap and towels while the Happy Meal crowd poured in to relieve themselves."

Throughout the mission, nobody questioned Agent Simmons's story—that McDonald's was placing bathroom attendants in their restrooms as a promotion. Even Ted the manager convinced himself that this wasn't a prank but a simple misunderstanding. Surely the bathroom attendant was just at the *wrong McDonald's.*

agent assignment / fast food bathroom attendant

objective / To provide quality bathroom-attendant service in a fast food restaurant's public restroom.

Bathroom-attendant service is usually reserved for high-end nightclubs, fancy restaurants, and classy hotels. But why not bring a touch of elegance to your favorite fast food eatery? Perform the duties of a bathroom attendant at a local fast food joint and give the restaurant's customers a dose of sophistication and class. (And free mints, too!)

01 / Choose a location. Select a fast food restaurant with a single-gender, multiple-occupancy restroom.

02 / Stock up on supplies. Purchase an assortment of bathroom-attendant supplies to display near the sink. This could include cologne, deodorant, mints, gum, dental floss, Tylenol, Advil, condoms, shaving cream, disposable razors, Q-tips, baby powder, Gold Bond powder, Band-Aids, cough drops, mouthwash, plastic cups, hair gel, Kleenex, and, if possible, a Barbicide canister with several combs.

03 / Don formal attire. If you have access to a tuxedo, it will come in handy for this mission. If you don't, wearing a suit and tie will be an acceptable alternative.

04 / Create an attendant's table. If the restroom has a diaper-changing station, fold out the table, cover it with a white tablecloth, and use it as your supplies station. If the bathroom doesn't have a diaper-changing station, bring a small folding table or just set up your supplies near the sinks.

05 / Be polite. Stand in the corner and act as courteous and polite as possible. Greet the customers as they enter, and be sure to address them as sir or madam (depending on their gender). Graciously offer them a paper towel after they wash their hands. Make sure to put out a basket for tips.

06 / The cover-up. If any restaurant employees or customers ask you what you are doing, answer them by kindly explaining that you are from the restaurant's corporate office and that you were sent to offer bathroom-attendant services as part of a special promotion.

the power of formal wear

by agent todd simmons

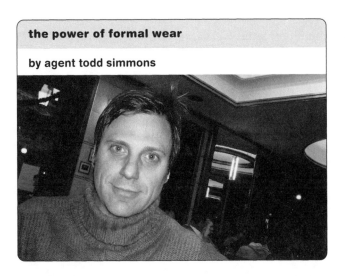

Every mission comes with its own series of obstacles. Whether it's keeping a straight face or avoiding arrest, there is always something that forces you to maintain a keen sense of awareness and generate a little luck. Infiltrating a major fast food chain in broad daylight is one thing. Setting up a full-service operation on a diaper-changing station in the men's room of that major fast food chain, covertly videotaping customers who are about to or just have relieved themselves, is another, potentially delicate thing.

The only way to do it properly is to be formally dressed. People want to trust a tuxedo-clad man. Outside of the military, the police, a doctor, or a priest of some kind, the (sober) tuxedo-clad man may be the most trusted man in society. Once you don your well-pressed formal wear you simply have to paste a smile on your face and say "Yes, and . . ." to all inquiries regarding your presence in a public toilet. It also helps

greatly to attempt this mission on a Sunday while the corporate office is dark. That way when the manager comes sputtering into the room, eager to learn why you have a table laden with mints, condoms, combs, and Barbicide, you can refer them to the corporate office. You are wearing a tuxedo after all. How could you be wrong?

Every year people always say to me, "I bet you've got something huge planned for April Fools' Day this year!" Usually, I don't. While April 1 is still my favorite day of the year, it's not the right day for an Improv Everywhere mission. Frankly, it's amateur day. It's the one day of the year where *everyone* is a prankster. People have their guard up on April Fools'; they're expecting to be pranked. Improv Everywhere thrives on striking when people least expect it. For me April Fools' is a day to try to fool your friends and family, not to stage something elaborate in public.

That said, we couldn't let the day pass without celebrating it. Every year on April Fools' we make some sort of big announcement on our website. It's always some type of hoax—a ridiculous piece of Improv Everywhere news. Here's a journey across our April Fools' Days.

2002 / We sent out a press release to our fans saying we had been picked up by MTV for a series of shows and two movies. At the time Improv Everywhere was only eight months old, so such a feat was completely shocking. The text was actually taken from a *Jackass* press release I found online; I switched every mention of *Jackass* to Improv Everywhere.

2003 / Everyone on our e-mail list got an e-mail saying that Improv Everywhere had been shut down by the NYPD. We took our website offline for one day to make it seem more believable. Little did we know that the NYPD would shut down more than a couple of our missions in the years to come.

2004 / Just a few weeks after our bookstore mission, we announced that the estate of Anton Chekhov was suing us for defamation of

character. Hundreds of e-mails poured in offering legal and financial help. We guiltily laughed at each one.

2005 / We got into legal trouble again; this time McDonald's was suing us over copyright infringement for our McDonald's Bathroom Attendant mission. Once again we got tons of e-mails offering to donate money for our legal fees; many of the senders had fallen for the same prank the year before. We're not con men, so we turned down all the money.

2006 / Everyone was asking me what had happened to the eight agents who were arrested at that year's No Pants! Subway Ride. I sent out an e-mail letting everyone know that they were found guilty and forced to serve time at the Riker's Island prison facility in New York. Outrage spread across the blogosphere as angry bloggers cried foul over the injustice toward the No Pants. We let everyone know on April 2 that the charges against them had in fact been dropped.

2007 / We were served a lawsuit once again in 2007. The jazz combo Improv Everywhere was suing us over our name, which they claimed to have first. I announced that we would be changing our name to the completely lame Humor In Public Places, or HIPP for short. I even changed the name all over the website. Angry commenters bickered over copyright law and poked fun at our dumb new name.

2008 / I sent out an e-mail telling everyone I had paid $4,000 for a website redesign. When people clicked to see the new site they were treated to a page right out of 1997. Animated GIFs, flashing text, and Under Construction signs littered the page as a MIDI music file blasted. There was even a Dancing Baby graphic. Not many were fooled, but everyone had a good laugh.

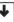

urban prankster global network / human dominoes

In March of 2008, the Boston Society of Spontaneity, a prank collective in the Urban Prankster Global Network, played an impressive game of Human Dominoes. Fifty agents gathered in South Station, Boston's main train terminal, and posed as out-of-town tourists waiting in line for a tour bus. Each agent in line also strategically placed a suitcase by his or her right-hand side.

The mission started when an agent at the front of the line scratched her head, and one by one, each agent in the line followed suit and scratched his or her own head. The lead agent then impatiently checked her watch, and then removed her gum and put it in her pocket—the agents standing in line behind her mimicked each of her actions one by one. For the grand finale, the last agent in line let out a thunderous sneeze, knocking over the man in front of her and his suitcase. This set off a chain reaction as each agent along with his or her suitcase fell over like a row of dominoes until they were all splayed out on the floor of the train station. Agent James Cobalt recalled, "Security looked completely befuddled, unsure if they should kick us out, laugh, or rush to our aid. Instead they stood there with looks of confusion. Dozens laughed and applauded."

mission 🔟

date / annual (always in january)

number of agents / thousands around the world

objective / On a freezing-cold afternoon, have countless agents agree to live in a world where riding the subway without pants is totally normal.

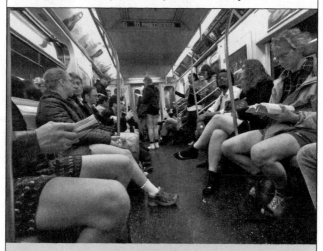

Pantsless agents pack a NYC subway car.

Back in 2001, when Improv Everywhere was still in its infancy, I took a bus up to Woodstock, New York, to visit a friend. Although the trip from Manhattan to Woodstock is breathtakingly scenic, I departed after sunset, so when I peered out the window, I saw nothing but darkness. Instead of looking out the window at a dark landscape, I decided to check out my fellow bus passengers. People-watching is a favorite pastime of mine, and as I scanned the bus I noticed different riders of all races, ages, and sizes. Then, to amuse myself, I started imagin-

ing these people without their pants on, wearing nothing below the waist but boxer shorts, shoes, and socks. The thought of pantsless passengers made me laugh out loud, and then it hit me like a lightning bolt: *pantsless public transportation would be a perfect mission for Improv Everywhere.*

The first No Pants! mission took place shortly after that fateful bus ride, on January 5, 2002. I gathered six of my buddies to depants along with me and a couple of other agents to

A group of agents sans pants wait for the next train.

document our stunt on camera. The mission was so funny that we decided to pull it off again the following winter and then every winter since then. Each year, the number of participating agents has skyrocketed, from 7 (in 2002) to 30 (2003) to 40 (2004) to 50 (2005) to 160 (2006) to 300 (2007) to 900 and hundreds more in ten different cities around the world (2008). Our No Pants! missions have been featured on the front pages of newspapers on every continent and covered on countless TV programs. Even David Letterman has cracked jokes about our pantsless rides in a couple of his monologues.

As our army in underwear grows exponentially each year, No Pants! has become less of a prank and more of a parade.

That's fine by me. Each year hundreds of people experience our pantsless operation for the first time (both as spectators and participants), and no matter how much publicity it gets, in a city as big as New York, there will always be people who will have no idea what is happening when they get on a subway car packed with pantsless people. But the No Pants! mission's rise from a subtle seven-person prank to the global phenomenon it has become was not always a smooth ride. In 2006, eight of our agents were handcuffed, detained, and fined for riding the subway sans pants. Ultimately, the charges were dropped, and now the NYPD provides a police escort (referred to by the cops as the No Pants! detail).

As No Pants! transforms into a huge social event, with pantsless participants making fast friends with each other, I hope that more agents will participate each year in cities across the country and around the world. It's a prank that works on any type of public transportation. Here are the mission reports for three of my favorite No Pants! years—2002 (the first year), 2006 (the year we tangled with the cops), and 2008 (the year the phenomenon started to spread around the world). So curl up with this chapter, take off your pants, and get ready to ride!

no pants! subway ride 2002:

This Is Not the Opera House!

For the No Pants! Subway Ride's maiden voyage, I invited six agents to join me as pantsless passengers. The plan was to get on subway car A together, and each time the train pulled into a station, one of us would remove his pants and throw them at Agent Julia Cassis while pretending not to know her. When the train made its next stop, the pantsless agent would exit car A, walk down the platform, and enter car B. Once in car B, we

would just ride without our pants and act completely normal. After riding in our boxers or briefs for several stops, Agent Cassis would enter car B and sell us back our pants for $1.

On the day of the mission, we all boarded the train together, confident that we were in for quite an adventure. One by one, we started taking off our pants and hurling them at Agent Cassis. The bizarre scene we created on the train perplexed our fellow subway passengers.

"Some agents threw their pants, some agents tossed them, and some agents put them firmly in my hands," Agent Cassis said, "but each time I acted more and more pissed off and started muttering to myself about how ridiculous it was. Eventually, I averted my eyes, but pants kept landing on my head. For the last agent, I walked away and tried to ignore him, but he came up to me and put the pants in my hands. People in the car were snickering, everyone was watching, and some people were trying to ignore it." One man nudged his wife, pointed at Agent Jesse Good as he removed his pants, and said, "Honey, look!" His wife rolled her eyes at him and explained, "Honey, it's *New York*."

Each pantsless agent made the mad dash down the bitter cold underground platform (remember, this is in *January*) from subway car A to car B, one at every stop. At the first stop, Canal Street, I entered car B wearing my heavy winter coat, a hat, a scarf, and gloves—and only my chartreuse boxers with bright red ladybugs on the bottom. I sauntered into the middle of the car and checked the map. Every head in the car turned and looked at me with surprise, but no one commented. At Spring Street, the next stop, Agent Good, wearing a winter coat and blue polka-dot boxers, waltzed into the car. Two Danish tourists guffawed, while others on the train were straining to hold back laughs. Agent Richard Lovejoy, wearing sunglasses and Hawaiian-themed boxers, entered the car at Bleecker Street. The

Danish tourists again erupted into uncontrollable laughter. The jaw of a young woman reading *The Rape of Nanking* dropped with disbelief at the sight of three pantless men getting on the subway at three consecutive stops.

Back in car A, agents were still taking off their pants and chucking them at Agent Cassis, who was collecting them in a bag. As the train kept heading uptown, Agents Andy Schnetuer, Todd Robertson, Chris Nadan, and Dave Willner all took off their pants, gave them to Agent Cassis, and then ran up to car B in their underwear. "People started saying, 'Who's next?' while looking around eagerly as the mission went on," Agent Cassis said. "As I left, I said sourly, 'Anybody else have any more pants you want to throw at me? Jesus Christ!'" By the time we reached Twenty-eighth Street, there were seven passengers riding the train in their underwear.

As the train pulled into Thirty-third Street, a man grinning ear to ear approached me. "Is there a Man Without Pants convention today or something?" he asked.

"I don't think so."

"So you guys aren't going to a convention?"

"I'm not. I don't know these guys," I said.

"Well, take it easy," he said, exiting the train.

"You too," I said. "It's cold out."

"Yeah! *For you!*" he said, bursting into a laughing fit.

As that man exited the train, Agent Cassis walked into car B holding a large duffel bag full of our pants. "Pants! Pants!" she cried out. "Who needs pants? One dollar! Only one dollar for pants!"

"Perfect!" Agent Robertson said, reaching for his wallet.

"Got to have exact change!" Agent Cassis said. Soon, all the pantless agents were fumbling through their coat pockets, searching for a dollar bill to buy a pair of pants. Everyone on

the subway car stopped what they were doing, laughed, and enjoyed our little show. Even the woman who was engrossed in *The Rape of Nanking* put down her book and tried to figure out what was happening.

Every passenger on the train seemed to be thoroughly enjoying our joke except for a gay couple in their fifties, who were holding hands and staring at us grimly. "Get a life," one of the men shouted at me. "The last thing I want to see is you putting your fucking pants on in the train."

"I'm just trying to make an honest buck here," Agent Cassis explained to the couple. "People want pants, I'm going to sell them to 'em."

"At my expense," the angry man shot back.

"At *my* expense," I said. "I'm the one that just paid a dollar for them."

The man's partner focused his anger on me. "This is really retarded," he said. "What you are doing . . . it's stupid. Maybe in the sixties or seventies it would have been funny, but today . . . it's embarrassing."

"Because I woke up this morning and forgot to wear pants?" I asked.

"And you all did. You all didn't wear them," he said.

"Oh, I don't know those guys," I said with a shrug. "You'll have to ask them."

At that point, a young woman entered the argument and defended the pantsless riders against the increasingly annoyed couple. "These people need to lighten up!" she said, wagging a finger at them.

"This is so stupid," one of the men said.

"It's asinine!" the other one chimed in. "The cops will know about this!"

"What did I do wrong?" I asked.

"It's a quality-of-life issue," he explained. "It's a public nuisance!"

"I don't think this qualifies as a public nuisance," the woman interjected. "I think this qualifies as a 'happening' or a piece of performance art, i.e., from the sixties. That's exactly what this is, and you just have to accept it and move on."

"Well, then bring it to the theater, not a public place," one of the men grumbled.

"No! That's the beauty of it! It happens in public spaces like this. This is why we have happenings—"

"Honey," the man interrupted, "you're forgetting that this is not the opera house! *This is the subway!*"

"It doesn't take place in the opera house, *honey,*" she said. "It can happen right here, in a public place."

"You're full of shit," the man announced. "I hope you all get colds!" Shortly thereafter, the couple exited the train.

Once every agent had purchased his pants from Agent Cassis, we got off the train at Sixty-eighth Street, still pretending not to know each other. The mission lasted a total of seventeen minutes.

Riding the subway in New York City is usually a pretty dull experience; one of our objectives was to add a little excitement and give the passengers a story to tell. We did not intend to embarrass or annoy anyone, nor did we want to appear asinine or retarded. By staying committed to our objective of acting normal while not wearing pants, we made that couple the stars of our scene. We could have broken character and explained to them what we were doing, but all the agents stood firm and insisted that they merely "forgot their pants" and even went so far as to apologize to the couple. We could not have scripted a better scene; it's just too bad the couple didn't enjoy the show. As for the rest of the train, judging by their laughter, our goals were

achieved. We didn't set out to fool anyone, we just set out to create a bit of live comedy through commitment to character—one of the main principles of improvisation.

Five years after the first No Pants! mission, I posted the undercover video of our initial ride online (there was no YouTube in 2002). During that first pantsless trip, our concealed camera captured the priceless reaction of the young woman reading *The Rape of Nanking*. Her eyes were as wide as Frisbees as a different pantsless man walked on the train at each stop. I thought she would have contacted me at some point over the years as the No Pants! missions started getting press. She appeared to be the same age as me and looked like someone who might be into Improv Everywhere, but five years passed from the inaugural No Pants! before I received the following comment on my web page from a woman named Kate:

Hey, that's me! I'm the girl reading The Rape of Nanking.

Your mission totally worked because I have been telling people the story about the time I was on the subway and all these guys without pants got on for years now. And now I have video proof that it happened! And a reason, because I've been wondering about that . . .

Do I get a free t-shirt or something?

I was thrilled that she had contacted me. Kate's wide-eyed reaction is one of my favorite moments in all of our Improv Everywhere videos. I quickly wrote back asking for her address so I could mail her a T-shirt, and also to confirm that she was 100 percent positive that she was the girl in the video. Kate wrote back saying,

> *Yeah, it really was me! I'm not sure how my friend stumbled across it, but he forwarded the link to me, being like, "Am I crazy or are you the chick in this video?" It was hilarious . . . totally made my day. I really have been telling people the story of that incident for years.*

I happily sent Kate a No Pants! Improv Everywhere T-shirt. She confirmed for me that the No Pants! missions embody what Improv Everywhere is all about: creating a hilarious scene in public and giving a stranger a great story to tell.

No Pants! Subway Ride 2006:
The No Pants 8

The first No Pants! was so successful that I decided to make the pantsless ride an annual tradition. Each January, more and more agents participated. The No Pants! ride blossomed from a little prank involving seven white dudes in their underwear into a major annual event featuring a diverse mix of men and women of different races and ages . . . in their underwear. The daydream of a subway car full of pantsless passengers that I had on a bus to Woodstock became fully realized. It always turns into a memorable day for both the agents and the random strangers we encounter. New friends are made, people laugh and smile, others totally ignore us, but that's pretty funny, too.

By the time the fifth No Pants! Subway Ride rolled around in 2006, the day had acquired all of the emotions associated with a real holiday for me: stress, excitement, joy, laughter, and a tinge of nervousness. I was slightly panicked as I walked over to our meet-up point on that morning because I was expecting more agents to participate in our pantsless parade than in any Improv Everywhere event ever at that point. I invited everyone

on my New York mailing list to participate, and the details were forwarded all over the Internet, posted on dozens of blogs, and even featured on AOL's front page. Even though No Pants! is a tradition and not a secret, I was worried about having to wrangle hundreds of participants and deal with the headaches that go with managing a crowd of that size.

Once all of the participating agents arrived at our meeting point near the Brooklyn Bridge, I took a head count of 160 agents. It was a massive increase from the 50 agents who'd depantsed the year before, but I was prepared to handle a group of that size. No Pants! 2006 was one of the first missions I pulled off where I didn't know many of the participants personally, because word of the event spread all over the Internet. It was quite a diverse group of agents; one agent even came dressed as a UPS employee (for all I know, he *was* a UPS employee). In addition to our army of agents, several journalists and photographers showed up uninvited. I instructed them not to take any pictures until everyone had their pants off—I didn't want this to look like a media event.

With everyone gathered outside the subway station, I picked up my megaphone and briefed the crowd about our mission. "The most important thing is for everyone to keep a straight face and refuse to break character," I said. "If a stranger on the train asks you what you are doing, just say that you forgot your pants and that you don't know any of the other riders without pants." In the past, we'd only used two cars on the train: one staging car for the depantsing and one target car for riding without pants. This year, we planned to use all ten cars on the subway train—five staging and five target cars. The agents were divided into five groups, and their team captains divided their groups into even smaller groups, assigning everyone a particular stop where they would take off their pants.

As in years past, the punch line of the No Pants! Subway Ride is that all agents would buy their pants back from a "pants seller" on the train. In the staging car, agents would throw their pants at an agent I assigned, then in the target car, this person would sell everyone back their pants for $1 a pair. "I was a pants seller, or as I interpreted it, a pants hustler, so I tried to dress the part," Agent Ben Rodgers said; he wore an oversized parka and a New York Yankees hat. "Someone selling pants on the subway, I imagined, would look similar to the young, urban gentlemen who sell candy for basketball uniforms, class trips, or to 'keep themselves out of trouble.'" With all of the agents, team captains, and pants sellers in place, we marched over to our subway stop and boarded the train, ready to unleash chaos, joy, and our pants.

As the train pulled into the first stop, one agent in each of the five staging cars removed his or her pants and threw them on the floor or at the agent who was the designated pants seller. "As the pants started flying my way, I nonchalantly tucked them into my duffel bag," Agent Susan Gill, a pants seller, said. "Tourists took out their cameras and camera phones and started snapping away as more and more pants found their way over to me." After agents depantsed, they exited the staging car and entered the target car directly in front of them. The effect, for passengers in the target car, is that the agents have been waiting for the train, pantsless, on the platform in the middle of January.

At the second stop on our wild ride, another single agent shimmied out of his or her pants, threw them to the floor, and hustled up the platform into the target car. The two pantsless agents now riding in the same car did not acknowledge each other. All agents were instructed to behave as if everything was normal. Some agents read a newspaper, others listened to their iPods. I pretended to fall asleep.

At the third stop, two more pantsless agents entered the target car. Four entered at the fourth stop, and then groups of eight entered at each consecutive stop until everyone had depantsed. As in years past, our charade elicited a wide range of reactions. People either laughed, smiled, or simply ignored us. A few of the less jaded passengers desperately tried to figure out what was happening. "A little kid—about five or six years old—was trying to point out to his dad that a girl next to me had no pants on," Agent Nate Shelkey said. "The dad was trying to ignore it, but the little kid kept pointing. I guess like when asked, 'Why is the sky blue?' the dad didn't have an easy answer to 'Why is that lady not wearing any pants?'" Some people applauded us and others accosted us. ("You kids think you're pretty funny, don't you?" one man shouted.) Throughout it all, everyone kept a straight face and continued riding.

As soon as all 160 agents had their pants off, the pants sellers came through the cars and began selling the agents back their own trousers for a dollar. Our joke was met with laughter, smiles, and queries from a few curious onlookers. When asked why he wasn't wearing pants, Agent Gill replied, "Just trying to pay off a student loan." When the pants sellers entered my car at 59th Street, I remember thinking that the mission was running a little bit too smoothly; we still had several stops until our final destination (125th Street), and everyone already had slipped back into their pants. When a pants seller tried to sell me my pants, I politely declined in an attempt to stretch out the fun. As everyone around me started putting their pants back on, I decided to take another catnap in my boxers on the subway. While I was trying to catch forty winks, I noticed that the train hadn't left the 59th Street Station yet. Curious as to why our train was being held in the station, I stood up, peeked my head out of the door, and peered down the platform. My heart sank

when I saw one of New York City's finest, a big burly police officer, wreaking havoc at the other end of the train.

"What is being protested here?" the cop demanded as he removed pantsless agents from the train. "We just forgot our pants," I heard an agent say. Clearly, this police officer did not appreciate the joke. The cop ran over to the conductor, who then announced on the PA, "This train is not in service. Everyone please exit the train and wait for the next one. Due to a police investigation, this train is out of service." Suddenly, total chaos broke out on the platform. There was a flurry of frenzied agents desperately trying to get their pants back from the pants sellers and onto their legs. The pack of journalists and photographers who were covering the event emerged from the subway and besieged the cop with a barrage of questions and strobelike flashbulbs. Our delicately orchestrated mission (which hadn't been causing any problems) was transformed into a chaotic mob scene by one cop.

The police officer started rounding up every pantsless subway rider he saw and called for backup. Agent Rob Kelley, one of the first participants to be nabbed, later commented, "Skateboarding is not a crime, but apparently my pale-ass chicken legs are." Agent Rodgers, one of the pants sellers, quickly tried to defuse the situation. "I just stepped in front of the police officer," Agent Rodgers explained. "I said, 'Yo, I'll just sell 'em pants.' Then I yelled, 'Excuse me, ladies and gentlemen, I am on the subway selling pants, not for no charity, but for myself, to stay out of trouble. One dollar!' I knew I had to act fast and dish out as many pants as I could. Time was of the essence, but people were shouting, 'Do you have any thirty-twos?' Even a passenger, an elderly black woman, spoke on an agent's behalf, saying, 'He wants a thirty-two!' In the end, I said, 'All I got is a women's size eight. I think you better take it.'"

Thanks to the police officer's radio call for backup, twenty-five NYPD cops came barreling down into the subway station. "I haven't run that hard since the academy!" one of the men in blue shouted as he arrived on the scene. Many of the officers were visibly annoyed; clearly nothing illegal was going on—it was just a bunch of people in their underwear. There was a group of basketball players on the platform who were showing more skin than we were. Yet a couple of officers started detaining pantsless agents. One of the cops rounding up agents was named Officer Panton. No kidding. *Panton.*

The eight agents caught with their pants down were lined up against a wall in the subway station by the mob of policemen. The cops slapped handcuffs on six of the agents and led them upstairs to a police van while members of the press snapped pictures and shouted questions. The other two agents were given tickets on the spot and released.

It's always regrettable when the police get involved in one of our missions, especially since we've never done anything illegal, and it ends up just being a waste of the authorities' time. The No Pants 8 were taken downtown and kept in custody for several hours. Two other agents were given court summonses and were fined $60 for: "Walking in underware [*sic*] and causing a public alarm." Eventually, all eight ticketed agents had their cases dropped. Six of them had to appear in criminal court and two had to appear in transit court. Officer Panton even appeared in court and testified that it was a "fun day."

The arrests of the No Pants 8 became a major media story. It's not every day that the NYPD cracks down on people riding the subway in boxer shorts, so the mission made headlines across the country, and the Associated Press coverage appeared in several languages and papers around the world. All that publicity was

bittersweet considering that the six handcuffed agents had to be put through a somewhat traumatic ordeal. Some of the No Pants 8 decided to enjoy their fleeting fame as pantsless rebels.

"I participated in three radio interviews," Agent Flynn Barrison said. "In the first, for a Santa Barbara, California, classic rock station, I followed Peter Frampton's 'Show Me the Way,' which was a lifelong dream of mine. The DJs on that station were particularly fond of the term 'banana hanger,'

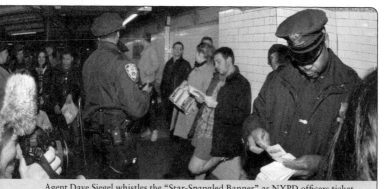

Agent Dave Siegel whistles the "Star-Spangled Banner" as NYPD officers ticket agents and press photographers snap pictures.

which apparently means 'men's briefs.' Then I appeared on a morning show in Ontario, Canada, where I followed Stevie Nicks's 'Edge of Seventeen,' and finally a nighttime chat show in Dublin, Ireland, where I followed local traffic conditions. It appears my fifteen minutes are now up."

The night after the mission, I appeared as a guest on *Countdown with Keith Olbermann* to discuss the controversy. Olbermann was oddly dismissive of our prank, but I held my own. I even managed to blurt out a plug for ImprovEverywhere.com, which prompted Olbermann to deadpan, "You'll be billed for that." *Late Show* host David Letterman even made a reference to

the pantsless incident two nights in a row in his show's opening monologue. "Yesterday in New York City, eight guys were arrested for riding on the subway without their pants," Letterman said. "How many times have you been on the subway and said, 'Wow! If I could only see those guys without their pants!'"

No Pants! 2007—Present:

A World Without Pants

After our 2006 No Pants! fracas with the NYPD's boys in blue, I was concerned that the police might try to put the kibosh on any future No Pants! subway adventures. The year following our tangle with the police, more than three hundred agents (double the previous year's turnout) showed up for the 2007 No Pants! ride. As I arrived at the meeting point to start the mission, I was devastated to see two cops blocking the entrance to the subway station.

"Are you here to shut us down?" I asked.

"Nah," one of the policemen said with a smile. "We've been assigned No Pants! detail. We're here to make sure you all have a safe ride."

The two policemen rode with us for the duration of the No Pants! trip and made sure everyone was safe, well behaved, and free from harassment. What a difference a year makes! Now, every January, two police officers are assigned No Pants! detail. Usually, it's two confused cops who have no idea that they are about to escort hundreds of people parading around without pants on—the NYPD probably uses the assignment as a rookie initiation. As the No Pants! detail rides along with us, a few agents usually playfully prod the cops and try to get them to shed their pants. To date, the police have always politely declined.

In 2008, the number of riders participating in our pantsless odyssey tripled from the previous year to a whopping nine hundred agents. To accommodate the overflow of agents, we used three different subway lines. Pantsless passengers were sent in different directions all over New York City. Certain logistics had to change as well. We placed about thirty agents in each subway car on each of the three trains. One agent would depants at each station, exit the train, and actually wait on the platform for the next train. With this new twist, the mission became more daring, as some agents had to wait on the platform for the next train in their underwear for upwards of ten minutes.

The mission always starts down at the southern tip of Manhattan, near City Hall, and ends uptown in Harlem. But in recent years, people have continued the No Pants! party into the wee hours of the night. In 2007, hundreds of pantsless agents exited the train at 125th Street in Harlem; a drummer was performing on the platform and the agents decided to start a spontaneous pantsless dance party. The following year, nine hundred pantsless agents rode their trains all the way up to Harlem and then back downtown to Fourteenth Street, where everyone all spilled out into Union Square. Many agents left their pants off for the duration of the evening and went barhopping in their underwear. There were definitely some interesting pictures posted on the Internet the following morning.

In addition to the nine hundred agents participating in New York in 2008, approximately twelve hundred agents participated in nine different cities spread across three countries around the world. There were pantsless riders on Chicago's famous el train (in aboveground 39-degree weather), Washington, DC's Metro (the second-busiest subway system in the United States, after New York), Portland's MAX train, the San Francisco Bay

Area's BART train, the Metro in Adelaide, Australia (where it was summertime and a balmy 78 degrees outside), Boston's MBTA train, Baltimore's Metro, Toronto's subway, and Salt Lake City's TRAX train.

In 2009, twelve hundred agents braved a frigid snowstorm to participate in the eighth annual No Pants! Subway Ride. In addition to the scores of pantsless New Yorkers that year, groups in twenty-two cities (in eight countries) around the

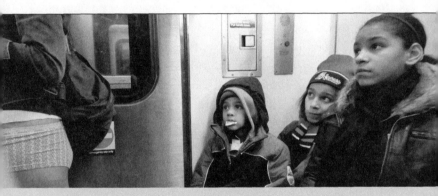

Confused children gawk at the pantless passengers.

world joined in on the fun. It's astounding to think that what started as a silly prank has morphed into an international pantsless movement.

In 2002, No Pants! was carried out like a secret mission—only myself and the eight other agents knew about our prank beforehand. Now the details of when and where to participate in No Pants! are announced on the *Today* show and numerous other television shows to millions of viewers.

In the mission's first year, we had no female participants; now, approximately 50 percent of the pantsless riders are women. No Pants! is a mission that attracts agents of all ages, races, shapes, and sizes. No matter how many people participate,

it always gets the same reactions from those we encounter: laughter, bewilderment, indifference, and (rarely) anger. The most rewarding aspect of this mission is that it brings people together in a strange way, and many of the participants become friends over their bonding experience without pants. The event has grown so big that last year, as I boarded my assigned subway car and sat waiting for the train to move, I realized that I didn't know a single agent in my group. We were all strangers

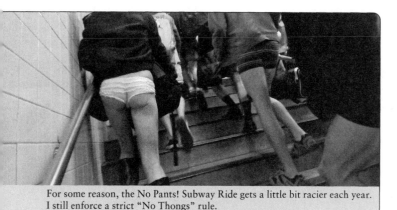

For some reason, the No Pants! Subway Ride gets a little bit racier each year. I still enforce a strict "No Thongs" rule.

to each other. In many ways, we were just like a normal train car, a bunch of people sitting silently and ignoring each other. The key difference was that we all knew that we would soon be seeing each other pantsless.

↑ | **mission accomplished**

The beauty of No Pants! is that you don't have to be underground to be in your underwear—it works just as well out in the daylight on buses and light-rail trains as it does on a subway. Just be sure to visit www.improveverywhere.com in early January to find out the date of [this year's] No Pants! the and look on the Urban Prankster Global Network to see if someone is organizing a pantsless ride in your hometown. If you want to organize your own event, here are some tips on how to pull off the mission (and your pants).

01 / Recruitment. Recruit agents to participate and explain the mission to them. You don't need a big group. Remember, only seven agents participated in our first No Pants! mission. If anyone asks them why they're not wearing pants, they are to say: "I forgot them at home."

02 / Assign roles. Designate one agent as the pants collector/ seller. One by one, as the agents remove their pants, they will throw them at the pants collector, who will later sell them back to the agents. Every other agent will be depantsing. You can also choose to eliminate this role by having agents hide their pants in a backpack. This takes away a funny punch line, but it makes it a lot less likely that agents will lose their pants!

03 / The plan. Assign each agent a stop to exit the bus or train after removing his or her pants. If you have enough agents, as-

sign at least two per stop. It can be lonely on a train platform or at a bus station when you are by yourself and you're not wearing pants.

04 / The mission. Board the bus or train at the start of the line. Without acknowledging each other, the agents should remove their pants at their assigned stop and exit the bus or train. Every agent should then board the next bus or train. Toward the end of the ride, the pants seller will come on board and sell everyone back their pants for a dollar.

05 / The aftermath. Throw a No Pants! party with your friends!

how to keep a straight face while in your underwear

by agent zach linder

01 / Simply forget that you are not wearing pants. On a normal day standing on a train platform, do you think to yourself, *Hmm, am I wearing pants?* The answer is certainly no. When you are lounging on the beach during the summer, do you think to yourself, *Am I not wearing a shirt right now?* Absolutely not. Today should be no different. So you are not wearing any pants. Put it out of mind and read your book.

02 / Remember, there are wars happening. Are you really that self-centered of an individual that you are concentrating on the fact that you are not wearing pants? The country is in turmoil. There is instability in the Middle East. Maybe there are those surrounding you right now who are stricken with poverty. Many people cannot afford pants. This will remind you that there is nothing funny about not wearing pants.

03 / Embrace the cold. Let's not forget that sometimes the absence of pants occurs in the middle of January in New York City. Some of your fellow passengers are out returning Christmas gifts; others are still recovering from New Year's Eve. You have forgotten your pants. This is not a pleasant scenario. The strong gusts of cold air that come barreling down the train tunnel and up your boxer shorts should not be doing you any favors. One reminder that you are freezing will wipe that smile right off your face.

04 / Be prepared to answer questions. "Where are your pants?" "Are you in a fraternity?" "Is this a show?" "What are you protesting?" You just forgot your pants; it's already bad enough without getting pestered. One reminder that you are constantly being bothered will surely make you grumpy and end any thoughts of humor.

05 / Shopping is not fun. Now we must move ahead and buy a new pair of pants. Vendors are selling pants for one dollar, but this won't be easy. There are the problems of style and size. No time for fittings, so I tend to grab the first pair of pants I see. But then I grab girls' pants and my legs are suffocating. I ask the pants seller, "Do you have a thirty-two?" The inevitable response is that I should poke around and check for myself. I eventually find a 32 waist with the proper inseam and am on my way. Some around you might declare that they don't buy "street pants," but one reminder that you have navigated a difficult and unpleasant shopping experience will stop your laughing right away.

06 / The New York City subway system is full of problems.
So you've made it to your destination. Now you must head back

home and meet up with your fellow pranksters at the starting point. You wait for a train. And wait. And wait. Finally a train arrives, packed to the gills. You cram your way into the train. People look at your legs as though you have lost your mind. This is no longer fun. "There's no room!" people will shout. You insist, "No, you don't understand—I *have* to board this train." Passengers are disgruntled around you. They see your bare legs as a nuisance, not a joke. You arrive home, walk up to street level, and see the humor in this absurd situation. You are wearing no pants. You break down in laughter. Nobody is around. Mission accomplished.

Over the years one of Improv Everywhere's most reliable stages has been the New York City subway system. Little does the Metropolitan Transit Authority know that they've helped produce over a dozen missions. Everyone knows about our annual No Pants! Subway Ride, but here are some of our other favorite underground missions:

Surprise! / In February of 2002, we held a surprise birthday party in a subway car. A team of agents boarded an uptown 6 train with balloons, banners, and party hats, telling everyone on board that our friend was getting on at Twenty-third Street and we needed their help to throw him a surprise party. We claimed we had another friend making sure our birthday boy got on in the right car, but really Agent Jesse Good was placed in the car in front of us, ready to hurry down the platform and walk into our car at the right stop. Total strangers helped us decorate the car, and as we approached Twenty-third, I got everyone to quietly crouch down. It made absolutely no sense to crouch in a brightly lit subway car, but for whatever reason everyone played along. Agent Good walked in on cue and the crowd of strangers erupted with, "Surprise!" After singing "Happy Birthday," we all ate cupcakes and played pin the tail on the donkey, which we taped to one of the doors. My favorite part was watching a row of people who didn't know each other sharing the same cupcake. Everyone was in such an awesome mood that no one cared about germs!

B-I-N-G-O / In the summer of 2002, Agent Carl Arnheiter and I boarded a subway car announcing that everyone was on "the Bingo Train" and that we would be playing bingo for fabulous prizes. We passed out bingo cards to everyone on board and proceeded

to play until someone yelled, "Bingo!" It was a blast to see total strangers smiling and playing the game together. Our fabulous prizes were only plastic whistles we bought at the dollar store, but no one seemed to care.

Woddy Doddy Ding Dong / Agent Todd Robertson came up with the idea for this mission: what if people who seemed like they didn't know each other started singing the same nonsensical song one by one? One agent singing our made-up tune "Woddy Doddy Ding Dong" would seem like a crazy person, but the world would seem crazy when other agents started joining in. We ended up heightening the gag by having people enter the subway car wearing T-shirts with the song's name on them and finally by having someone enter with a boom box playing a recording of the song (that we made ourselves right before the mission).

The Dollar Dudes / It's common to be asked for money on the subway, but have you ever been asked to take money? For our Dollar Dudes mission Agent Anthony King and I wore shades and dollar-sign necklaces and entered a subway car announcing that everyone was riding the lucky "Dollar Car." We had a big bucket with around fifty single dollar bills and proceeded to hand out cash to every passenger while the Calloway song "I Wanna Be Rich" blasted from our boom box. Almost everyone happily took a dollar and some asked for a second helping. Things got tense when a rival gang (played by Agent Ken Keech and Agent Chris Kula) arrived in sombreros with a bucket full of pesos.

Haunted House / On Halloween night 2003, we turned a subway car into a moving haunted house. Agent Neil Casey developed the idea and helped us cover the car with cobwebs. Music from the movie *Halloween* played eerily from the boom box as a group of

twenty costumed agents moaned and howled at subway riders. No one got too scared, and everyone was happy to take some of our free candy.

Human Mirror / In the spring of 2008, we recruited fifteen pairs of identical twins to create a human mirror on a subway car. The twins dressed exactly alike and sat directly across from each other. They mimicked each other's movements, creating an amazing mirror effect for the New Yorkers who boarded the train. It was hilarious to watch people do double takes at the subway car chock-full of twins. One lady speculated, "They must be going to a twin conference."

mission

date / august 30, 2006

number of agents / 10

objective / Have an entire section of fans at a baseball game help a "lost" agent find his seat.

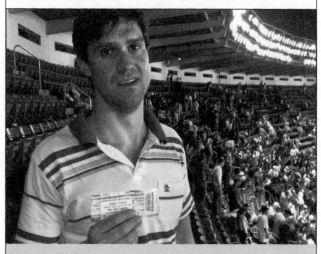

Agent Rob Lathan at Yankee Stadium.

Love it or hate it, Yankee Stadium was the greatest venue in American sports for eighty-five years. Sure, a beer would set you back $9.50 and there was always at least a forty-five-minute wait for the bathroom, but you can't deny that some of the greatest moments in sports history occurred inside the hallowed walls of the House that Ruth Built. Prior to being torn down after the 2008 baseball season, the old Yankee Stadium hosted thirty-seven World Series (twenty-six of which were won by the Yankees), numerous heavyweight prizefights (including

Joe Louis's historic first-round knockout of Max Schmeling in 1938), and the 1958 NFL championship (often referred to as "the greatest game ever played"). Three popes have even given a mass on the field where Joe DiMaggio and Mickey Mantle once roamed. In fact, the Mick once said, "When I first came to Yankee Stadium, I used to feel like the ghosts of Babe Ruth and Lou Gehrig were walking around in there."

Thanks to an Improv Everywhere mission that took place on baseball's grandest stage, the name Agent Rob Lathan needs to be added to the list of legends who have walked around Yankee Stadium. But unlike the Great Bambino or the Yankee Clipper, Agent Lathan never chased down a fly ball or stole second base on the Diamond in the Bronx—he was simply a baseball fan who couldn't find his seat. Among his friends, Agent Lathan was already a legend because of his propensity for getting lost. "In general, I do get lost from time to time," he admitted. "I have an extremely bad sense of direction." So with the help of some Improv Everywhere agents, Rob wanted to get lost on purpose at a baseball game and have an entire section full of Yankee fans help guide him back to his seat. Essentially, Rob would play a bumbling fan even more confused than Abbott and Costello in their Who's on First? routine. The question was, could Rob count on the fans of Yankee Stadium to help bring him home?

 the plan

If you don't know where you are going, you might wind up someplace else.

—Yogi Berra, Yankee Hall of Fame catcher

Few people have a knack for getting lost like Rob Lathan. "One night I was driving next to a golf course in the mountains of North Carolina," he said. "I made a wrong turn and ended up driving on the cart path for all eighteen holes before I found my way out. And when I delivered pizzas in college, you'd be lucky if I showed up with your pizza less than two hours after you ordered it. I never had a cell phone. I'd blindly drive around looking for the right address." Rob's terrible sense of direction was a lifelong source of frustration until, on a fateful night in Boston, he realized that he could use his powers as a directionally challenged man to entertain others.

"Me and some friends from college took a weekend excursion to watch the Red Sox play at Fenway Park," Rob said. "In the fifth inning, I went to get a beer and some popcorn, and when I came back, I couldn't find my friends. Pretty soon, they spotted me looking like a lost puppy and shouted, 'Rob! Rob! We're over here!' I heard them loud and clear, but I thought it would be funny if I pretended that I couldn't. Their whole row started screaming for me, but I kept walking further away from them, a few aisles over, then a few more aisles over. Everyone got a good laugh out of it."

The following summer, Rob decided to pull off his "lost guy" prank once again, this time on purpose. "The next time I did it was at Shea Stadium [the home of the New York Mets]," he said. "That time, I meandered around several sections. My whole section in the upper deck was involved in trying to get my

attention. I totally ignored them. Everyone in my section was shouting, 'Rob! Rob!' After wandering around Shea for about an hour, I finally walked back to my seat in the ninth inning. I just looked at my friends and said, 'Oh, there you are. I've been looking all over for you guys.' It was pretty funny."

In the summer of 2006, a group of performers from the Upright Citizens Brigade Theatre planned on attending a New York Yankees game. A few weeks before our field trip up to the Bronx, Rob approached me about pulling off his "lost guy" prank on an even bigger scale at Yankee Stadium. I thought it would make a perfect Improv Everywhere mission. It's a fun, simple, and victimless stunt that ropes dozens of people into helping a hopeless guy find his seat.

"This mission calls for something I specialize in: being *lost*," he said. "Yankee Stadium promises to be a good place to get a reaction from the fans for three reasons: there are tons of people around, a baseball game has many lulls, and people are drunk."

Despite its rowdy fans and rich history, Yankee Stadium provided several obstacles that would make our mission difficult to pull off; the stadium has a no backpacks/no video cameras policy, so we'd have a tough time documenting it, and the stadium's ushers are notoriously strict, which might prevent Rob from roving around in a daze from section to section.

Rob and I decided to wait until the day of the game to tell the eight friends who would be accompanying us to Yankee Stadium about the mission. On the subway ride to the ballpark, I explained our plan to everyone.

"In the sixth inning of the game, Rob is going to get up to buy a beer and a hot dog," I said. "When he comes back to find his seat, he's going to pretend to be lost. We all need to try to

get his attention by shouting his name and getting people sitting around us to do the same. Rob will ignore us and gradually move further and further away from our seats. Throughout the game, he will periodically pop up in a different part of the stadium. We need to spot him and shout out his name. Eventually, we'll try to get our whole section to help guide Rob back to his seat."

Our friends were all on board with the plan. Rob dressed for the mission by wearing a red and white striped shirt. "That shirt was key because it's noticeable from all corners of the stadium," he said. "It made me easy to spot in a crowd, and it somewhat resembles Waldo's shirt from the *Where's Waldo?* books. It's a staple of my wardrobe."

The game we were attending was the second contest of a doubleheader versus the Detroit Tigers. It was a beautiful summer evening, and we were enjoying the game from our seats in the upper deck out in right field. The Tigers were ahead of the Bronx Bombers two runs to none in the sixth inning. During a pitching change, Agent Lathan stood up and addressed his friends. "I'm gonna go get a beer and a hot dog," he said with a smile. "I'll be right back."

the mission

Rob returned a few moments later carrying a cardboard tray with a couple of jumbo hot dogs and a giant beer. He paced up and down our aisle right by our group several times, pretending that he couldn't see us. The few agents who were in on the prank hopped up and started yelling, "Rob! Rob!" while waving their hands. Rob just stared past us with a vacant look on his face, neither hearing nor seeing us. A few strangers in the vicinity of Rob's seat started shouting his name as well, but no one could seem to get his attention.

"I glanced around at everyone who was shouting my name, squinted in their direction, and glanced down at my ticket stub," Rob said. "I eventually gave up, retreated from my section, and disappeared back into the tunnel under the stands."

Approximately five minutes later, Rob appeared again, this time in an aisle two sections over. An agent from our group spotted him and we all started yelling his name again. Since Rob was now two sections over, dozens of spectators in between the group of agents and our lost friend also started shouting out his name.

"The hysteria caused by the agents had quickly spread," Rob noted. "I thought nobody would care, but as soon as I appeared again, all of these Yankee fans went crazy. I didn't know any of these people, but they were all like, 'Rob! Rob! Your friends are looking for you! Your friends are over there!'"

Rob just kept pacing up and down the stairs, looking quite pitiful while lugging around his huge platter of concessions. After failing to locate his seat for a second time, he disappeared again into the tunnel and everyone sat back down. The Yankee fans seated around us started laughing hysterically.

"What the hell is wrong with your friend?" one of them asked.

"I dunno," I said. "He just seems totally lost."

"How much has he had to drink?"

"It looks like one too many," I said.

After another five minutes passed, Rob appeared again, this time in the section just to the left of us—the one in the middle of the two sections he had already searched.

His head emerged from the tunnel for about ten seconds, like a turtle's head peeking out from its shell. "I quickly squinted up at my section, heard a loud 'Rob!' Then I darted back in the tunnel," he said. "It was just a little tease to keep my spotters on their

toes. I also didn't want to get tackled or grabbed by a concerned citizen who desperately wanted me to find my seat."

In case you forgot, there was still a baseball game in progress during our search for Rob, and a pretty exciting one, too. The Tigers were ahead of the Yankees two runs to nil, but the Bronx Bombers had two runners on base and were poised to tie the game. Yankee fans quickly forgot about Rob and focused their efforts on rooting for the home team. Just when the fans' enthusiasm reached a fevered pitch and it seemed the Yankees were about to mount a serious comeback, the Tigers decided to change pitchers. This break in the action provided a nice lull for Rob to strike again.

The fourth Rob appearance occurred seven sections away from his seat. During the pitching change, he sauntered up and down an aisle about fifty yards away from us. Agent Chris Kula and I spotted him. We started pointing at him and screaming his name at the top of our lungs. Nearly every person in our section jumped to their feet and joined us, waving their arms and shouting, "Rob!" At the sound of his name, Rob cocked his head in our direction, squinted his eyes like Mr. Magoo, shook his head in frustration, and then disappeared back under the stands.

After the fourth Rob sighting, the enthusiasm for helping him back to his seat had swelled to the point where other groups of people were more excited about it than the agents were. A group of Yankee fans sitting directly behind us began leading a series of chants as they waited for Rob to emerge again. Several rounds of "WHERE-IS-ROB? WHERE-IS-ROB? WHERE-IS-ROB?" were followed by the somewhat cruel chant "ROB'S RE-TAR-DED! *[clap-clap! clap-clap-clap!]*" A few other sections joined in on the chants as Yankee fans speculated about what was going on with this poor Rob character.

For his fifth appearance, Rob deftly used his training as a comedic performer. "In improv comedy, you always need to heighten your joke," Rob said, "so I figured the best way to heighten my awful sense of direction would be to make an appearance on the exact opposite side of the stadium. I wasn't sure if they'd be able to spot me from that far away, but when I looked to the other side of the stadium, I saw everyone in my section standing and waving their arms at me."

Sure enough, just after the Yankees surged ahead of the Tigers in the bottom of the sixth with a score of 3–2, I spotted a very tiny Rob, wearing his red and white Waldo-style shirt, amid a sea of fans wearing Yankee blue in the farthest section possible from his seat. Word of the Rob sighting traveled quickly through the upper deck, and soon sections of strangers rose to their feet and started waving frantically at our lost friend. "From that extreme distance, I couldn't hear them, but I definitely saw my section waving at me," Rob recalled. "I walked up and down the aisle a few times, making sure everyone on the other side of the stadium could see me, and then I disappeared again." The concern and frustration of the fans seated around us were escalating with each new Rob sighting. Rob's odyssey to try to find his way back to our section had become a race against the clock. Could this poor, hopeless, lost soul ever locate his seat?

Not any time soon. The seventh-inning stretch provided another break from Rob spotting, but as soon as we were done singing "Take Me Out to the Ballgame," Rob made his most surprising appearance yet: right next to the Yankee dugout!

"I knew that if I popped up by the Yankee dugout it would be the ultimate Rob sighting, but this was no easy feat," he confessed. "I knew it'd be difficult to make an appearance by the dugout because they have chain-link fences guarding the aisles. You have to show your ticket to the usher in order to

gain entrance. So I waited there until a hot dog vendor walked through, and I just snuck in behind him. And then I walked right down to the dugout. I took my time, looked around, and stayed in character—even though the people I was performing for were in the upper deck and couldn't see my face. I was still far away from my section, but I could hear a faint roar when I appeared. That got my adrenaline pumping. I was excited with how well the mission was going."

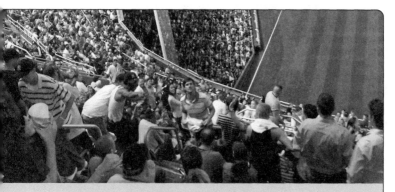

Fans pointed a very lost Rob in the direction of his seat.

After Rob disappeared under the stands at the end of the seventh-inning stretch, the fans seated around us began to grow restless. "What is the deal with this friend of yours?" they demanded. The agents just shrugged their shoulders. Dozens of people seated around us expressed concern about Rob's well-being, while others devised plans to find him. Hundreds of fans in the upper deck were on the edges of their seats, trying to be the next person to spot Rob. In the middle of the eighth inning, they didn't have to look far.

Without warning, Rob suddenly emerged from the tunnel directly in front of our section. The reaction from the Yankee fans was priceless. They jumped to their feet and erupted in

deafening cheers. It seemed like the appearance of Rob in his own section gave the fans the same jolt of energy as a Yankee home run in the bottom of the ninth. Several sections began chanting, "Rob! Rob! Rob!" while others pointed him toward his seat. With his overloaded concessions tray in hand and a huge grin on his face, Rob was mobbed by several fans who gave him high-fives and took pictures with him. A concerned usher walked up to him and firmly grabbed his arm.

"Have you been drinking, sir?" he asked.

"Only one beer."

"Well, this is your last beer! Are you a diabetic or something?"

Rob nodded and said yes, even though he isn't. He walked up the aisle to our row as the Yankee fans continued cheering and chanting his name. He had finally reached the end of his epic journey through the House that Ruth Built. With a look of relief on his face, Rob took his ticket out of his pocket, raised it in victory, and said the words everyone had been waiting to hear:

"I've been looking all over the place for you guys!"

 the aftermath

The Yankees ended up losing to the Tigers by a score of 5–3 that night, but none of the Yankee fans in our section walked out of the stadium with dejected looks on their faces—they were all still buzzing about Rob's discovery of his seat in the eighth inning. During his quest, Rob had somehow managed to become a semi-celebrity. People approached Rob and asked to have their picture taken with him or to have him autograph a baseball.

"After the game, as I strutted down the exit ramp, several people from other sections of the stadium pointed me out and

gave me a few shout-outs," Rob said. "I nodded my head and pointed back at them as the Fonz would have done back in the day. I realized I better soak up this attention while I can."

In the weeks after the game, the legend of Rob getting lost in Yankee Stadium continued to grow. Will Leitch, the former editor of deadspin.com, wrote on his popular sports blog, "All in all, it's not just funny, but kind of sweet, as random New Yorkers band together to help a dopey fan with a hot dog figure out where the hell he is."

Even years after he got lost, Rob still remembers this mission fondly. "It was a blast to pull that prank off in Yankee Stadium," he said. "So many amazing things have happened in that ballpark: Lou Gehrig gave his farewell speech, Reggie Jackson hit three home runs in the World Series, Don Larsen threw a perfect game in the Series, and Lathan got lost. I mean, where's my plaque?"

Despite the quasi-fame Rob attained because of this mission, he noted that the best part of the prank was giving the Yankee fans a story to tell and something to cheer about even though their home team lost. "It felt great to see all of those people go crazy when I found my seat," Rob said. "It made me realize I should get lost more often."

↑ | **mission accomplished**

objective / Get separated from your friends in a crowded area. Act extremely lost and let members of the public help you find your way back.

Are you as directionally challenged as Rob? Then this may be the mission for you. Here are a few locations other than a baseball game where you can get lost.

Ski Resort / Enter a posh ski lodge wearing a pair of board shorts and sunglasses. Carry a surfboard and ask skiers if they can direct you to the beach.

High School Football Game / Wear a football uniform of a team that is *not* playing in the game you go to. Wander around the sidelines and the stands asking people, "Is Central High playing in this game? Shoot! I must have gotten on the wrong bus!"

Rodeo / Attend a rodeo dressed like a matador. Speak with a thick Spanish accent and ask various cowboys and rodeo clowns, "*¿Donde está el* bullfight? Which way to España?"

Marathon / In 2007, Rob's "lost guy" character made an encore appearance at the New York City Marathon. Rob ran the entire marathon, but never on the right course. Dozens of New Yorkers tried to steer him in the right direction, but to no avail. Rob never crossed the finish line.

Parade / Everybody loves a parade. Pose as a wayward marching band member, beauty queen, drum majorette, or Shriner in a miniature car and get lost on the parade route!

how to look lost

by agent rob lathan

I probably have an unfair advantage in this department, since I was born looking lost. But for those of you who don't automatically appear disoriented, here are some helpful tips:

01 / Pick an open and crowded area. It also helps if this area is heavily populated with loud, obnoxious, drunk people who will eagerly hurl obscenities at you as you wander around in your oblivious state . . . I chose Yankee Stadium. But if you don't have access to Yankee Stadium, there are plenty of other open and crowded areas all over the world.

02 / Be noticeable. Wear something that people can easily pick out in a crowd, for example, a red-striped shirt from *Where's Waldo?* Carry something too, like a tray of food or some ski equipment. The more awkward you look, the better.

03 / Squint. Look up into the air and squint your eyes as if you can barely make out what is in front of you.

04 / Stumble. Move your feet and body around aimlessly.

05 / Look desperate. Open your mouth wide and have a frantic look about you. You want people to think you are a poor, lost puppy. Be the puppy.

06 / Tease your audience. Get really close to your desired destination. Then walk away fast.

07 / Drift farther and farther away. Slowly start to get more and more lost until you are a tiny speck on the edge of the horizon.

08 / Act surprised to find your way. When you finally make it to your desired destination, say something like, "There you are! Aw, man, I've been looking all over for you guys!"

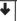 **urban prankster global network /
where's waldo?**

R!OT, an Improv Everywhere–inspired prank collective operating out of Houston, invaded a Target store in Katy, Texas, and brought the children's picture book *Where's Waldo?* to life. In their mission, one agent was dressed exactly like Waldo (red ski cap, red and white striped shirt, blue pants, and black horn-rimmed glasses) and another agent dressed like Waldo's girlfriend, Wenda. Another eleven agents, also dressed in red and white from tip to toe, milled around the store, while a plainclothes agent approached Target customers and employees and asked if they had seen his friend, Waldo. Customers who claimed to have spotted Waldo were rewarded with an I Found Waldo sticker. To signal the mission's end, the plainclothes agent got an employee to page Waldo over the intercom and ask him to come to the front of the store, where a crowd of Waldo admirers had gathered. The agents of R!OT had so much fun reenacting *Where's Waldo?* that they repeated their mission in a Petco, an AT&T store, and Famous Footwear.

mission 12

date / march 19, 2005

number of agents / 68

objective / Capture the attention of pedestrians by having sixty-eight agents dance in the window of a department store.

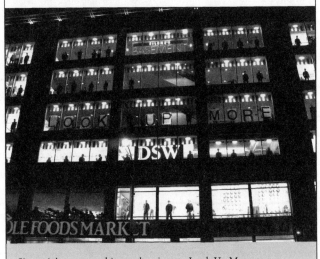

Sixty-eight agents asking pedestrians to Look Up More.

New Yorkers are notorious for being in a hurry. Commuters push and shove their way onto crowded subways. Taxi drivers cut each other off and blare their horns as everyone hustles to get where they're going in—what else?—a New York minute. Whether they're on their way to work, a dinner date, a Knicks game, a gallery opening, or any of an infinite number of activities to do on any given day, residents of the five boroughs are constantly on the move. Not only do New Yorkers live life at a frenzied pace, but they also tend to be a bit removed from their

surroundings. Most people dash around the city while listening to an iPod or ride the subway with their nose buried in a newspaper or a book, oblivious to the chaotic jumble of city life.

The goal of Improv Everywhere is to create scenes of joy and chaos throughout the city—scenes that will make people look up from their newspapers and turn off their iPods for a minute or two. In 2005, a team of sixty-eight undercover agents dressed in black invaded a building that housed a department store, a shoe store, and a women's clothing store, and pulled off a performance that asked their fellow New Yorkers to Look Up More.

❶ the plan

My initial intention for this mission wasn't to make any kind of social or political statement. I just wanted to capture the attention of people walking on the street. The idea for Look Up More came to me one evening while I was walking through Union Square near Fourteenth Street in Manhattan. I stopped in the park for a moment, and while looking up, something caught my eye. A girl was dancing in the second-floor window of Forever 21, a brand-new retail store at the time. Since it was night, the windows of the store were brightly lit, making the dancing girl a silhouette. I watched and laughed as she danced with wild abandon. The girl's behavior was unexplainable. A few minutes later, her friend appeared in the window, and the two giggled and ran away. It seemed that the dance had been a dare.

The girl's window dance was one of the most entertaining performances I had seen in a while. I stepped back and looked at Forever 21's building as a whole. The six-story structure had been empty for years, but each level had recently been

spruced up and leased to four different businesses: Forever 21 (a women's clothing store), DSW (a shoe store), Filene's Basement (a discount department store), and Whole Foods Market on the ground floor. The Whole Foods was the last new store in the building, and it had just opened its doors a few days before I saw the dancing girl.

I figured if watching one girl dancing in one window had been so interesting, it would be incredible to see dancers in every single window in the building. A few days later, I began to do some reconnaissance. I calculated that there were sixty-eight accessible windows that any shopper could stand in front of and dance. There were a few more that would require jumping barriers to reach, so I decided it was best to leave those alone. The windows provided an ideal stage for a mission. At night, they are brightly lit and they're perfectly situated directly across the street from one of Manhattan's largest parks. At any given moment, hundreds of people walk through Union Square and out of its busy subway station. Attracting an audience wouldn't be a problem.

I began brainstorming choreography ideas with Agent Ken Keech (who also choreographed the Synchronized Swimming and Megastore missions). Together, we envisioned having one agent dressed in black dancing in each of the retail store's sixty-eight windows. I knew that at some point in the mission, I wanted the agents to use giant letters to spell something out, like student sections at college football games do. Agent Porter Mason suggested the perfect phrase: Look Up More. It was simple and it would surely get the attention of pedestrians down below. Agent Chris Kula was able to print out the message using four-foot-tall letters at the engineering firm where he worked. A couple of weeks before the mission, I contacted

all of the agents on the Improv Everywhere e-mail list and asked them to dress in all black and meet in Union Square at the designated time.

On a Saturday night at eight-thirty P.M., sixty-eight undercover agents slowly trickled into the park all dressed in black pants and black shirts. It looked like a convention of either ninjas or beatniks or both. This was our first meeting. We had had no rehearsals, and we needed to mobilize and take over the windows before the stores closed at nine-thirty P.M. I distributed two items to every agent: a photograph of the building with each of the windows individually numbered, and a palm-sized cheat sheet of instructions for our performance. The instructions were personalized for each agent, telling them where their window was located and giving specific direction's unique to their spot on the grid.

Ten agents were chosen to hold up our LOOK UP MORE letters, and Agent Tyler Walker was given the task of smuggling the letters into the building and distributing them to the appropriate agents. Three agents were chosen to be solo dancers. During our performance, each of the soloists would have a moment in the spotlight while the other sixty-seven agents pointed toward their window.

Using my megaphone, I addressed the agents gathered in Union Square. I explained that our mission was to put on a dance performance in the windows of the retail building overlooking the other end of the park. The dance routine would be choreographed by a simple signaling system that I devised. I would position myself next to a green trash can on Fourteenth Street. My location would be visible to each agent so long as there were no large buses or trucks obstructing their view. I would advance the dancing agents' performance through eighteen different stages by using a very simple binary code.

My hand would either be on the trash can or by my side. Every time my hand moved, it was the signal the agents to move on to the next phase of the mission. We did a quick run-through of the performance at the meeting point (which was out of view from our target building), and it seemed that all the dancers could follow my signals with relative ease.

With about a half hour left before the stores would start to close, the agents stealthily dispersed and headed to their windows. Our digital video cameramen and photographers staked out the area from all angles, including some who positioned themselves discreetly inside the stores. This was the most ambitious Improv Everywhere mission to date in terms of both logistics and personnel size. As I stood by the trash can, waiting for the dancers to get in place, I suddenly got very nervous about our guerilla performance. How would three separate stores on five different floors react to our invasion? Would they communicate with each other and try to shut us down? Would they realize that the dancers on their floor were on every floor of the building? We wouldn't be breaking any rules or laws,but there was still no way to know how they would handle sixty-eight dancers taking over their store windows.

❚❚ the mission

It took a few minutes longer than expected to get all sixty-eight agents in place. Agent Aziz Ansari (who later starred in MTV's *Human Giant*) was in charge of the letter U and he got a little bit lost on the way to his window. In the meantime, three agents in DSW were unable to get to their post. I warned them that this might occur; their windows were behind a roped-off area near the DSW cash registers on the far right side of the building. Once they were told the area was off-limits, the agents

cleverly filled a few holes elsewhere in the building. Two went downstairs to Forever 21, and another jumped a barrier by the elevator on the fifth floor at Filene's Basement and occupied an extra window there.

With Agent Ansari and his giant U finally in place, I gave the first signal to initiate the performance. Fifty-eight agents remained still while ten others picked up their letters and placed them against the windows, spelling LOOK UP MORE. People

Onlookers in the park cheered as our agents executed the jumping jacks phase of their dance routine.

walking through the park stopped in their tracks to look up, and many laughed and cheered at the impressive sight. Dozens of people began pointing out the sign to strangers, taking photos, or phoning friends to tell them about our stunt. From my spot on the street, I could tell that the management at DSW was giving the agents trouble, so I gave the signal to move things along. In unison, the entire grid began doing jumping jacks. As I was orchestrating the agents' dance moves, I saw a security guard at DSW physically forcing some agents to leave the store. I later found out that he literally yelled, "No jumping jacks allowed!" Apparently jumping jacks are taboo in a shoe store. Things looked to be under control on the other four floors, so

I gave the next signal and initiated the free-form dancing segment of the performance.

Our first dance soloist was Agent Flynn Barrison, located at window fifty-one in DSW. Unfortunately, by the time I gave the signal for his dance solo to start, he was being escorted out of the store by security. Unaware of this turn of events, the rest of the grid pointed to Agent Barrison's empty window. The next signal threw the focus to Agent Alan "Ace$Thugg" Corey, positioned on the far right-hand side of the building in window twenty-four. As every dancer in the grid pointed toward him, Agent Corey flailed his arms in the air and danced his heart out with overexaggerated moves that could be enjoyed by his audience in the park hundreds of feet away. Agent Nick Kroll had the final dance solo. Located in the especially bright lights of Forever 21, he rocked his body all by himself, unable to hear the crowd outside cheering him on.

I put my hand back on the trash can, signaling the agents to lie down on the ground for a count of fifteen seconds. The black-clad agents disappeared to the spectators in the park and then suddenly popped back up and continued dancing. Another signal was given, and the dancers faced backward and danced with their backs to the park for another count of fifteen.

The dance portion ended and the grid stood still. When signaled, row two began jumping as the other rows above it pointed downward. Row three, in DSW, was supposed to join in with the jumping on the next signal, but the agents in that store had been totally cleared out by security. Each of the three rows of Filene's Basement joined in as the jumping spread upward one row at a time until the entire grid was hopping up and down. The next signal took the dancers back to their original standing position. I then took my hand off the trash can to signal the return of our letters.

As LOOK UP MORE was displayed a second time, the crowd instinctively knew we had reached the end of our performance. They began to applaud and cheer as I gave the signal for the agents to disperse. Having been focused on the building, I didn't get much of a chance to see the crowd watching our performance, but it was quite impressive when I finally did turn around. More than one hundred people had stopped to witness the mission, and they were all smiling and cheering. Throughout the performances, and even afterward, nobody took any notice of me. It seemed as if none of the onlookers realized that I had been conducting the entire performance with my hand signals. I had simply been a guy talking on his cell phone with one hand and leaning on a trash can with the other. With many spectators still applauding, I walked through the crowd and back to the meeting point in anonymity.

III the aftermath

Although it seems like a simple mission on the surface, Look Up More was a watershed moment for Improv Everywhere. It was the first time I had organized a large group of agents (sixty-eight seemed like a lot of agents at the time) and coordinated and planned every detail of the mission. As I explained the directions to the sixty-eight agents dressed in black, I felt like we were Robin Hood's Merry Men about to pull off a covert operation for the common good. The success of Look Up More gave me the confidence to pull off bigger and riskier missions, like Even Better Than the Real Thing, Best Buy, and Frozen Grand Central.

Two years after we pulled off Look Up More, I received an e-mail from a stranger who had watched our performance from Union Square. This e-mail was one of the best compli-

ments Improv Everywhere has ever received and it validated our goal of causing scenes of joy and chaos and giving people a story to tell:

Just wanted to drop you a quick note—I've actually been on your mailing list for the past year and a half or so, but I just found out today (through the Gothamist website) that the Look Up More mission in March 2005 was done by you guys. I was so happy to find this out, because the night of that mission was the night of my girlfriend's and my first date, and we happened to be sitting in the park, and saw the dancers. We were so confused (but highly entertained), and spent a good amount of time sitting there, taking it in and laughing about it. We've been together for the two years since then, and every so often we'll still bring that event up, wondering who was dancing in the windows. I like to think that it added a little something extra to the night and maybe contributed to us getting to know each other a little better from the very start, and like I said, it's been a great two years together since then. So I guess I just wanted to say thanks and share a story of an unexpected way that one of your missions hit two people. I think you guys are awesome—please keep it up!　　　　*—Jeff Morgan*

↑ | **mission accomplished**

how to get noticed dancing from a five-hundred-foot distance

by agent alan "ace$thugg" corey

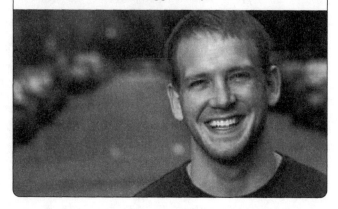

Being a great long-distance entertainer is not without its challenges. The three rules I always abide by to get noticed from five hundred feet are basically to just do the opposite of what you would do when finding yourself in a long-distance relationship.

01 / Exhibit erratic behavior. Yes, turning tears into laughs into death threats creates distance between college sweethearts, but on the other hand, it gets the attention of family, friends, and local authorities. Already we have tripled our audience! In dance form, this is turning the Running Man into the Grand Right and Left into the Booty Clap.

02 / Be a jerk. Bicoastal lovers have to be obedient, attentive, and sweet to keep the fire burning. On the other end of the

spectrum, a long-distance entertainer must completely disregard store managers and security guards trying to stop a storefront-window dance montage from taking place. Remember, to people five hundred feet away, a scumbag being tasered looks very much like the Electric Slide.

03 / Have hype men. When your out-of-reach paramour is someone you've only met online, anyone in his right mind would keep that information to himself. You don't tell your buddies about it and you might tell a coworker or two that your girlfriend lives in Peru. But that's where the details stop. However, a long-distance entertainer lets his friends know what he's doing and where he's doing it and encourages the whisper campaign that accompanies it. You don't want to be doing the herky-jerky ten stories up to an audience of zero. Make sure you are seen and seen by many.

mission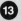

date / october 18, 2003

number of agents / 11

objective / Stage a hypnotism show in a public park, with a chaotic twist ending.

The Amazing Hypnotist (Agent Anthony King) striking an intimidating pose.

Ladies and gentlemen! Step right up and don't be shy.
The time is nigh to read all about the tantalizing mental powers
of Improv Everywhere's Amazing Hypnotist!

Prepare to be astonished! He'll make a grown man strut about
like an ostrich in front of your very own eyes! He'll convince
a volunteer from the audience that he's in the middle of a vast
desert without water! He'll hypnotize complete strangers to fall
in love in the blink of an eye! And he'll make a fat guy dance like
a stripper . . . all by using his spectacular powers of hypnosis!

The Amazing Hypnotist will make you believe the unbelievable! Read on (*if you dare!*) about one of Improv Everywhere's most notorious missions! Imagine you are in a public park on a hot day . . . a tall, menacing man and his dutiful assistant are entertaining a large crowd by hypnotizing total strangers to commit bizarre acts . . . are these men for real or are they fakes? And then, without warning, the hypnotist and his assistant do something that leaves their audience in a state of complete and utter chaos. What could the sensational surprise be? Read on, if you must, but before you continue, just relax and look into my eyes. You're getting sleepy . . . very s*le-e-e-epy*!

 the plan

I just want real reactions. I want people to laugh from the gut, be sad from the gut, or get angry from the gut. —Andy Kaufman

The idea for our Amazing Hypnotist mission was hatched on September 17, 1978, in Chicago, just a few months before I was born. On that night, Andy Kaufman, the great avant garde comedian, and Bob Zmuda, his trusty sidekick, devised a routine to conclude their sold-out show at the Park West Theatre that was intended to shock and appall their audience. Kaufman had grown tired of performing his wildly popular characters, like Foreign Man and Elvis; he wanted his grand finale to be a showstopper that would challenge and bewilder his loyal fans. To achieve their desired effect, Kaufman and Zmuda created an infamous routine called The Masked Hypnotist.

In this bit, Kaufman informed the audience that he had just encountered the Masked Hypnotist on the previous night for the first time, and he wanted to share this amazing performer with them. Kaufman then trotted out the Masked Hypnotist,

who was actually Zmuda wearing a terrifying ski mask. The Masked Hypnotist then took the stage and began hypnotizing volunteers from the audience to perform lewd acts, like eating their own boogers, pissing their pants, or removing their clothes and dancing like strippers. The "volunteers" were, of course, all plants. As Kaufman and Zmuda had hoped, the audience was outraged by this offensive display.

Kaufman stood on the side of the stage, admiring the chaos the Masked Hypnotist caused. When he figured the audience was about to reach their breaking point, he bolted out onto the stage and tried to prevent the Masked Hypnotist from continuing to torture these poor volunteers. But the Masked Hypnotist was an unstoppable force, and he immediately hypnotized Kaufman to sit in a chair and fall asleep. This struck fear into the hearts of the audience—their beloved comic idol had been hypnotized and a mad hypnotist was torturing innocent victims! Just before an audience uprising was about to erupt, a patrol of Chicago police burst into the theater, arrested the Masked Hypnotist, and sent everyone home. The audience trickled out of the theater, shocked and unnerved by what they had just witnessed. They had no idea that the entire Masked Hypnotist scene was a setup, including the cops, who were off-duty pals of Zmuda's.

Twenty-five years after Kaufman and Zmuda pulled off their legendary stunt in Chicago, I was beginning to create my own brand of joyful chaos with Improv Everywhere in New York. I studied every aspect of Andy Kaufman's career and his most infamous performance art pranks. From Andy's career as a "professional wrestler" (he preferred wrestling heavyset women) to his performances as his abrasive, lounge-singing alter ego, Tony Clifton, I devoured as much information on Andy's prankster exploits as I could. When I learned about Kaufman and Zmuda's

Masked Hypnotist prank, I immediately had an idea for how to make their over-the-top prank even wilder. But instead of doing our bit in a packed theater, I wanted Improv Everywhere's hypnotist prank to be performed in the greatest of all New York City street performance venues: Washington Square Park.

Like Kaufman, I didn't want to play the hypnotist; I wanted to be the puppeteer who would manipulate the audience. I decided to play the barker, or hype man, who would rove the park to attract a crowd. So to play the role of the Amazing Hypnotist, I enlisted the help of Agent Anthony King. As you may remember from Romantic Comedy Cab, Agent King is tall and lean, and he sports close-cropped jet-black hair. He's a really friendly guy, but I knew he could play an imposing mentalist, one who would be all business and no smiles.

"I knew I wanted to be a very austere hypnotist," Agent King said. "I was going to wear a black suit, then just stand silently in front of this tall column. I'd just try to look really menacing while my hype man went out and attracted an audience."

My next step was to round up a group of agents to play volunteers. I sent out an e-mail to my agents' list asking if anyone had a bizarre talent, similar to something that would appear on David Letterman's Stupid Human Tricks. My hope was that Agent King would pick out a plant from the audience at Washington Square Park and "hypnotize" him or her to perform a weird trick. Agent Dan Berman immediately contacted me and said that he could be of some assistance. "I can drink an insane amount of liquid in a really short period of time," he claimed.

"Perfect," I said. "The Amazing Hypnotist will hypnotize you to think you are in a desert and that you are very thirsty. Then we'll just give you a large bottle of Gatorade, and you can drink it all in one gulp."

"I can do that," Agent Berman said. "But there's one catch: whenever I pull off this trick, I barf."

"As long as you're okay with that, I'm okay with that," I told him, and with that, we had our first volunteer.

One of the most important rules of performing improv comedy is that the scene should heighten comedically, so I wanted our volunteers to perform progressively crazier acts. I cast Agent Ken Keech in the role of the first volunteer. He would be hypnotized into thinking he was an ostrich. Next, as the Amazing Hypnotist's barker, I would select Agents Charles Roche and Brooks Ann Camper from the audience and interview them in front of everyone. In their interviews, they would say they had never met and were each in a relationship with someone else, even though in real life they were actually dating. The Amazing Hypnotist would then hypnotize them into falling in love and kissing each other.

By this point, my hope was that the audience would be agitated by the Amazing Hypnotist's cruel act, just like in Kaufman and Zmuda's routine. Agent Berman would be the next volunteer selected and would perform his astonishing feat of drinking Gatorade really, really quickly. Finally, Agent John Gemberling, a hilarious comedian who would later star in *Fat Guy Stuck in Internet* on the Cartoon Network, was going to be the last volunteer from the audience. Agent King would hypnotize Agent Gemberling into performing a raunchy striptease.

For the grand finale, the Amazing Hypnotist would hypnotize every volunteer at once. A man in dire need of water, a kissing couple, a male stripper, and a man acting like an ostrich would suddenly inhabit the park. Then for our show's big finish, I had something else in mind, something that would transform Washington Square Park into a chaotic madhouse.

On the afternoon of the Amazing Hypnotist's show, all of the agents who would be playing volunteers met Agent King and me a few blocks away from the park to review our plans. "We didn't rehearse any of it," Agent King said. "We knew what everyone was going to be hypnotized to do. I would give a color, and when I said that color they would be instantly hypnotized. When I said the color again, they would snap out of it. That's all we had planned in advance."

The agents playing the volunteers headed over to the park first to blend in with other park-goers. Agent King and I got into full costume; we were both wearing black suits and oval-shaped eyeglasses—typical hypnotist getups. When we arrived at the park, Agent King slipped into character. "I just stood in front of this large column, legs shoulder-width apart, arms at my sides, and piercing eyes staring straight ahead," Agent King said. "I was trying to look as ominous as possible."

Once Agent King was in place, I started roaming the park, trying to drum up interest in our show. "Ladies and gentlemen, boys and girls, come one come all to witness the Amazing Hypnotist!" Within minutes, a large crowd, including our planted agents, had gathered to watch the performance. "Don't go anywhere!" I announced. "The show is just about to begin!"

❚❚ the mission

"Ladies and gentlemen, I give you The Amazing Hypnotist!" I bellowed at the large crowd that was slowly gathering, with Agent King standing stern-faced and stiff as a board behind me. "Witness his remarkable powers of hypnosis! Prepare to be astonished! May I have a volunteer from the audience?" Agent Keech, who was wearing a blue tracksuit, raised his hand. "I'll volunteer," he said. I coaxed a hearty round of applause out of

the crowd for Agent Keech. He introduced himself. "I'm Ken," he said with a goofy grin on his face, acting like this whole hypnotist act was pretty silly. Agent King, fully immersed in character, began circling Agent Keech like a bird of prey as he delivered his stage patter.

"When Ken hears me say a certain code word, he is going to believe that he is an ostrich," the Amazing Hypnotist announced to the disbelieving audience. "Do you believe that, Ken?" Agent Keech shook his head and laughed, saying sheepishly, *"Ha ha ha . . .* no." The Amazing Hypnotist approached Agent Keech, gripped him firmly by the shoulders, and looked deeply into his eyes. "Ken," he said, *"yellow!"*

At the mention of yellow, Agent Keech instantly transformed into an ostrich. He puffed out his chest, flapped his arms like wings, and strutted around the park. The audience howled with delight. After letting Agent Keech prance around like an ostrich for a good thirty seconds, the Amazing Hypnotist shouted out his code word once more, *"Yellow!"* and Agent Keech snapped out of his ostrich trance with a bewildered look on his face, acting wildly confused by what just happened. "How about a big hand for Ken!" the Amazing Hypnotist said, and the crowd of onlookers roared in approval.

The next part of the mission probably ranks as one of the cruelest acts Improv Everywhere has ever pulled, but that doesn't mean it's not devilishly funny. Agents Roche and Camper were dating in real life, but for the purposes of this prank, they had brand-new significant others. On one side of the audience, Agent Camper stood with her arm around Agent Matthew Kinney, her fake boyfriend. Approximately thirty feet away, Agent Roche was holding hands with Agent Kate Spencer, his fake girlfriend. When I proposed the plan to Agent Roche beforehand, he said, "Being hypnotized to fall in love with

my *actual* girlfriend shouldn't be that hard." As the Amazing Hypnotist's assistant, I pried Agents Roche and Camper away from their faux partners.

I took Agent Camper by the arm and led her in front of the crowd. "What is your name, ma'am?" I asked.

"Brooks Ann," she replied.

"Brooks Ann, is that it? *Brooks* Ann? Now, are you single?"

"No, I have a boyfriend. He's right there," she said, and

The audience looks on in surprise as Agents Brooks Ann Camper and Charles Roche kiss.

smiled and waved at Agent Kinney, who in turn smiled and waved back. Very convincing.

"Now, Brooks Ann, is there any way you could ever fall in love with anyone else?"

Her cheeks became flushed with embarrassment. "No!" she answered with a giggle.

I turned to Agent Roche and grilled him with the same line of questioning. "How about you?" I asked him. "Are you single?"

"No," he said, pointing at Agent Spencer, his fake girlfriend. "She's right back there."

"Oh, so *your* girlfriend is here *as well!*" I said. "So today, the Amazing Hypnotist is going to see if the power of hypnosis is

stronger than the power of love. In just a few moments, he is going to hypnotize Charles into falling in love with Brooks Ann."

The Amazing Hypnotist solemnly stepped forward and put a hand on Charles's and Brooks Ann's shoulders. He leaned forward and whispered into each of their ears. Then, in a booming voice, he said, "Charles . . . Brooks Ann . . . *pink!*"

In an instant, Charles and Brooks Ann went from total strangers to passionate lovers. They gazed amorously into each other's eyes. Charles pulled Brooks Ann closer to him as she gently caressed his arms. The audience gasped, hoping that the Amazing Hypnotist would put an end to this, for the sake of their real boyfriend and girlfriend. Then, Charles did the unthinkable: he leaned in and began slowly kissing Brooks Ann. The audience's gasps turned to shrieks. As their little kiss became a mini make-out session, the audience's focus shifted to Agent Spencer and Agent Kinney, who were acting horrified by what was unfolding before them.

"I got visibly upset, and people were really on my side," Agent Spencer said. "They were saying, 'C'mon, girl, you don't have to take this! This is wrong! You gotta stop this!'" Before the audience became too agitated, the Amazing Hypnotist shouted, "*Pink!*" and Agents Roche and Camper abruptly ended their make-out session. "How about a big hand for Charles and Brooks Ann!" the Amazing Hypnotist said. The audience clapped nervously. What other devious tricks did this Amazing Hypnotist have up his sleeve?

For our next volunteer, I pulled Agent Berman out of the audience. If you remember, Agent Berman has a knack for consuming large amounts of liquid in a ridiculously short period of time. When the Amazing Hypnotist hypnotized him to believe he was in the desert and in dire need of water, Agent Berman reached for a nearby bottle of red Gatorade (which I had conveniently placed there beforehand) and poured it all

over his face. His crisp, clean white shirt (which I told him to wear) was destroyed, and the audience looked aghast at the sight of Agent Berman chugging any water, soda, or Gatorade he could get his hands on. "I think I drank a gallon's worth of liquid in about a five-minute period," he recalled (and for the record, he did vomit afterward).

I could sense our once bemused audience becoming unnerved by the bizarre brand of hypnosis practiced by the Amazing

Agent Dan Berman guzzled an insane amount of liquid after being "hypnotized." Later, he vomited.

Hypnotist. For the final volunteer, I picked Agent John Gemberling out of the crowd. "Ladies and gentlemen," I said, "the Amazing Hypnotist will make this young man believe that he is a stripper!" Agent Gemberling laughed and shook his head. "No way," he said. "No way that is happening." The Amazing Hypnotist placed his hands on Agent Gemberling, looked penetratingly into his eyes, and whispered into his left ear.

"When Anthony was hypnotizing me, I guess someone was listening in, and so he kind of had to bolster up his spiel a little bit to actually make it sound real," Agent Gemberling recalled. "At one point he was like, 'Are you calm? All right, I am going

to come inside of you.' I didn't know if he was trying to make me laugh . . . or if he was just being weird."

"John started laughing when I whispered that in his ear," Agent King recalled. "It almost made me crack. I really have no idea why I said that."

After the Amazing Hypnotist finished casting his hypnotic spell on Agent Gemberling, he announced, "John . . . *green!*" At the mention of his code word, Agent Gemberling transformed

A few minutes later, Agent Gemberling performed a striptease.

from average guy to exotic dancer in the blink of an eye. He twirled his jacket over his head, and then, in a display of raw sexuality, he tore off his shirt. He seductively strutted in front of the crowd, bumping and grinding against anything within his reach, like a statue or a trash can. Some audience members erupted in cheers at Agent Gemberling's striptease; others shuddered in embarrassment at the skanky dance the Amazing Hypnotist was making this poor man perform.

While Agent Gemberling sexily slithered around Washington Square Park like Elizabeth Berkley in *Showgirls*, the Amazing Hypnotist initiated his show's grand finale. "Ken . . . *yellow!*

Dan . . . *blue!*" he called out. "Charles . . . Brooks Ann . . . *pink!*" Suddenly, Agent Keech was prancing around like an ostrich, Agent Berman began lapping up dirty water from a puddle, Agents Camper and Roche started full-on French kissing in front of their horrified and heartbroken boyfriend and girlfriend, and Agent Gemberling was shimmying out of his pants. The Amazing Hypnotist stood still as mass chaos erupted around him. An angry man wearing a striped shirt charged up

The Amazing Hypnotist works his magic on Agent John Gemberling.

to him. "You gotta stop this madness *right now!*" he shouted. Then he turned to me. "Do something!" he begged. "You're breaking up a couple!" We didn't respond to his pleas.

As the ostrich, the stripper, the thirsty man, and the passionate couple were all escalating their actions, the audience was getting ready to start a riot to make the Amazing Hypnotist put an end to the insanity. In the Andy Kaufman version of this prank, this is where the police would have intervened, "arrested" the hypnotist, and sent everybody home. Show over. However, we wanted to do something even crazier. So when the audience was reaching its boiling point, Agent King and I ran out of the

park like two Olympic sprinters, leaving the helpless audience with five hypnotized people on their hands.

"Where did the hypnotist go?" someone demanded to know.

"He ran out of here!" another spectator said. "He left these people hypnotized here!"

"This is insane!"

Agent Gemberling, who at this point was wearing nothing but his boxer shorts, started mounting a statue. Agents Roche and Camper walked over to a bench, where they continued their heavy-duty make-out session. "One lady and the angry guy in the striped shirt came up to us, and they were shouting, *'Pink! Pink! Pink!'* trying to make us snap out of it," Agent Camper said. "But I was just like, 'I gotta go, all you crazy people. I gotta go make out with this guy.'"

Agent Berman turned to the spectators and was begging for anything to drink to save his life. The audience responded by shouting back, *"Blue! Blue! Blue!"* trying to get him to break out of his trance. "At some point, when I ran out of liquids that the Amazing Hypnotist was supplying, I started asking the audience for drinks," Agent Berman said. "Somebody had an ice cream, and I ran over to the crowd and I asked for the ice cream. The guy was trying to hold it away from me. You know, making me dance and beg after it. And the people all around were saying, *'Just give him the ice cream! Just give him the ice cream!'"*

Agent Dan Powell stayed behind to capture the insanity we left in our wake on video. The angry man in the striped shirt spotted him filming the Amazing Hypnotist's victims and immediately confronted him. "Were you with them? The two hypnotists . . . *were you with them?*" the angry man shouted at Agent Powell. "Because if you were, I'm dead serious, we're having a real problem. I got a lot of friends that are cops, and

I will call one right now if you really want it! Because you just broke up a goddamn couple, so if you're with them, tell me! Right now!" Agent Powell assured the angry man that he was just a tourist who happened upon the hypnotist's show.

Meanwhile, Agent King and I were sprinting away from the park as fast as we could. "No one came after us, but I actually fell running, and ripped my suit, and skinned my knee," Agent King said. "I remember thinking as I was falling, *Oh, no! Oh, no! Oh, no! Someone is going to catch me!* I was bleeding from my hands and legs, but I just kept thinking, *You gotta keep running!* Because I was worried that the angry guy in the striped shirt was chasing us."

Back in the park, Agent Spencer and Agent Kinney had abandoned their significant others, Charles and Brooks Ann, out of frustration. Spectators continued yelling, *"Pink!"* at the new lovers, but to no avail. Agent Keech strutted out of the park, still acting like an ostrich, while a man followed him and tried to free him from the hypnotist's spell by shouting, "Ostrich! Ostrich!" Agents Berman and Gemberling slowly trickled out of the park, while Charles and Brooks Ann continued kissing on a bench. A man who had watched the show approached them.

"Do you two know each other?" he asked.

"We just met," Charles said.

"Do you know you have a *girlfriend?*" the man asked.

"What are you talking about?"

"Do you two know that you are hypnotized!?!"

(III) the aftermath

What's real? What's not? That's what I do in my act, test how other people deal with reality.

—Andy Kaufman

Charles and Brooks Ann stared blankly at the man, stood up, and walked out of the park hand in hand, to the shock of everyone who witnessed the Amazing Hypnotist's show.

After every agent fled the park and they were sure that no one had followed them, we agreed to meet up at the Astor Place Barnes & Noble. About half an hour after the Amazing Hypnotist and I disappeared from the park, everyone arrived at the bookstore, giddy with excitement over the successful prank we had just pulled off. While we were all standing around, swapping stories about outraged audience members and Agent Keech's zany ostrich dance, a concerned middle-aged man approached Agent Berman, who was still drenched in red Gatorade. "Excuse me," he said. "I was just in Washington Square Park and I saw the hypnotist's show. I wanted to make sure that you were all right." Apparently, the man didn't notice that not only was he standing in the midst of all of the audience "volunteers" from the hypnotist's show, but he was also standing next to the Amazing Hypnotist himself! "Yeah, I think I'm gonna be okay," Agent Berman assured the man. "I'm out of the desert."

When I saw the concerned man breathe a sigh of relief that Agent Berman was unharmed, I realized that we had just pulled off one of the most convincing Improv Everywhere performances. Because we were so committed to our characters, no one in the audience thought the Amazing Hypnotist was a sham. "That was my biggest fear going into the prank," Agent

King said. "The Amazing Hypnotist seems so ridiculous that I didn't think anyone was going to believe it. That's what blew my mind when we actually pulled it off. I never felt like the crowd doubted what was happening at all. No one ever yelled, 'Fake!' It made me realize how easy it is to fool an audience."

Commitment was definitely the key to making the Amazing Hypnotist's performance believable. "We played it very serious. We were not tongue-in-cheek at all," Agent King said. "Ultimately, I was the straight man, because I just had to be real or the Amazing Hypnotist doesn't work."

Although Kaufman and Zmuda's Masked Hypnotist inspired this prank routine, our ending to the mission was pure Improv Everywhere: we created a scene of chaos by fleeing and we never let the audience in on the joke. By having the cops bust in on their stunt, Kaufman and Zmuda assured their audience that justice would be served to the devious Masked Hypnotist. In our prank, we left the audience to think that these poor people would spend the rest of their lives as a hypnotized ostrich, a dehydrated man, a stripper, and a pair of lovers. "It was like setting up a joke and then leaving before the punch line," Agent King said. "We didn't even get the satisfaction of seeing the audience respond to our joke. It blew my mind that people used the language of the hypnotist to try and get people to snap out of their trances. Basically, the whole thing is just a setup for us running away. It's one of the longest setups ever. Until we saw the video later, we had no idea how much chaos the Amazing Hypnotist caused."

Andy Kaufman not only provided the inspiration for this mission, he also provided the inspiration for the spirit of Improv Everywhere. Kaufman's comedy was filled with mischief and infectious joy, two things that I try to inject in each Improv Everywhere mission. Sadly, Kaufman didn't live to see what he

inspired. He was diagnosed with a rare form of lung cancer in 1983 and subsequently died of kidney failure in 1984. "I think Andy would have liked our take on his hypnotist routine," Agent King said. "It was a fun, different approach to what he did. He played the role of the audience in his. He shouted out, 'This is wrong!' And he tried to stop the Masked Hypnotist. In our version, we didn't have anyone saying 'This is wrong!' The audience had to make that decision on their own. Ours was a little bit experimental, and I think Andy would have approved."

⬆ | **mission accomplished**

how to run away

by agent anthony king

Running. Seems simple, right? Heck, you've probably even done it before. "It's just like walking," you say, "only faster."

But running away? From a befuddled crowd? While wearing a suit? Don't front, yo. That takes skillz.

Now, if you're like me (and let's face it, while we may have some things in common, we're really very different), when you're running away, you may be too focused on your fear that someone might chase after you, catch you, and beat you soundly to pay attention to the often uneven concrete paving the courtyards of New York City's finest parks. And if that happens, you may find yourself tripping, crashing ludicrously to the ground, and sliding across said concrete, leaving layers of skin in your wake.

It's at moments like these that you're going to need those skillz I mentioned earlier. Because you may be tempted to lie

there and wait for your punishment, but you must not give in. You must rise, ignore the stinging sensation emanating from your raw palms and the sharp pain shooting through your twisted knee . . . and run. Run! Better than you did before!

Now, I'm not saying this happened to me (though I'd hope the immense amount of detail in my hypothetical scene might clue in more-astute readers that I'm not exactly inventing from whole cloth here), but I am saying this: when you stand at the edge of the abyss, if you don't keep running as fast as you can, you'll still be at the edge of the abyss when they catch you . . . and beat you soundly.

People often want to know how I came up with the idea to start Improv Everywhere and who influenced us. There are many examples of pranksters and artists using the public space long before we were born, including Augusto Boal's Invisible Theatre, Guy Debord and the Situationist movement, and Allan Kaprow's "happenings" in the 1960s. Truth be told, I really didn't know much about any of those guys when I first started causing scenes. My initial influences were a little more contemporary:

Andy Kaufman / I started learning about Andy Kaufman in college, around the time the Jim Carrey movie *Man on the Moon* was released. I read as many books on Kaufman as I could, my favorite being *Andy Kaufman Revealed,* by his writing partner Bob Zmuda. Zmuda's book tells countless tales of him and Kaufman playing pranks on the unsuspecting public in roadside diners and comedy clubs. I loved how the two of them could pull off a prank at a moment's notice, and that concept of spontaneity really struck me. Kaufman's commitment to staying in character was an inspiration.

The Flaming Lips / Also in college, I started listening to the Flaming Lips and seeing their live performances whenever they were in town. Through the Internet I learned of some of Wayne Coyne's amazing audio experiments in Oklahoma City. One of my favorites was the Parking Lot Experiments, where Coyne got a huge number of people to park their cars in a local parking deck and create a symphony of sound with their car stereos. Coyne passed out a specific cassette tape (hey, it was still the '90s) to each driver and counted down to the moment where they all pressed play simultaneously. I was struck by the idea of people coming together

to pull off an experiment in the public space. Their regular concerts were also a huge inspiration. The participatory atmosphere they create by passing out giant balloons and asking the audience to sing along generates an amazing sense of communal fun that I strive to match with Improv Everywhere missions.

The Upright Citizens Brigade / It's no secret that I'm a huge UCB fan. When I moved to the city one of the first things I did was sign up for an improv class at the UCB Theatre. You may know the UCB from the TV show they had on Comedy Central in the late '90s. We lovingly borrowed (ripped off?) our agent and mission terminology from their characters on the show. During the closing credits of each episode they would take their sketch characters out onto the streets of New York to interact with real people. The results were always hilarious. The UCB and their disciples also taught me a hell of a lot about comedy. It was there I learned the keys to long-form improv that influence everything I do.

how to film or photograph a mission undetected

In 2008, Improv Everywhere pulled off a mission called Mobile Desktop in a Starbucks. The objective of the mission was to have three agents enter the coffee shop one by one and set up a giant desktop computer, each with an enormous monitor, and use the shop's Wi-Fi connection. The mission was a success, and that is thanks to two of my most trusted agents, Matt Adams and Katie Sokoler, who covertly film and photograph the majority of our missions. Here are their recollections of Mobile Desktop, along with some tips on how to film your own missions.

do you know you can't tape in here?

by agent matt adams

When you're filming a prank, it's important to never call attention to yourself. Hide your video camera however you can. With a still camera, it's not imperative that you should conceal it, but if you are filming with a video camera exposed, people

will immediately start asking questions. Put the camera in a bag. Shoot from your hip. Do your best to conceal the camera. I'm not saying that you can't ever expose your camera, but you'll definitely have less of a headache if you can pull off a prank without letting anyone know that you were filming.

When I was shooting Mobile Desktop, I hid my camera in a paper Starbucks bag with a hole cut in the front so the lens could peek out. You want to get footage that's not only usable but that also contains honest reactions. Thirty minutes of people running up to the camera and flipping it the bird, throwing gang signs, and asking you what reality show you work for isn't going to be usable footage. When people know that they are being videotaped, they act completely different. As soon as the camera is spotted, people know that something's up.

The key to getting the best possible footage in any location is being able to adapt. You don't want people to know that you're in on the gag. If you get busted with a camera or need to take it out to interview someone, always have a reason for having a camera that suits the situation, but never let it be that you are part of the prank.

I've played several characters during Improv Everywhere missions that have allowed me to film uninterrupted. Some of the characters that have worked well for me are a film student, who just happens to have a camera on him, and a tourist who is confused but intrigued by what's happening.

by agent katie sokoler

Unlike Agent Adams, I never hide my camera during a mission! Instead, I hang it around my neck and try to blend in. People tend to think I'm a lot younger than I am. I'm pretty small, I have a high voice, and it's impossible for me not to smile, so they usually assume I'm a student. When the mission starts and people notice strange things happening, I react with everyone else—*I'm shocked!* People ask me if I know what's going on and I tell them, "No, but thank God I have my camera; these will make great photos for my photography classes!" The people around me agree and actually encourage me to take more photos.

My favorite mission was Mobile Desktop. I met a woman who quickly befriended me when she noticed something was going on. She grabbed my arm and started ranting about what had been happening. She thought I was so lucky to have a camera on me to photograph it. She didn't want me to get in trouble because you're not supposed to take pictures in a Starbucks, so she covered me up so I could get great pictures for my "class." She then started making calls to her friends. When they didn't pick up she left them lengthy voice mails saying that she was in the Twilight Zone.

I always wished I had photos or video from the Ben Folds mission that started Improv Everywhere. It was an amazing night, but the story is all we have to show for it. There is only one artifact that exists, a cocktail napkin with the word Kristen and a Los Angeles telephone number written on it. It was from one of the two super-friendly girls I had spent most of the evening talking to. They were in town on business from L.A. and happened to be in the right bar at the right time. I didn't ask for her number; she just offered it to me, hoping to stay in touch with her new celebrity friend. I told Kristen that I'd call her "the next time I do a show in L.A."

In the months that followed the mission, I debated calling the number. Wouldn't it be hilarious to call her and pretend again to be Ben? Even calling her to let her in on the joke and hear about the experience from her point of view would be fascinating. I ultimately decided it was best to just let it be. Part of the fun was giving someone a strange experience that could not be explained. Still, it irked me that I never heard from Kristen or her friend. I thought for sure I'd get an e-mail from her at some point as the website became more and more popular.

In August of 2006, exactly five years after the mission, I decided it was time to give her a ring. Our five-year anniversary was a big landmark for me. I couldn't believe how far we'd come, and it seemed like an appropriate time to check in with someone who was there the moment it all started. On the evening of the anniversary, Agent Chris Kula set up his camera on a tripod, and I prepared to dial the number using Skype (so I could record the audio as well). I gave a three-minute intro to the camera explaining what I was about to do and how long I had waited to

do it. I dialed the number and held my breath. "We're sorry, but the number you have dialed is no longer in service." It was the biggest anticlimax ever, and it's caught on tape. I guess I'll never hear from her. Unless of course she reads this book!

Three months later I got an out-of-the-blue e-mail from Corn Mo, a New York musician whom I had once seen perform in Brooklyn. "Hi, I play in a one-man band called Corn Mo," he wrote. "I'm on the road with Ben Folds. He wants to do something with you at one of the NY shows this weekend." I was skeptical about the legitimacy of the e-mail (when you run a prank website you have to treat incoming e-mails with a certain amount of suspicion), but I wrote back and said I would be thrilled to help Ben out in any way he saw fit. I was always a little worried he might be upset if he ever found out I had stolen his identity for a few hours that fateful night, but at least I had done my best to represent him as an awesome guy.

The next day I got a call from Ben himself. He explained that his bassist Jared Reynolds was a fan of the Improv Everywhere website and had told Ben all about our antics and how it had all begun with a prank involving him. Ben was coming to New York at the end of November and wanted to know if I'd be interested in pulling a stunt at his show. "Yes, that sounds great," I said, picking my jaw up from the ground and trying to hold back my excitement. I've been a Ben Folds fan since I saw him at the small Cat's Cradle club in Chapel Hill back in college. This was a dream come true!

Together, we devised a plan. The concert would start out with a group of imposters. For the second time in my life I would get to impersonate Ben Folds, but this time rather than doing it in a bar for 30 people, I would be onstage at the Hammerstein Ballroom in front of 3,300. Agent Anthony King would play drummer Lindsay Jamieson and Agent Flynn Barrison would

play bassist Jared Reynolds. Since none of us could play our assigned instruments, we would pretend to play along to a prerecorded track and attempt to fool the crowd into thinking we were the real thing.

We had a rehearsal at sound check where Ben taught me the proper way to imitate his trademark piano-playing stance. But no amount of rehearsal could prepare us for how it felt standing backstage and peering through the curtains to see the sold-out house. The lights went down and an announcer boomed, "Ladies and gentlemen, Ben Folds." The crowd absolutely erupted as the three of us walked onstage. As I've mentioned before I don't *really* look like Ben, but I was dressed as close to him as I could be, and it certainly didn't hurt that he had loaned me his glasses. As I positioned myself in front of the piano and looked to Agent King to cue the start of the song, I could tell almost everyone was falling for it. Sure, there were a few rows of die-hard fans who had camped out all day to be at the very front who immediately knew I was an imposter, but the other three thousand didn't notice a thing. They were too far back.

For whatever reason, Ben chose his cover of the Cure's "In Between Days" as our song. I don't think he knew that the Cure is my all-time favorite band, but either way it was just like heaven for me when the track began blasting from the PA system. We fake-played along for twenty seconds or so and then the song skipped slightly. This was planned, of course; Ben had his engineer in Tennessee alter the song just for this prank. We played through, pretending like it didn't happen, until moments later it skipped again, this time so badly that the song stopped. Boos erupted from the crowd as most thought Ben Folds had just been busted lip-synching. It was Milli Vanilli and Ashlee Simpson all over again. We had a camera in the audience that picked up one fan's succinct assessment of the situation: "You guys are fucked."

The track started over from the beginning as the crowd continued booing. Those savvy enough (and close enough) to know what was really going on were laughing. The song skipped and stopped again, and this time my bandmates abandoned me, fleeing for the wings. The crowd roared as the real Ben Folds came

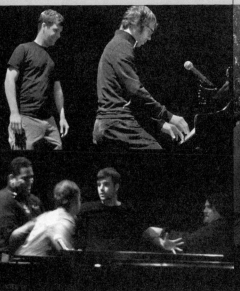

Ben Folds showing me his tradmark stance.

Security guards hold me back as Ben Folds pretends to sock me in the gut.

Ben Folds and me. Five years after our first prank . . .

. . . Improv Everywhere comes full circle.

onstage. Two real Hammerstein Ballroom security guards held me back as Ben slowly reclaimed his glasses and then socked me in the gut, which was faked but looked real from the crowd's point of view. Without commenting on the stunt, he took his seat and started the show. It was an awesomely creative way to begin a concert and the fans went wild for it. For us, it was

an incredible way to mark our five years as a group, coming full circle to our very first mission.

Speaking of coming full circle: congrats on making it to the end of this book. You did it! Now, what's next? If you're interested in learning more about Improv Everywhere and seeing the videos from these and many more of our missions, get thee to ImprovEverywhere.com right away. We promise you can procrastinate an entire week's worth of work reading about and watching our missions there. I certainly procrastinated a few years' worth of work building the site. If you're already a fan and have seen it all, check in with our blog urbanprankster.com to get a steady stream of updates featuring pranks and public art around the world.

Or better yet, get involved yourself! In January of 2008 I set up a site to help people just like you get organized at the local level. Head to UrbanPranksterNetwork.com and see if your hometown has a group already formed. We've seen an explosion of local groups since launching the site, and many have gone on to create some pretty spectacular missions, some of which you've read about here. If there's not a group in your town, well, start your own! Hopefully this book has filled your brain with fun ideas and practical tips for making that happen.

If you don't feel like you have the organizational skills to get something started, you can always aid the cause by spreading the word to your friends or sending in ideas to Improv Everywhere. We love getting new ideas, and every now and then an Internet submission from a stranger becomes our best new mission. You can reach us via the website.

Have fun causing scenes, and see you at the next mission!

Agent Charlie Todd

This book, like any successful Improv Everywhere mission, was only possible because of the hard work and dedication of many people. We'd like to thank Farley Chase, our intrepid agent from the Scott Waxman Literary Agency, for believing in this project from the beginning. Jennifer Schulkind and Mauro DiPreta, our fantastic editors, brought our vision for this book to life and helped keep us on course as we wrote it. The entire HarperCollins team was extremely generous and helpful as they shepherded this book through production, and we'd especially like to thank Bri Halverson and Jean Marie Kelley. We'd also like to extend a huge thank-you to Chad Nicholson, our photographer; so much of Improv Everywhere's humor is visual, and Chad is always on the front lines, camera in hand, to document our missions. His contribution to this book is immeasurable. Ben Berry, our illustrator pal, contributed some fantastic illustrations in the planning stages of this project. And thanks to all of the agents who contributed a Tips from an Agent segment. Your invaluable work will help inspire new Improv Everywhere missions everywhere.

Charlie would like to thank: my parents, Chuck and Jennifer, as well as my sister, Pierrine, for being incredibly supportive from the very beginning and for teaching me how to play pranks; Miss Cody Lindquist for being a wonderful partner and for proofreading my mission reports at two in the morning; all of the old-school agents who helped me start and build Improv Everywhere (to name a few: Brandon Arnold, Jon Karpinos, Richard Lovejoy, Jesse Good, Ross White, Matthew Kinney, Anthony King, Ken Keech, Chris Kula, and Alan Corey); everyone who has ever volunteered to take pictures or shoot video of a

mission (to name a few: Chad Nicholson, Jamey Shafer, Matt Adams, Katie Sokoler, Brian Fountain, and Ari Scott); Tyler Walker for his music; Wade Minter for his incredible website support over the years; Andy van Baal for his awesome work on our DVDs; Anne Hong, Dave Rath, Kara Welker, and everyone at Generate Management; the Upright Citizens Brigade for everything you and your disciples have taught me and for providing an incredible clubhouse for all of us; Ben Folds for letting me wear his glasses; and Alex Scordelis for his awesome work in making this book a reality.

Alex would like to thank: Byron and Stephanie Scordelis, my wonderful parents, and Marisa and Stephen, my sister and brother, for their love and support; Melissa Seley, for always being there for me and for her help in making this book really spectacular; and Charlie Todd, for creating so much joyful chaos with Improv Everywhere and for the incredible opportunity to collaborate on this project. I also owe a huge debt of gratitude to all of the IE agents and innocent bystanders who offered their time to be interviewed for this book. For their friendship throughout the writing process, I'd like to thank Ben Lev, Chris Schell, Matthew Benjamin, Lesley Robin (who always joins me for No Pants!), and Jude Volek. I'd like to give special thanks to the College of Creative Studies at UC Santa Barbara and the Upright Citizens Brigade Theatre, two institutions where I learned everything I know about writing and comedy, respectively. And finally, I'd like to thank Chuck McMahon for making all of this financially possible.

Charlie Todd is the founder of Improv Everywhere, producing, directing, performing, and documenting the group's work for nearly eight years. He is also a teacher and performer of improv comedy at the Upright Citizens Brigade Theatre in New York City.

Alex Scordelis grew up in Saratoga, California. He is currently a writer for *mental_floss* and an Improv Everywhere agent living in New York City.

.